The Photographer's Internet Handbook

Joe Farace

Allworth Press, New York

Published by Allworth Press
An imprint of Allworth Communications
10 East 23rd Street, New York, NY 10010

Cover design by Douglas Designs, New York, NY

Cover photo © 1997 Joe Farace

Book design by Sharp Des!gns, Holt, MI

ISBN: 1-880559-62-5

Library of Congress Catalog Card Number: 96-84657

In case anyone's been counting, *The Photographer's Internet Handbook* is the ninth book I have written or co-authored. Writing is a solitary business and I could never have completed my first one—or even this book—without the love of my dear wife Mary. She is my biggest fan and for that I'll always be grateful. For all of the support and love she has given me over the past years, this book is dedicated to her. Mary, this one's for you.

JOE FARACE
Brighton, Colorado

Table of Contents

Acknowledgments

Like my last book for Allworth Press, *The Digital Imaging Dictionary*, this one began as a gleam in publisher Tad Crawford's eye. He had the original idea for *The Photographer's Internet Handbook* and gave me his input to help shape the book's outline. I thank him for having the faith that I could bring form to his vision.

One of the most important tools a writer needs when tackling a subject as big as the Internet is a good modem. The modem I used for the Macintosh sections of this book is a Supra Fax/Modem 288, lent to me specifically for this project by Supra Corporation—now known as the Communications Division of Diamond Multimedia Systems. I would like to thank them and Stefana Young, formerly of Imagio Public Relations, for their assistance. My other modem is a Zoom 14,400 internal model that was installed in my IBM-compatible computer by Vern Prime, who also constructed the computer itself. As usual, I would be lost without the technical assistance of Mr. Prime for all things in this book that are PC-related.

Many computer book readers think (and it does *sound* reasonable) that software, hardware, and other Internet-related companies will fawn over an author in order to see their products mentioned in print, especially in a book. The truth is just the opposite. While some firms are glad to help a writer with projects such as this book, many, many more have attitudes that range from benign indifference to belligerence. What this means to a hapless author, such as myself, is that in order

to provide you—the reader—with all of the information I think you need about a specific subject, I must be part detective. And so, like my previous book for Allworth Press, *The Photographer's Internet Handbook* is like a mystery novel in which the search for information is replete with dark alleys and red herrings.

To all of those wonderful people and companies that took some of the mystery out of the process and helped me with various sections of this book by providing technical support and review copies of software and hardware, I would like to say a big "thank you." Here are a few individuals without whose help this book would never have been completed: Philip Anast of US Robotics for providing information about his company's modems, but more importantly for setting me straight about modem transmission standards and getting me up to speed (no pun intended) on the Integrated Services Digital Network that's coming soon to a neighborhood near you. Robin Rothman of Jones Internet Channel for introducing me to the world of cable TV modems. A special thank you to Steve Deyo, editor-in-chief of the ComputerUSER magazines, for his thoughtful insights on why e-mail isn't always the best way to communicate electronically. Douglas Frohman of Digital Frontiers, producers of the HVS Color plug-in, for his help with using image compression technology for use on the World Wide Web. Also a big thank you to Dana Rudolph for introducing me to the free e-mail services provided by Juno Online Services. I also want to thank Claris's Kevin Mallon for his help with their Home Page Website-creation software. Connectix's Don Pickens provided information about his company's compact video camera and helped me get a glimpse into the future on how video technology will be changing the Internet. Thanks, Don. Lastly, I would like to thank Sonya Schaefer of Adobe Systems for keeping me up to date with the latest developments with Adobe Photoshop—including version 4.0.

There were also many photographers who helped shape parts of the content of this book. Foremost was *People* magazine photographer and good friend Barry Staver, who acted as a sounding board for me not just for this book but for many other book and magazine projects. Thanks Barry for your insight and friendship! A big thanks also goes out to those photographers who shared the agony and the ecstasy of going on-line. These include Mark Surloff, a talented architectural and fine arts photographer in Florida; Joe Felzman, owner of Joe Felzman Photography and JFP Stock Photography; Bill Craig, a fine arts, black-and-

white landscape photographer and one of the owners of The Photographer's Gallery in Denver, Colorado; Gordon Baer, a world-class photojournalist with a world-class Website; commercial photographers Joe and Lou Colucci of Colucci Studios in New Jersey; and special thanks to John Todd of Photosphere Studio in Manchester, United Kingdom. Proving that the World Wide Web is, indeed, worldwide he shared information on the creation of his CyberPix Website.

All of these wonderful folks are responsible for the good things you will find between the covers of this book. Any mistakes, errors, or omissions you discover are mine.

JOE FARACE
Brighton, Colorado

Introduction

I use an electric razor and a color television. However, I hang back from computers. I'm afraid they would cut down on my production.

—Isaac Asimov

Isaac Asimov wrote the above words just before he became a spokesman for Radio Shack computers and started using word processing software to increase his already prodigious output of books and magazine articles. Nevertheless, Mr. Asimov probably didn't experience the Internet and never embraced high technology as much as the characters in his science fiction novels did. Many photographers seem to feel the same way and have stayed with traditional business methods—what photographer, Rohn Engh, calls the three F's—of Fax, "Fone," and FedEx. But high technology is not always necessary for success. Mathew Brady built up what would eventually become a legendary photographic business before telephones even existed. Ten years ago, few photographers even had a fax. The point is that not only have the tools of our profession—cameras, film, and lenses—changed, but so have the ways we communicate with our clients and potential clients. Most photographic studios are small enterprises and the most successful ones are those that have maximized the use of technology,

especially communications, to maintain and expand their business. While computers have become popular in studios, they are too often used for word processing, desktop publishing, and database management. A savvy marketeer like Mathew Brady would have used a fax if he had one available, and the same is true throughout the history of photography. The most successful photographers are those who have mixed creativity with technology to maximize their opportunities. If you feel you are not getting the maximum productivity out of your studio's computer, this book's for you.

What This Book Is About

The Digital Imaging Dictionary defines the Internet this way: "Originally developed by and for military use, the Internet is made up of thousands of interconnected computer networks in over seventy countries, connecting academic, commercial, government, and military networks for academic and commercial research. It is also used as a worldwide electronic mail system. The fastest growing part of the Internet is the World Wide Web (WWW), where thousands of companies are creating what might be called the real 'Information Superhighway.' Connection to the Internet is available through on-line services such as Compu-Serve, Prodigy, America Online, and many, many local and national Internet Service Providers."

Your first reaction to reading the above definition may be "Huh?" But don't despair. Like everything else in the world of technology, the Internet has developed its own language and buzzwords combining terms from the worlds of computing and telecommunications. So just relax. When new terminology is introduced in the body of the book, it will be explained in as much detail as those who are less-than-technically inclined will be able to stand. For those impatient souls who want to know what a new term means right away, they can feel free to jump ahead to the glossary, which contains definitions of all of the Internet jargon used in this book. I've also included definitions of imaging-related terms—such as types of image compression graphics file formats—that photographers plying the Internet may find useful.

If anything has been more overhyped than the Internet, I don't know what it might be. The hoopla surrounding the original launch of Microsoft's Windows 95 pales in comparison with that surrounding the Internet. The Internet has been featured on television on everything

from CNN to Nick at Night. Wall Street loves the Internet and the skyrocketing stock price for Netscape's and Yahoo!'s initial public offerings has kept Dow Jones watchers salivating.

Vice President Al Gore has called the Internet the Information Superhighway; digital imaging guru Kai Krause calls it the Super Information Highway. You can call it anything you like, but you cannot escape the fact that it's here and is changing the way that the world— and that includes photographers—does business.

Much of the real action—for photographers anyway—is centered on the World Wide Web, sometimes called the Web or WWW. One of the most popular aspects of the Internet, the World Wide Web uses a set of conventions for publishing and accessing information that provides access through a graphical user's interface that makes use of point-and-click techniques. What this means practically, is that the Web's technology provides photographers with the ability to treat visual data, like photographic images, as if they were text.

While the Internet contains a wealth of information, the WWW contains everything you ever wanted to know about anything. While there are special interest groups on the Web featuring everything from cameras to film to digital imaging, there is plenty of marginal information there too. Like television, finding useful information can be a challenge. Since there's no *TV Guide* to help you, this book will save you time by finding many kinds of photography-related areas on the Internet and Web and showing you how to find more.

Who Should Read This Book

A little over two years ago I attended a seminar on the World Wide Web conducted by a computer company. With me were two other Colorado photographers, Barry Staver and John Blake. Our reason for being there was simple: we had heard all the hoopla surrounding the Web and were there to find an on-ramp to the information superhighway. We were no "babes in the woods." All of us had been using computers in our photography studios for some time. Although I had had an Apple II computer when I was an in-house photographer, I started using an Apple Macintosh in 1984 after I started my own business. The other two guys had similar experience. We also had on-line experience and had all been using CompuServe for communications and as a way to keep up to date with our computers and our photography studios. Yet we

were unprepared for what we found. The all-day session began with a barrage of acronyms that had us gasping for air. This was followed up by an introduction to the software bits and pieces we would need to add (and tweak) to our system to access the World Wide Web. Something seemed horribly wrong. After four hours of listening to techno-babble, Barry, John, and I decided to call it quits and left—the barrage of compu-speak still going on. Later, on our own, we discovered our own on-ramps and are all three surfing the Net—no thanks to our Internet seminar leader. This book is dedicated to those guys and the experience that we shared. It is my intention, writing this book, to spare you from a similar experience.

The purpose of *The Photographer's Internet Handbook* is to bring the power of the Internet to every photographer. The goal of this book is to make it possible for the *average* photographer—not the digital gurus (you know who you are)—to take advantage of the latest communications technology. Whether you are a commercial photographer doing advertising shoots, a portrait photographer creating family portraits and weddings, or a stock shooter communicating with clients around the corner or around the world, the Internet can help you increase sales by offering new, electronic means to market your company, studio, and images. This book is an introduction to the opportunities available for photographers to use the Internet to gain knowledge and, at the same time, increase their studio's productivity and profitability.

In Don Feltner's audio tape *How to Make Money in Photography,* he suggests that photographers, like skiers, can be classified into three distinct groups: Beginner, Intermediate, and Advanced. I would like to suggest that computer-using photographers fall into similar categories.

Here's my view of how you might fit into one of these three groups of computer-using photographers: a Beginner works alone in a small or home-based studio and spends two hours a day, or less, at their computer using simple word processing, spreadsheet, and graphics applications. Intermediate users often work four hours a day in a larger studio and use desktop publishing, scheduling programs, and database managers. Advanced, or Power, users, spend more than four hours a day using process-specific software like Adobe Photoshop. There are always exceptions, but most photographers fit comfortably into one or another of these categories.

In *The Photographer's Internet Handbook,* all three groups will find something they can use and apply at the levels where they are working. Even

if you're a photographer with a shiny, brand-new computer sitting on your desk, you'll be able to find something you'll be able to use right away.

In creating this book I have made a few assumptions: the book is aimed at both users of IBM-compatible computers running Microsoft Windows and owners of Macintosh and Mac-compatible machines. These are the same kinds of computers you will find in the homes, offices, and studios of photographers all across the country. (Amiga or UNIX-based machines are not covered for the simple fact that few photographers use this type of equipment). I've tried to make this book as useful to both platforms as possible and have attempted to make sure that equal emphasis is placed on software and hardware products for both Windows and Macintosh working environments.

While Beginners will be able to use this book, I've assumed that readers have a working knowledge of how to use their computers and are familiar with their basic functions. If you don't know what a mouse is or how a menu works, this is not the place to learn it. Go back to your computer's manual or read one of the many excellent introductory books available for Macintosh and Windows computer users. Intermediate and Power users will be able to put the advice immediately to work in their operations. I've also assumed that you have a basic understanding of graphics (especially photographic) file formats, and the use of image editing programs. You may not be a Photoshop wizard—few people are—but I expect you to have a basic grasp of how image manipulation programs work and have the ability to save images in various graphics file types. If you're a Beginner, don't panic! The most common graphics files used on the Internet will be explained early on in the book so you'll have time to brush up on your image handling skills. In short, I have assumed that you are the average photographer who want to see what all the hype about the Internet is and find out if you want to put it too use. I think that you will find there is at least one, and probably more, aspects of the Internet and World Wide Web that you can use to increase your ability to make creative photographs—and make money at the same time.

How This Book Is Organized

The Photographer's Internet Handbook contains eleven chapters covering topics that are designed to help photographers connect to the Internet, learn to explore, and exploit it, and ultimately harness its power.

Chapter 1 is called "What is the Internet and Who Is Surfing It?" This chapter introduces you to the World Wide Web and the multimedia capabilities that allow you to treat photographs as data. You will also discover why the Internet is important to photographers and digital imagers.

In chapter 2 you'll be introduced to the hardware that's needed to connect to the Internet, including conventional modems and their all-digital equivalents. This chapter includes a non-propeller-head look at how modems work and what to look for when shopping for modems so that you can find one that's right for you. This chapter also includes buyer's tips along with what you should know before plunking down your hard-earned bucks. Alternatives to conventional modems like ISDN (Integrated Services Digital Network) and cable TV Internet connections are also examined. A modem is useless without wires connecting it to the Net. That's why chapter 2 also includes information on Internet Service Providers—what they are and how to find one. This chapter also includes the advantages and disadvantages of using conventional online services, such as CompuServe, America Online, Prodigy, and the Microsoft Network; national Internet networks, such as AT&T or NetCom; or a local Internet Service Provider.

If you're looking for an answer to the question "Now that you're there, what's next?" you'll find it in chapter 3. This chapter includes a look at the kind of information (and a whole lot more) that can be found on the World Wide Web, and it includes an overview of popular Internet browsers and how they work. You will also find advice on what to look for in Internet browser software.

Chapter 4 shows you how to cut through cyber clutter by using various search engines to hunt the Internet for information on specific photo-related subjects. This chapter includes a look at how search engines work, advice on what to do when they don't work, and a comparison of popular search engines, such as Yahoo!. This chapter also provides an introduction to Internet utilities and plug-ins. It explains how to use e-mail to communicate around the corner or around the world and gives tips on how you can keep up to date with everything from the impact of new photographic developments, like the Advanced Photo System, to auctions of historic photographs.

Information about commerce on the World Wide Web can be found in chapter 5. You'll quickly discover that the WWW can provide an international storefront for your photography studio or operation, but

does contain some caveats. For example, the Web provides worldwide exposure to your work, but for the Web to weave its marketing magic, people must be able to find you. This chapter includes tips on how to make that happen. Security is an important question surrounding your own Internet purchases and those of your customers and clients. That's covered here too.

Chapter 6 includes information on World Wide Web sites that you shouldn't miss. This includes an official "thumbs up" guide to the top ten photography sites. In this chapter, you will learn about how to find information on digital imaging and photographic products, including images that can be used for art, commerce, or experimental use.

Chapter 7 explains how to build your own home page. This includes an overview of the easy-to-use cross platform software tools, such as Claris Home Page and Adobe PageMill, that will enable you to construct a Website in the shortest amount of time possible. This includes a step-by-step guide to using both programs to create a working Website site for commercial, stock, or fine art photography.

Chapter 8 contains case histories of several photographers who have taken the plunge into the WWW and what it has done—or not done—for their businesses. In this section they share information on the tools and techniques they used in the creation of their home pages and the kinds of reactions they've received.

Chapter 9 includes tips on designing your new home page so that it can be accessed from the various search engines, along with how to maintain the site, and further tips on how to make sure that people will be able find you.

If hackers can break into the Pentagon's secret files, you may have good reason to be concerned about the security of any your own images on the Internet. That's why the information found in chapter 10, "Cyber Theft," may become important to you. This chapter covers methods for protecting your images from unlawful use, including the use of imbedded copyright symbols on images and the effectiveness of posting low-resolution images to deter thieves.

The final section takes a look at photography in the digital age and what you might expect from the Internet and World Wide Web in the future. It includes a look at two forward-looking Websites and an examination of where all this technology may be taking photographers. Wrapping up the book is a glossary of Internet-related terms and digital imaging buzzwords that an Internet surfer may find useful, and a

detailed list of all of the companies whose products and services are mentioned in the book, including toll-free contact telephone numbers and Internet addresses.

All of the products and services covered in the book represent those that I use every day or that have been recommended to me by other photographers. They are presented here as examples of what can be done, not the final, absolute word on what you can do on the Internet. The inclusion of any products and services is not intended to be an endorsement by Allworth Press, their employees, or subcontractors. All of the opinions represented here are mine and mine alone. You may feel free to disagree—or agree—with them or any parts of them. As is prudent in both photography and computers, my opinions are just that— opinions. Use them as guidelines to perform your own tests and benchmarks to see how the software or hardware I'm writing about matches your own unique work habits.

One Final Note

The Internet is big. So big, in fact, that no single book can possibly contain "everything you always wanted to know" about it. If your favorite software or hardware product or Internet Service Provider is omitted, it is not intentional. The reason could simply be that I was unaware of the product or service, in which case, I apologize. On the other hand, it is also likely that I contacted the company and they refused to cooperate on this book or just ignored me. Many large companies—some that fill your mailbox with demo and sample disks, for example—would not return my phone, fax, or e-mail messages.

The Internet is constantly changing. The software version numbers mentioned are the current ones in use at the time this book was written and reflect the features and bugs present at the time. Newer versions of almost all of the software will, most likely, be available by the time you read this.

The Internet is no panacea. And it's easy to loose sight of the advantages of having an Internet presence for your studio. Don't do it just because you think it's cool. You have to use common sense. And not everybody does. Pizza Hut spent millions of dollars on a Website to serve the people of Santa Cruz, California, only to discover that (contrary to what you see Sandra Bullock doing in the movie *The Net*) people would rather order a pizza by the telephone than via their

. .

computer. Huh? Big surprise here?! It's just as easy to lose sight of those obvious goals when planning your own Internet project. When discussing a marketing plan, professional marketers always refer to a "marketing mix," as a combination of different media and tools aimed at reaching existing and potential clients. Just as you wouldn't shoot all of your photographs with the same lens, don't put all of your marketing eggs in one basket. The Internet is just another tool—or lens—in your marketing gadget bag.

The Internet is new but not all that new. No recent comprehensive study of buying habits has been done since the oft-quoted 1994 survey conducted by the University of Michigan's Business School that focused on Internet *consumer*—not business— buying habits. At this point in Internet history, photographers getting involved in the Internet are not pioneers but will be doing pioneering work. That pioneering effort takes hard work, but offers great rewards too. When working on your own Internet-related efforts, just remember one of Farace's rules of photography: success is hard, failure is easy.

Since this book is aimed at photographers, you might want to read some of Allworth Press's other Internet-oriented books, such as *Arts and the Internet* or *The Internet Publicity Guide*. If you're interested in purchasing one or more of these other titles, you will find the appropriate information on the last page of this book.

On a Technical Note

For those readers interested in that sort of thing, this book was written using a Power Macintosh 8100/80 using Microsoft Word 6.01, and some editing was done on an Apple PowerBook 180 laptop computer using the same word processing program. To make the on-screen type look more like the printed page, I used SmoothType, a Macintosh shareware extension. Using anti-aliasing techniques, SmoothType blurs the jagged edges of bitmap fonts with shades of gray, effectively doubling your screen resolution, and makes your screen look more like the printed page. It even works with Internet browsers, like Netscape Navigator. The Apple Website, for example, looks exactly like their ads, manuals, and other literature. Please note that SmoothType is shareware and if you use it, please pay the five dollar registration fee.

These same computers were used for some of my exploration of the Internet. My Macintosh Internet Browser is Netscape Navigator 3.0, while CompuServe Spry Mosaic and NetCom's NetCruiser were used on

my Prime-built IBM-compatible computer. The original manuscript of the book was printed on an Epson Stylus Color printer, but a copy was also provided to the publisher on floppy disk.

The method for producing the images on these pages is as follows: Photographic prints were scanned on an Epson EC1000 flatbed scanner and 35 mm slides were scanned using a Nikon Coolscan film scanner. Screen captures for the Macintosh were made with Flash-It 3.0.2, a shareware Control Panel, and Quarterdeck's HiJaak Graphics Suite 95 for programs running under Microsoft Windows 95. When necessary, all of these images were converted into grayscale form, saved as a TIFF file, and tweaked using Adobe *Photoshop* 3.0.5 before being placed in the final manuscript by the book's designer. Digital images for all of the illustrations were provided to the designer on a 44MB SyQuest removable media cartridge.

About the Cover

One of the best ways to ride the information superhighway may be in a fire truck—the subject of this book's cover. The design is by David Milne, the talented designer who also did the cover for *The Digital Imaging Dictionary.* The background image, however, is a digital image created by me.

Here's the genesis of how I created "Ford Fire Truck." The original image of a unrestored, vintage fire truck was made at a fireman's "muster" in Littleton, Colorado. The original image was photographed with a Nikon N90s with a 35–70 mm zoom AF Nikkor lens using Kodak Ektachrome 100 Professional (EPN) film. The slightly underexposed (a minus ⅓ stop exposure compensation was dialed in) slide was digitized using Kodak's Photo CD process. A 2048 × 3072 pixel image from the Photo CD was opened in Adobe Photoshop 3.0.5. Using Second Glance Software's Chromassage plug-in, I manipulated the color palette of the originally red truck to produce the variety of colors that you see. Photoshop's brightness and contrast controls were used to tweak the image to get the color intensity where I wanted. Auto F/X Photo/ Graphic Edges were added to the image to give it less of a straight-edged look. Contact information for these suppliers can be found in the list of resources at the end of the book.

1 What Is the Internet and Who Is Surfing It?

We are moving inextricably toward total non-silver–based imagery. What we are seeing now is the first wave of changes in our industry in which computers, telecommunications, and entertainment will merge.

—Joe Farace, *Photomethods*, February 1987

In this chapter you'll be introduced to some of the technical definitions and descriptions that you will need to know in order to become a proficient Internet surfer. For reasons that have been lost in antiquity, people who use computers to connect to the Internet—for whatever purpose—are said to be "surfing the Net." The real reason that people "surf" the Internet is probably based on the same rationale that photographers "shoot" brides and children. Ya think?

What Is the Internet, Anyway?

If you are satisfied with the definition of the Internet found in the Introduction you can skip to the next major heading, but if you are the kind of photographer who likes the details, read on.

The Internet is actually not a single entity; it is composed of thousands of interconnected computer networks that are located in over

seventy countries. If you prefer to think of it in organic terms, the Internet is a limbic system connecting the gray matter of independent computers by a series of high-speed communication links between major supercomputer sites located at educational and research institutions within America and throughout the world.

Like many successful enterprises, the Internet had rather humble beginnings. In 1969 the Advanced Research Projects Agency of the US Department of Defense created a computer network, called ARPANET, enabling scientists doing research for the Department of Defense to communicate with one another. The original ARPANET connected just four computers, but by 1972 fifty different universities and research sites had access to it. During the late 1980s commercial restrictions were lifted and (what eventually became known as) the Internet began to grow dramatically. In 1991, $20 million a year in federal subsidies were awarded to the National Science Foundation to maintain a major chunk of the system through another network that was to be called, not surprisingly, NSFNET. The actual management of NSFNET is handled by a joint venture of IBM and MCI called Advanced Network and Services, which links supercomputing centers and 2500 academic and scientific institutions around the globe. Commercial service providers of all kinds, including telecommunications giants like AT&T, connect to the system and provide links to subscribers like you and me. Eventually, all of these public and private networks were interconnected allowing any computer on any one of the subnetworks to access computers anywhere else in the entire Internet. The Government Accounting Office estimated that in 1995 the Internet linked 59,000 computer networks, 2.2 million individual computers, and 15 million users in ninety-two countries.

With many different kinds of computers connected on the Internet, designers had to develop a method by which they could all speak to one another using a common language. In 1983 a communications protocol was developed, which ultimately became know as TCP/IP. Let's attack both of these terms in reverse order: "protocol" is a communications industry buzzword that defines a system by which the computers on both ends of a network connection are operating under the same set of rules so it's possible for them to communicate without experiencing any problems. TCP/IP stands for Transmission Control Protocol/Internet Protocol—that's a big help isn't it?—and is the official protocol for the Internet. (This is kinda like Coke being the official soft

drink of the Olympics.) TCP/IP's job is making sure that the number of bytes that starts out at one end is the same number of bytes when it gets to the other end. TCP/IP was originally developed for UNIX computer systems but is now the communications standard for all Internet-connected computers, including the Power Macintosh I'm writing this book on. For Windows users, Winsock is a software standard that provides a common interface between TCP/IP and Internet software. When Internet software is installed on your PC-compatible, it is in the form of Dynamic Link Libraries (DLLs).

The closest thing to an organization that actually runs the Internet is the IAB, or Internet Activities Board. The IAB is ostensibly its governing body. A subcommittee called the Internet Research Task Force (IRTF) investigates new technologies, which it then refers to the Internet Engineering Task Force (IETF) to work on specifications for new standards.

There are over two million "hosts" on the Internet, a host being a mainframe, mini-computer, or workstation that directly supports the Internet Protocol (the "IP" in TCP/IP). The Internet is connected to all types of computer networks around the world via gateways that convert TCP/IP into other protocols. Let's climb the acronym ladder one more rung and mention that TCP/IP includes a file transfer capability called "FTP" for File Transfer Protocol. What's so wonderful about FTP? It's the protocol that lets you send and receive files on the Internet. If you don't already know why this is a cool thing, you will by the time you're finished reading this book. One more rung, OK? Another important feature of TCP/IP is SMTP or Simple Mail Transfer Protocol. SMTP permits Internet users to send e-mail (electronic mail) by allowing both sending and receiving computers to emulate a terminal connected to a mainframe computer. E-mail allows you to send a message electronically to another user who may be located anywhere in the world. Asking for an e-mail address is fast replacing "what's your sign" at bistros everywhere.

The Internet vs. the Intranet

Sooner or later you're going to encounter the term "Intranet." So before you become quickly confused: an Intranet is a private computer network that has been designed to have the same look and feel as the World Wide Web, and combines HyperText links with text-based

information, animation, graphics, and video clips to allow its users to communicate. A Full Service Intranet, a concept developed by Forrester Research in 1996, is a TCP/IP network inside a company that links the company's people and information in a way that makes people productive and information-accessible, and permits navigation through the company's computing environment. A Full Service Intranet takes advantage of open standards and protocols that have emerged through development for the Internet. These open standards make possible applications and services like e-mail, groupware, security, directory, information sharing, database access, and management that are as powerful, and in many cases more powerful, than traditional systems, such as Lotus Notes or Microsoft Office.

Intranets are the latest buzzword. Many Fortune 1000 companies are installing them to allow their employees to communicate with one another around the world. By the end of 1996, "every major Fortune 1000 firm" will have an Intranet installed, predicts Rick Spence, an online strategies analyst for Dataquest, a market research firm located in San Jose, California. A Forrester Research project of fifty major corporations found 16 percent already have an Intranet in place and 50 percent either have plans to or are considering building one.

What does all this mean to the photographer with few, if any, employees? As more powerful computing hardware becomes more affordable a new category—the personal Web server—is emerging. As I write this, Apple, Quarterdeck Corporation, ResNova Software, and others are moving toward providing the same kinds of file sharing and communications services once reserved only for large LAN systems and, later, corporate Intranets. I see two sides of the Intranet question affecting photographers. On one side, the chances that only the larger studios in the country will install an Intranet or personal Web server. On the other side, the key part of the word "Intranet" is "net." If Eastman Kodak or Fuji Photo Film creates an Intranet for use by the employees of their world-wide organizations, it's a sure bet that, over time, some of us on the outside will be invited into the company Intranet to obtain information or communicate directly with the company. "But that's just my opinion," as comedian Dennis Miller says, "I could be wrong."

The World Wide Web

The World Wide Web, WWW, or just plain Web, was originally designed by Tim Berners-Lee and his colleagues at the European Center for Nuclear Research as a way of linking various kinds of information—no matter where it might be located—on the Internet. The WWW was not designed as a physical entity, but as a series of basic specifications for interchanging linked information. *The Digital Imaging Dictionary* defines the World Wide Web as: "One of the most popular aspects of the Internet, the World Wide Web has a set of defined conventions for publishing and accessing the information found on it using HyperText and multimedia." One of the reasons that the World Wide Web is popular is that documents on it can display text and—attention photographic shoppers—graphics.

Right away, we're in acronymville again. Let's start with HyperText and see where it ends. The term "HyperText" was originally used by computer visionary Ted Nelson to describe a method that would allow computers to behave the same way people do when they are looking for information. HyperText accomplishes this the same way our brain does by linking related information together. Linked information on the Web is created by programmers using HyperText Markup Language or HTML. Specific locations on the WWW are called "home pages" and

Figure 1-1. Jonathan C. Winter's Toy Camera home page is the place to start if you are interested in toy cameras or images made with them. HyperText links to other home pages allow Internet surfers to jump from location to location—even country to country—to find what they are looking for.

usually contain links with other documents either locally or anywhere on the Internet. Sometimes a home page will be called a "Website," and as is common in general usage, I will use the terms interchangeably in the book. Currently there are more than eight hundred thousand Websites on the WWW, and I have heard (although it is impossible to verify) that two thousand more are added each day.

What all of this jargon means in practice is that the World Wide Web uses "hot spots" on its home pages to link related information. If you're interested in toy cameras, for example, a home page may contain links to sources to purchase cameras, like the plastic-lensed Diana, or locations that display photographs created with the Russian-made Lomo. The mere act of effortlessly moving—by just pointing and clicking—from home page to home page, country to country, and location to location is what, I really think, gave birth to the term "surfing" the net.

In the not too distant past, the only way you could create your own home page was by writing HTML code. Fortunately there are now much easier ways for non-programming photographer to do produce their own home page and these methods will be discussed later in the book.

Multimedia Aspects of the WWW

Multimedia is another computer buzzword that has been overused. It is nonetheless the fastest growing aspect of the Web. On the most basic level, a Website with multimedia can be any home page that mixes graphics, text, animation, movies, and photographs. Macromedia Corporation upped the multimedia stakes with the introduction of ShockWave. ShockWave is a software plug-in (or add-on) for Internet browsing programs that allows animation and movies to be viewed in real time on the World Wide Web. Later on in the book, the software and plug-ins needed for browsing the WWW will be introduced. In the meantime, the most important multimedia feature of the World Wide Web for readers of this book is that it's the place that allows photographs to be displayed and downloaded. (When data is retrieved from the Internet or WWW and saved on your computer it is said to be "downloaded." When data—text or images—is sent to a home page it is "uploaded.")

Graphics File Formats

Photographs on the Internet are usually displayed or saved in one of three graphics file formats:

- **JPEG:** JPEG is an acronym for a compressed graphics format created by the Joint Photographic Experts Group, within the International Standards Organization. Unlike other compression schemes, JPEG is what the techies call a "lossy" method. By comparison, LZW compression (see below) is lossless— meaning that no data is discarded during the compression process. JPEG, on the other hand, achieves compression by breaking an image into discrete blocks of pixels, which are then divided in half until a compression ratio of between 10:1 and 100:1 is achieved. The greater the compression ratio that is accomplished, the greater loss of sharpness and color detail you can expect. JPEG was designed to discard information the eye cannot normally see, but the compression process can be slow.

- **GIF:** The Graphics Interchange Format (GIF, pronounced like the peanut butter), originally developed by CompuServe, is platform-independent, i.e., the same file created on a Macintosh is readable by a Windows graphics program. A GIF file is automatically compressed and consequently takes up less space on your hard disk than other graphics formats. Some image and graphics programs considers GIF files to be "indexed" color, so not all software read and write GIF files, but many do.

 The future of the GIF format is uncertain. When CompuServe originally developed the format, it used the Lempel-Ziv-Welch (LZW) compression algorithms as part of the design believing this technology to be in the public domain. As part of an acquisition, UNISYS (formerly Univac Corporation) gained legal rights to LZW and a legal battle ensued. The way it stands now, reading and possessing GIF files (or any other graphics file containing LZW-compressed images) is not illegal, but writing software which creates GIF (or other LZW-based files) may be. This has led to the creation of the PNG format.

- **PNG:** Portable Network Graphics (PNG, pronounced *ping*) is the successor to the GIF format widely used on the Internet and online services, like CompuServe. In response to the announce-ment from CompuServe and UNISYS that royalties would be required on the formerly freely used GIF file format, a coalition

of independent graphics developers from the Internet and CompuServe formed a working group to design a new format that was called PNG.

Among the features of the new file format: PNG's compression method has been researched and judged free from any patent problems. PNG allows support for true color and alpha channel storage and its structure leaves room for future developments. PNG's feature set allows conversion of GIF files, and PNG files are typically smaller than GIF files. PNG also offers a more visually appealing method for progressive online display than the scan line interlacing used by GIF. PNG is designed to support full file integrity checking as well as simple, quick detection of common transmission errors. And all implementations of PNG are royalty-free.

Most, if not every, image enhancement programs will read and write JPEG files. Because of the legal difficulties described above, an ever decreasing amount will read GIF files, while an ever increasing number will read PNG files.

One of the most popular image enhancement programs is Adobe Photoshop but version 3.0.5 does not support PNG—at least as it leaves the factory today. Because of Photoshop's ability to accept plug-ins, third-party software producers have rushed in to fill the gap. In this case, by creating a PNG Photoshop v1.00 plug-in. As is the case with all Photoshop-compatible plug-ins, this one works with any compatible program, including Fauve Matisse, Fractal Painter, Paint Shop Pro, and others. This is a Windows-only plug and the system requirements include Intel 80x86 (minimum 80486) and Windows NT. To install the PNG filter, copy it into the same directory with the other filters (8bi file extensions). (For Adobe Photoshop, this directory is usually called PLUGINS. For other programs which accept Adobe filters, such as Fractal Painter, see your user's guide.) Then, exit Photoshop and start it again. The Open and Save dialog boxes should now contain an entry for PNG file type. The plug-in should also be present in the list of filters under Help About Plug-ins. There is a twenty dollar shareware fee payable to Banana Software. (Contact information can be found the Appendix.)

• **A PNG alternative:** Most photographers already know the importance of image management. When a customer calls to

order reprints from a photo session, you look up the negatives by client number or name, "pull" the negatives from your filing system, and order the prints. Digital images, by their nature, can be more difficult to locate. As you generate more digital images, remembering file names and locations can be a challenge. It's all too easy to forget which folder or directory a file was placed in, when created under deadline pressure. Sooner or later you are going to need help to manage your images. As with any storage and retrieval system, sooner is better than later.

Software Avenue's PhotoFiler 2.0 is a Windows-only image management program that includes everything you need to know about using it through its built-in online help. Moving the cursor onto a control or part of the interface pops up a balloon that tells you what the control does. Clicking the Plus button brings up a blank data entry field and clicking the large image window brings up the Image Viewer window, which allows images to be added. The Technical, Darkroom/Lab, and Notes sections allow you to add data about your images that can be searched through two Search windows at the top of the screen. The program supports GIF, PCX, BMP, JPEG, and the new PNG image graphic file

A New Format?

As I was completing this book, a consortium of companies, including Eastman Kodak, Hewlett-Packard, Live Picture, and Microsoft announced a new, open standard for digital imaging called FlashPix. The format will use a hierarchical storage concept allowing images to take less RAM and hard disk space than previous image-based graphics files. This will allow users to work with many on-screen images at the same time without overloading the computer's memory or adversely affecting performance. Edits will be easier, especially non-destructive edits, such as rotation, scaling, and color and brightness adjustments. This means that users will be able to experiment with changes and quickly undo them, without destroying original image data.

Here are some of the features of FlashPix format.

- A universal file format: software that uses the FlashPix format won't have to convert as often between other formats—like JPEG or TIFF—as they do today.
- Multiple independent resolutions and tiling: a FlashPix file will

contain the complete image, plus a hierarchy of several lower resolution copies within the same file. Applications can access a low-resolution image for on-screen or online use or employ higher resolution files for output to devices such as film recorders or film separations.

- Structured storage: a FlashPix file will employ Microsoft's OLE format, which holds image data and related information in a standard "wrapper." This allows developers to add extensions to provide proprietary features for applications that don't convert the image to a new format.
- Linking: FlashPix will support linking, allowing images to be used in multiple ways but keeping the original image data stored in one location. Linking allows applications to access original image data whenever it's needed without having to rewrite a full-resolution FlashPix file.
- Built-in Color: FlashPix supports two color space options: calibrated RGB and Photo YCC, used in Photo CD.
- Descriptive information: the new format allows users to store descriptive data along with image data. This includes keywords for imagebase applications, caption data, or copyright data.
- Optional compression: FlashPix can use JPEG compression or files can be stored uncompressed.

Knowing what file formats are Internet-friendly may not be important right now but will be later on when you start building your own home page. How to get your photographs into one or more of these Internet-friendly graphics file formats will be covered in chapter 9.

Why the Internet Is Important to Photographers

This section looks at the three major reasons photographers should discover and exploit the Internet. These are not the only reasons that you should surf the Net or waltz the Web, but they represent the major areas where the Internet will be of value to you—no matter what your photographic specialty may be. As you become more experienced with the Web and new elements are developed for it, you may discover other uses that affect you and your studio on different levels.

Access to Photographic Products and Services

All of the major camera companies have home pages on the Internet. If you're a Nikon user and you want to find out what's new with your favorite company, just visit their Website at **http://www.nikonusa. com**. The Web also provides access to photo retailers so that you can order a new 400 mm lens or ask a technical question while visiting a retailer's home page. The WWW also lets you find hard-to-get items, such as an all-plastic Holga camera or film for your old and now-obsolete Kodak "Party Time" instant camera. In chapter 6, I'll introduce you to several photo-related home pages you won't want to miss.

Figure 1-2. Nikon's (original) home page provides access to the latest information about the company's conventional and electronic imaging products.

One of the newest features of the World Wide Web is that photographic labs and photofinishers are providing online delivery of digital images from processed or unprocessed film that you send them. Seattle FilmWorks and Wolf Camera are just two companies that are currently offering this service, and I would be surprised if at sometime in the future other labs, especially the Kodak-owned Qualex don't offer similar services. The specifics of how one of these services works, along with a step-by-step download of actual digital images, is covered in chapter 3.

Nonphotographic Products and Service

Photographers do not live by digital imaging alone. They've got a business to run too and require assistance for everything from travel planning to demographics to information about government regulations on photographing assignments on public land or national parks. It's all here. The World Wide Web is big and getting bigger and contains information that can help you in business planning. The problem is how to find them. The main tools for finding information on the Web are search engines that look up Websites based on keywords that you supply. Chapter 4 includes a look at popular search engines and includes information on the strengths and weaknesses of each of them.

Figure 1-3. Netscape Navigator includes a Net Search function that provides access to many different search engines that will help you find what you're looking for on the World Wide Web. Later in the book, the pros and cons of each search engines will be compared.

Worldwide Marketing

In 1993, there were approximately 38 million Internet users worldwide, and according to International Data Corporation that number is expected to grow to nearly 200 million by 1999. While not all of these users are potential buyers of your images or services, the Internet is clearly becoming a business tool much in the way that the fax machine has.

Having your own home page on the WWW can give a single photographer, working alone, the same online marketing clout that General Motors has. It's this democratization of the Internet that empowers individual photographers, limited only by their creativity, to have the ability to market their images and photographic assignment

capabilities to buyers across the country or around the world. Never in the history of art and commerce has this kind of marketing tool existed that would allow a small studio to compete with the "big boys." If you have a studio in Spearfish, South Dakota, you may not be able to open an office in New York or Los Angeles to sell your work, but starting a home page on the Internet gives you the equivalent of an international office with little of the costs normally associated with opening another studio location. In this way, the Internet is truly the great equalizer. When someone lands on your home page, they will judge it by its design and the quality of images that are displayed—nothing else.

Communications

One of the most practical aspects of the Internet is the ability to communicate with people no matter where they may be located. For the cost of a local phone call you can send electronic mail to a company in Germany, order camera parts from a firm in Canada, or correspond with a photography professor in Haifa, Israel. One of the first things you will notice is that e-mail, like home pages, has a distinct format for addresses. For those readers who have been wondering what all those acronyms and symbols mean, I've prepared the following overview of e-mail and Internet addresses.

E-Mail

Sending electronic messages, or e-mail, is much easier than writing a letter on your computer, printing it, addressing an envelope, licking a stamp, and dropping it in your mailbox. An e-mail message is usually delivered in minutes and the cost of sending a message to Toledo, Spain, is the same as it is to send one to Toledo, Ohio. E-mail, therefore, allows photographers to communicate with potential clients as well as suppliers around the world for very little cost and provides access to international photographic markets that were once the exclusive province of well-heeled shooters.

To send e-mail, one of the first things you'll need is an Internet address. This happens when you sign up with an Internet Service Provider and is covered in more detail in the next chapter. Most ISPs allow you to pick your own e-mail address within the basic format of "name@ISP.domain." Most ISPs—with the exception of CompuServe, which used to assign you a cryptic account number—you pick your own

name. For example, my e-mail address used to be: **75300.413@ compuserve.com.** During the winter of 1996, CompuServe converted this all-number system to an alphanumeric naming scheme and my new address became **FaraceFoto@compuserve.com.** Much better, don't you think?

If the name is the first part of your electronic address and the ISP is your service provider, you may be wondering what the domain stuff is. Here's a quick overview of Internet domains.

- "com" is a business or commercial Internet domain and photographers using CompuServe, America Online, or NetCom usually have a **.com** domain.
- "edu" is assigned to educational and research users at colleges or universities. Student photographers or photography professors typically have a **.edu** domain in the Internet address.
- "gov" is the domain designation used by government or military agencies. If you're an in-house photographer for a government agency or a Photographer's Mate in the Navy, your address will end with **.gov.**
- "net," gateway or Internet host sites have a **.net** domain.
- "org" is used by non-profit organizations, like National Public Radio. Their addresses will have a **.org** domain.

In the next chapter, you'll discover how to get the hardware and software needed to actually begin sending e-mail. In the meantime here's a short overview of the basic language and etiquette, called "netiquette," you'll need to know before communicating electronically.

When corresponding via e-mail or in Newsgroups where more than the person you're sending your message may read it, a certain level of civilized behavior is expected by the people reading your messages. Instead of having an Internet Emily Post, people reading your postings will try to educate you in the proper forms of written behavior. One of the most common mistakes newcomers make is typing everything in CAPITAL LETTERS. This is considered a breach of netiquette because the writer is considered to be shouting and it's hard to read, too. If you get too loud or profane (sometimes called "flaming"), expect a stern warning from the Webmaster or Sysop. You may even find yourself barred.

After you read a message you might want to reply to it as soon as you can. This seems an obvious rule, but one that is gradually dis-

appearing. The golden rule applies here, I think. Part of the problem with the growing volumes of e-mail is that some of it is misdirected. That's why it's a good idea to routinely double check the "to:" field whenever you send a reply. This can keep you from replying to someone you don't have to.

IRC [By the Dawn's Early Light]

Yet another Internet acronym, IRC, stands for Internet Relay Chat, a system that allows users to interact in real-time with other people connected to the same channel. Some pundits have likened IRC to Citizen's Band Radio, good buddy, and for many years the Citizen's Band Simulator on CompuServe has been a popular area for its subscribers.

USENET Newsgroups

USENET is yet another form of information gathering that gives Net surfers access to a worldwide bulletin board with over ten thousand special interest categories that allow users to read and post messages as well as download articles on many different topics, including photography. It was established in 1979 as a bulletin board between two North Carolina universities and has grown to its current size through the use of volunteers only. All of the news that's found on the Internet is called "NETNEWS," and a newsgroup is a place where users have running conversations on a particular topic. While the topics can include photographic art, science, and commerce they are just as likely to include CyberSex, daily O. J. updates (while *that* trial was going on), and hate groups railing against Barney, the dinosaur.

URLs and You

If an e-mail address is important to budding surfers, a URL is just as important for Webmasters—the people who maintain and create a home pages. "URL" is an acronym for Uniform Resource Locator, which is the technical term for the actual electronic location of a home page on the World Wide Web. The first part of a WWW address begins "**http://**." The letters stand for HyperText Transport Protocol, which is the communications protocol that is used on the Internet—specifically the World Wide Web—to share information. For example, the URL for *Photo>Electronic Imaging* magazine's home page is: **http//www.peimag. com.**

To obtain an Internet network address and reserve a domain name,

organizations must register with the InterNIC Registration Service. A recent story in *Macintosh Today,* a regional Macintosh magazine, included an interesting rumor that some unscrupulous people were registering URLs, such as (hypothetically) Toyota.com, and then selling them back to companies that waited too long to get onto the Internet.

2 Getting Wired

She has an ultra-high–speed modem connection, I guess, since Internet stuff pops up the moment she hits the return key.

—Roger Ebert writing about Sandra Bullock's
character in the movie, *The Net*

To get connected to the Internet you will need two things: hardware and software. The first section of this chapter looks at hardware, modems, and the second section introduces you to software, browsers, that make communications over the Internet possible. No matter what combination of hardware and software you end up using, nothing can shield you from the reality of the Internet as I write this: accessing information on the Internet can be slow. According to Macintosh guru, Henry Norr, writing in *MacWeek*, "the main problems have nothing to do with the [band]width of your local pipe; the real issues are backbone bottlenecks, overcrowded servers, and insensitive [home] page design." There are always alternatives to using conventional modem technology and this chapter will look at digital networks and cable TV (yes, the same cable that brings you *The Larry Sanders Show* on HBO) Internet options.

Hardware: Modems

Your hardware ticket to the Internet is a modem. The word "modem" comes from two words: "MOdulate-DEModulate." That's what a modem does. Since the current telephone system across most of America is analog, computer data must be converted from digital form into analog form for transmission over telephone lines. At the receiving end, the data is then converted from analog back into digital form. A modem, when used with the appropriate software, can also dial a call to an online service or BBS, answer a call, and control transmission speed, which currently ranges from 300 to 28,800 bps (bits per second). While modem speeds have continuously been raised through a horsepower race between manufacturers, all this conversion back and forth ultimately limits the ultimate speed of data communications.

Modems come in two basic configurations: internal and external. The names indicate just what they're like. Internal modems are mounted on circuit boards and plug into a slot on your computer's motherboard. Any discussion of the advantages, disadvantages, and installation procedures for internal modems may be more relevant to computers running the Microsoft Windows environment and not Macintosh. There are few internal modems available for the Macintosh but that is rapidly changing as the current generation of Power Macs use the same PCI bus that's common in the IBM-compatible world. Apple upped the ante on internal modems by making them standard on some models of their consumer-oriented Performa series—notably the Performa 6400 models.

Internal modems cost less because they don't require a housing and they use your computer's built-in power supply. They also require no additional desktop space, something that, for most users, grows scarcer every day. One downside of an internal modem is that it takes one of your slots and, depending on your motherboard design, that may or may not be a problem for you. The ultimate decision of whether you choose an internal or an external model for your studio may boil down to how difficult it is to install an internal model. In the past, installation of internal modems in the typical PC-compatible was, let's be honest, a pain in the you-know-where. Windows 95's implementation of plug-and-play extends to all hardware and software, including modems. This makes the installation of an internal modem a matter of plugging in the modem in an available slot and double-clicking the add-new-

hardware Control Panel. This procedure launches one of Microsoft's famous Wizard sequences, guiding you step-by-step through the rest of the process. (Macintosh users have had this same plug-and-play capability since 1984 but that's another story.) This same procedure is not so easy to accomplish in Windows 3.1 and older versions. Therefore installing a internal modem in a computer using these operating systems/environments is best left to those technically inclined photographers who like to take things apart. Keep in mind that you don't have to do it yourself. Many computer and electronic superstores now include free installation of computer hardware items that you purchase from them. This is one of the better reasons to buy from a local retailer instead of a mail-order house.

External modems, on the other hand, are separate boxes containing their own power supply and circuitry and are connected by a cable to the serial port, or modem port on the Macintosh, of your computer. That's about as difficult as they are to install. You plug in a cable to the computer, insert the power cord into a wall socket or power strip, plug in the telephone line, install the software (if you don't already have some), and you're ready to go online. One of the major advantages of the external configurations is that they usually have some kind of LED display on the front of them that indicates the progress of your connection with the Internet or host computer. Some modems, like the Supra Fax/Modem 288 I've been using, have a panel that actual displays English words. Right now, the modem is turned on—but not in use—and it is displaying "OK." External modems are getting smaller too. The Supra modem mentioned above is the size of a thin paperback book, so it does not use up too much desktop real estate. I keep the Supra 288 sitting on top of my Power Macintosh 8100, so it doesn't require additional workspace. Because external modems have a separate power supply and external case, they are necessarily more expensive, but not too much more. As I write this, a good 28,800 bps modem costs about $150.

One of the advantages of external modems is they will talk to you and tell you what they are doing through a series of LED indicator lights. Some modem users think these coded lights are an essential part of the modem experience, while others (I'll raise my hand on this one) could care less. Above and below these lights a two or three letter code is usually printed to tell you what's going on when a light is illuminated. Here's a crash course in what these indicator-light codes mean:

AA: Auto Answer
CA: Compression Active
CD: Carrier Detect
TR: Terminal Ready
EC: Error Control
HS: High Speed
MR: Modem Ready
OH: Off Hook
RD: Receiving Data
TM: Test Mode
SD: Transmitting (Sending Data)

A subset of the internal modem category is the PC Card modem. PC Card is the current euphemism for PCMCIA. PCMCIA is an acronym for Personal Computer Memory Card International Association. A PCMCIA, or PC, card is a small credit-card sized module that is designed to plug into standardized sockets of laptop and notebook-sized computers. To date, there have been three PCMCIA standards: Type I, Type II, and Type III. The major differences between these types is the thinness of the cards. Type III is 10.5 mm thick, Type II is 5 mm thick, and Type I is 3.5 mm thick. Most laptops will take a combination of the different types. The Apple PowerBook 190, for example, has two PCMCIA slots that can accommodate two, Type I or II, PC Cards or one Type III card for installation of a modem.

Internal and external modems are produced by many different manufactures in different speeds, with a growing emphasis on the faster speeds. As the price/performance of all modems steadily improves, the modem's serviceability or warranty becomes less of an issue when deciding which kind or brand to buy. The chances are that if—and that's a big if—your modem ever fails, you will want to replace it with a newer, faster model. And chances are good that this new modem will cost less, have more features (like fax or voice mail), and cost less.

Which type is best? I have one of each, and if I had my "druthers," I prefer the internal style because my work area tends to be a mess. Now that you've read the pros and cons of each type, I'm sure you can decide what will be best for you.

How They Work

Techie alert: This next section gets into the basics of how modems work and what the technical specifications of a typical modem are. Reading this information is just as important as checking out the technical specs for a new camera or lens.

A modem's job is a simple one: they are designed to take the digital information stored in your computer and convert it into audio frequencies that are compatible with the analog telephone system. The modem, along with the appropriate software that we'll get to in a bit, will dial the phone number for your Internet connection. The speed of transmission for a modem is measured in bits per second (or bps). Not so long ago, 2400 bps modems were the norm, this quickly escalated to 9,600, then 14,400, and now 28,800 bps is considered *de rigueur* for Net surfing. Make no mistake about it, surfing the Net can be slow—slower than you may think—and having the fastest modem you can afford will make cruising the Internet less painful.

To control the modem, most use the Hayes AT command set of machine instructions. Hayes Microcomputer Products was one of the early pioneers in data communications and up until they created the Smartmodem 300 in 1981 most modems were passive devices used in dedicated data transmission systems. The Smartmodem created and understood a language of modems that other manufactures quickly adopted as a standard. When buying a modem you want to make sure that it is 100 percent Hayes-compatible.

Standards for data communications devices are created and approved by the International Telecommunication Union (or ITU). One of the most popular modem standards was the V.34. In its original form, V.34 defined speeds for 9,600 bps telecommunications; when speeds were increased to 14,400 bps, the new standard was called V.32 bis. The "bis" notation denotes a significant addition to the original standard. (Another designation that the ITU uses from time to time is "ter" to designate enhanced standards.) Later on the standard was enhanced to allow speeds from 28,800 to 2,400 bps. The latest V.32, which contains no suffix is just plain V.32 and allows speeds of up to 36,000. The real question modem users are asking these days is: "Will I be able to achieve modem speeds of 33,600 for each connection?" The answer is "not likely." Variations will exist in telephone line conditions, and modems on both ends may "step down" to produce a speed that's

appropriate for the quality of the actual transmission. Another international standard for 28,800 modems is V.First Class (or V.FC) that was created by Rockwell International before the specifications for V.34 were finally set.

Figure 2-1. The Courier V.Everything modem by US Robotics is a desktop modem for Macintosh or IBM-compatible computers that provides both data and fax capabilities.

Most modems these days have built-in error correction and data compression to increase speed of transmission. V.42 bis, the current ITU standard for data compression, produces an average ratio of 3.5:1. This means that a 28,800 V.42 bis modem can transmit up to 115,600 bps. V.42 bis uses an on-the-fly method of compression that works best when the data being transmitted is not already compressed. If you are sending a photograph in GIF, PNG, or JPEG format, the data has already been compressed, so compressing it a second time when using a V.42 bis modem won't accomplish the higher transmission rate I just mentioned. Most V.42 modems also incorporate ITU standard error correction LAP (link access procedures).

Many modems offer fax capabilities in conjunction with their data and Internet features. Fax modems often incorporate DSPs (digital signal processors) that allow the device with the appropriate software to become a digital fax machine capable of sending and receiving Class 1 and Class 2 faxes at 14,400 bps. A Class 1 fax is a series of Hayes AT commands that can be used by the appropriately designed fax software to emulate and control a fax machine or fax/modem. In 1991, Class 2 was developed that allows the modem to handle all of these functions through the hardware only. It does that by allowing the fax/modem to establish the connection, but places the burden on sending and receiving the image data on the processor of the host machine. Having a fax that can work with both Class 1 and Class 2 modes, as does the Zoom ComStar, gives computer users the greatest flexibility in selecting

the fax software they would like to use with their microcomputer. Do you need fax capabilities? Read on.

How to Find the Right Modem

The next two sections contain information on what to avoid and what to look for when shopping for a new modem. Consider it a highly opinionated look at the modem marketplace.

What to Avoid

Unless you are extremely knowledgeable about computers and modems, beware of close-outs at the discount computer store. At the end of the next section, you will discover Farace's Internet Rule #14. I won't spoil it for you now, but it tells you that there are few real bargains in older or used modems. Often these close-outs are used or demo models of older and slower modems. As I have mentioned, the Internet can be slow—annoyingly so, on some days—and if you buy a slow modem, you will not be happy with your "good buy" when it takes an hour to download a large file. On the other hand, used state-of-the-art modems are available at the used computer stores that are springing up everywhere. The best of these stores will guarantee the used modems, and you can pick up 28,800 bps modems at better than bargain prices. Why are these used modems available? Part of the problem is that the Internet has been oversold to a large part of the general population as a panacea for everything from your kid's poor grades in school to your gradually declining stock portfolio. Some people quickly realize that they are not Net surfers and dump their hardware—usually at a big loss. When shopping for a modem with fax capabilities, make sure it can handle both Class 1 and Class 2 faxes, so you can use whatever brand or type of fax software you want without being limited by the hardware design.

Don't cut corners when shopping for a modem. It will be one of the least expensive peripheral purchases you make, so now is not the time to scrimp. You didn't wince when you purchased that 600 mm lens. If you're serious about taking advantage of the Internet, you need to make the same kind of financial investment as you made in your photographic equipment—although the cost of the most expensive modem will be much, much less than any long lens for your Nikon, Canon, or Minolta.

Buyer's Checklist

Here are a few things to keep in mind before heading out to the computer superstore with your credit card or breezing through the pages of *Computer Shopper* looking for bargains.

- **Hayes compatibility.** If you have read the section about Hayes Microcomputer Products and their creation of the original, *de facto* modem standards, you now know that spending money on a modem that is not 100 percent Hayes-compatible is a waste of money.

- **Configuration—internal or external.** It's a good idea to go shopping with a specific kind of modem in mind. Don't just buy it because it was on sale. Because photographers tend to have more peripherals than the average user, I would like to recommend you get an internal modem. For example, I have a flatbed scanner, 35 mm film scanner, two color printers, an Iomega Zip, CD-ROM, and Micronet Jaz removable drives connected to my Power Mac. I'm not bragging, just pointing out the minimum, typical peripherals a digital photographer might have. When you add a modem to that menagerie of hardware, it makes for a cluttered desktop and space is always at a premium.

Taking the PC Bus

Personal Computer Interconnect (PCI) is the faster successor to the original slot designed for the IBM-PC and compatible computers, and until recently they were only found in this kind of computer. In the latest generation of Power Macintosh computers, Apple Computer abandoned their proprietary NuBus slot architecture in favor of the PCI bus, and makers of Mac-compatibles, like Power Computing, have followed with the same practice.

- **V.42 bis compression.** Sure it's expensive. Modems with V.42 bis cost a lot more than those without it and, yes, it won't help when uploading and downloading compressed graphics files, but there's more to the Internet than compressed files. If you're taking an airplane instead of driving to a location shoot, you know time is money and having a modem that saves you time will also save you money.

- **Telephone capability.** More and more modems are coming equipped with telephonic abilities. New software, like Internet Phone, allows users to use the Internet as a real-time voice telephone to call anywhere in the world with no long distance charges—just your normal Internet connection fees. Interesting packages, like Zoom's ComStar package, provide combination speakerphone, voice mail, fax, and Internet features. The package includes microphone and speakers to provide hands-free speakerphone telephone capabilities along with voice mail features. While "touch 1 to speak to the photographer" may be a cliché, business voice messaging is a fact of business life today. Your clients will not be offended and it might even upgrade your studio's image a bit. ComStar also includes fax capabilities and provides distinct ringing so you know if the call is voice, fax, or data.
- **Fax/modem.** Because I tend to send large batches of faxes at the same time, I'm less excited about fax capabilities for modems but many of my photographer/friends, like *People* magazine's Barry Staver, swear by them. Having a modem that offers voice, fax, and Internet capabilities is much less expensive than you might think and triples the use of a single office or home/office telephone line. Combining multiple capabilities in a single package of hardware and software helps saves you money and desktop space— something the typical photography studio can always use more of. Think about it.
- **Hybrid modem with ISDN capability.** The next section introduces you to all-digital ISDN communication, which allows for faster Internet access. If you can afford it, make sure your new modem is ISDN-capable and can perform transparent switching between digital and analog telephone networks. By purchasing such a hybrid modem, you will be avoiding obsolescence in the near future.

Finally, remember Farace's Internet Rule #14: always buy the fastest modem you can afford because the day after you buy it, someone will introduce another modem twice as fast and for half the cost. Being king-of-the-hill in the computer world is a short-lived experience and nowhere is that more true than in the fast-changing modem marketplace.

The ISDN Alternative

The dream of an all-digital network that would eliminate the need for all that modulating and demodulating has been a reality for some time. The problem, at least in the United States, has been implementing it.

ISDN stands for Integrated Services Digital Network and is the international standard for transmission over completely digital circuits and lines of voice, data, and video at 64,000 bps. Access to this network doesn't require new telephone wiring. ISDN converts your existing copper wire into a powerful communications pipeline by sending digital signals at high speeds over multiple pathways. ISDN enables voice, data, video, and graphics to be sent over a single, ordinary telephone line at speeds up to fifty times faster than typical analog voice lines capabilities. A newer generation of ISDN, called Broadband ISDN (or BISDN), that is built on fiber optic technology increases the potential top data transmission speed to 155,000,000 bps. One of the things that ISDN is based on is removing all of the signaling that accompanies standard telephonic practices, placing them on a separate path called the "D" channel that operates at 16,000 bps. This leaves another channel, called the "B" channel, that can operate at 64,000 bps, which can be used for voice and data. Unlike telephone lines that carry a single analog voice channel, ISDN is typically offered as a multichannel package called Basic Rate Interface (BRI), which includes three separate channels—two B channels and one D channel—as standard. This means you can be talking on your telephone and surfing the Internet—at the same time. You will, however, require an ISDN telephone set for your voice conversations, and while such sets are even available at Radio Shack, they aren't cheap.

Since data from your computer is already digital and doesn't have to be converted into analog form (and vice-versa), ISDN lines don't require modems. They do however require a terminal adapter to provide an interface between your computer and the ISDN line. ISDN terminal adapters, sometimes called Network Termination Devices, provide the basic interface between the ISDN line coming into your home, office, or studio. Recognizing that the whole world is not going ISDN overnight, companies, like US Robotics, have developed hybrid modems/terminal adapters that will function with traditional telephone lines and ISDN.

My old friend, Gene Jones of Bell Atlantic, introduced me to ISDN in 1986 when the first call was placed in Phoenix, Arizona. What, you

may be asking, took so long? All is not rosy and perfect in the land of ISDN. The biggest barrier seems to be costs. The cost to the consumer is reflective of the cost that telephone companies have to expend to upgrade their central office switching equipment and outside plant facilities. In Britain, as in the rest of Europe, ISDN has been a practical reality for some time, the cost of analog and ISDN lines, except for a slightly higher quarterly charge, are identical. Not so here is the Good Ole USA where prices tend to be higher. This is reflected in the amount of ISDN's market penetration. Dataquest estimates the number of installed ISDN lines is expected to hit 700,000 in 1996. By comparison, Europe is expected to reach an installed base of 2.5 million BRI lines in 1996. One thing that is slowing wider acceptance is a lack of definitive standards for ISDN. There are ITU standards, V.110 and V.120, that allow users to make a connection, but once established there are not yet industry-wide standards on compression and other issues—already established for modems—that will enable ISDN users to maximize their digital telephone line.

Most forecasts predict that ISDN will gradually become more affordable for the average user. One thing that might motivate some photographers to go ISDN sooner—instead of later—is that the increase in performance may be worth it. BT North America performed several comparison tests and found that a file that took twenty-three minutes to send through a standard modem took only twenty-five *seconds* over an ISDN BRI line.

Cable TV and the Internet

If you think that ISDN has telecommunications well poised to be the provider of choice for Internet access, watch out! The cable television industry has its sights set on the same goal and for good reason. Like the Baby Bells, Cable TV firms already have an enormous infrastructure in place—some including fiber-optic cables. Because these cable firms already carry video signals through the channels used for television, their cables have the potential for moving data at faster speeds than conventional analog telephone lines and ISDN lines, too. And cable companies already have access to content providers who can deliver a wide range of services to the users—including local and national news, shopping, sports, weather, as well as information about local entertainment and activities, schools, government, and libraries.

Most online services are connected by telephone lines to a central computer that is commonly known as a "server." The server is similar to a digital warehouse that's full of information. When you want to retrieve some of that information, you send a command to the server and the server fulfills the order, sending back the requested data to your computer. On a commercial online service, telephone lines move the information from the server to your modem, which passes the information into your computer at a speed that varies, depending on the modem's design. These speeds vary from (slowest) 2,400 bps to (currently fastest) 33,600 bps. A cable modem is different and is both faster and better. How fast? According to studies made by CableLabs using a 500MB image file as a test, a 28,800 bps telephone modem took six to eight minutes to download the file, a 64,000 bps line took one to one and a half minutes. A cable modem took approximately one second. How do they accomplish these high speeds? Using a fiber-optic cable, coupled to a coaxial cable—the typical cable television wiring— the connection from our servers to the cable modem hooked up to your computer can deliver information at multimegabits per second speeds. You get the information you want much more quickly and you don't have to wait for dialed connections. This also means that your phone line isn't tied up and you're not being billed by the minute. This kind of service is anticipated to have a single monthly fee and will allow you to use the services as much as you want.

@Home with Cable TV and the Internet

The @Home Network is a system for providing data services to personal computers, using the cable television infrastructure. It brings the Internet to residential and business consumers at higher speeds with greater levels of service than were previously possible. @Home, the company, is a joint venture of Tele-Communications Inc., the nation's largest cable television company, and Kleiner, Perkins, Caufield & Byers, a leading Silicon Valley venture-capital firm.

@Home is not simply a cable-modem connection to an already overloaded menu of Internet services. Instead, it uses proprietary network technology to maintain high-speed connections that are significantly faster than existing dial-up or ISDN offerings. In addition, @Home will deliver an interactive broadband experience featuring high-quality graphics and video, FM-quality audio, and animation. @Home

Figure 2-2. To learn more about @Home and the cable television aspect of access to the Internet, visit their home page at **http://www.@home. com.**

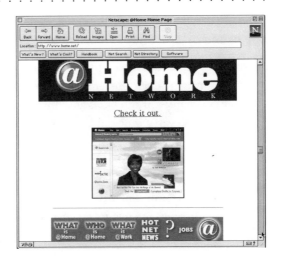

will also provide subscribers with an easy-to-use multimedia guide to the World Wide Web and the rest of the Internet.

The most apparent benefit of @Home is the network speed, but beyond the speed, it's a whole new network infrastructure providing high-speed communications and information delivery. Another unique advantage is that once the @Home service is installed, your computer becomes a node on the Internet. This means subscribers never have to worry about busy signals when dialing in to connect.

@Home is working with cable operators and content partners to roll out this service in select national and international markets over the next several years.

Finding an Internet Service Provider

Finding an Internet Service Provider, or ISP, is much easier than finding a local telephone company. It's even easier than, believe it or not, finding a long distance company, and the competition is not to the point that ISPs are calling you during dinner to ask you to switch to their service—at least not yet. Since there are many small, local ISPs, this section of the book will only look at a few of the popular national companies that provide Internet access.

Buzzword of the Chapter: Browser

You can't talk about Internet without the word "browser" (while some of them may be dogs, the term is *not* "bowser") coming up. Although the next chapter of the book goes into more detail about how they function, analyzing different browsers from different companies, now is as good a time as any to introduce the concept. When I use the term "browser," I am specifically referring to a class of software know as Web browsers. A Web browser is a program that allows computer users to locate and access documents on the World Wide Web. (Sometimes you will hear browsers referred to as "clients." The use of this term tends to confuse things—in my opinion—and this is the last time you will see the "C" word in this book.) While this sounds like a simple function—and it is—the differences in browser designs vary from the utilitarian to the feature laden. Like everything else in net surfing, and real surfing too for that matter, finding the browser that is right for you is a matter of smart shopping and research. Later on, you'll get some tips on finding a browser that fits your surfing style.

NetCom

This Internet Service Provider was founded in 1988 as an off-campus alternative to university computer access and was the first ISP to go public. At the end of 1995, the company had 300,000 subscribers for which they provided access to electronic mail, WWW, USENET newsgroups, Internet Relay Chat, and File Transfer. They also provide access to Gopher and Telnet, which are covered in the next chapter. NetCom provides what is commonly called "flat rate" service. In actuality, one monthly service charge ($19.95, as I write this) provides unlimited off-peak hours, including weekends, and forty peak hours (Monday through Friday from 9:00 A.M. until midnight). Additional peak hours are charged at two bucks an hour. For all but the most obsessed Internet junkies, this means that twenty dollars a month should be an average monthly expense. There are higher rates for ISDN and other high-speed services for heavy business users.

Recognizing that ISPs have to differentiate themselves from one another, NetCom began offering what they call "Personal Services" as part of the basic monthly charge. Included in the package are personalized services to help subscribers conduct research, receive topic-

sensitive news on a daily basis, publish Web pages, and manage investments as well as entertainment interests. The first service that was rolled out is called Personal NewsPage Direct that provides NetCom subscribers with their own daily customized news source. Not to be outdone, CompuServe has announced a similar service it calls NewsLinks.

Getting my PC set up to work with NetCom was a simple and pleasant experience. A single floppy disk contains a process that walks you through getting signed up, establishing an account, and setting up your e-mail address. The disk also contains a copy of NetCruiser, NetCom's World Wide Web browser. (More on NetCruiser later in this chapter.)

AT&T WorldNet

It took them a while, but in late 1995, AT&T announced plans to provide its 90 million business and consumer customers with access to the Internet. Their goal—and one that should have seemed obvious—is to make online services as easy to use as telephone service. To accomplish this task AT&T created three new businesses: AT&T WorldNet Services is designed to make the Internet accessible to individuals and businesses; Hosting and Transactions Services will provide businesses with a range of services to help them reach more customers, promote their products, publish electronic catalogs, and handle secure sales transactions through the Internet. Third, a content services business will also package content within broad interest areas.

Information about WorldNet can be found on the AT&T WorldNet Services home page on the Internet at **http://www.att.com/worldnet.**

Using Conventional Online Services

CompuServe One of the oldest online services is CompuServe Information Systems, often referred to as just CompuServe and sometimes as CIS. CompuServe is a subsidiary of H&R Block and is located in Columbus, Ohio. They came late to the Internet party, but have tried to make up for lost time by offering Macintosh and Windows computer users access to the Internet and more specifically the World Wide Web. Since their approach for the two computing environments is so different, the following two sections are provided as guides for Macintosh and Windows users to access the Internet and Web using CompuServe.

Windows

Getting to the Internet using Microsoft Windows 95 is a snap. (Doing it under Windows 3.1 is only slightly less easy.) Here's all you have to do:

- **Step 1:** get a copy of CompuServe Information Manager version 2.0.1 (or later). You can purchase a start-up kit, which usually includes ten or more hours of free connect time, or you can just use one of the promotional disks that are included with modems or delivered in the mail.

- **Step 2:** insert a disk or CD-ROM and launch Windows 95 Add/Remove Software Control Panel. This will run an installation Wizard that will ask you a few questions. For example, if you've never had any kind of Internet or online service, the installed program will ask if you want to install Winsock. (Winsock is a software standard that provides a common interface between TCP/IP and Internet software for computers using the Windows operating environment.) Be sure to answer yes or no as is appropriate. At the end of the sequence, all the software you need will be installed.

Figure 2-3. The Windows versions of CompuServe's Mosaic browser, and of CompuServe Information Manager, use this set-up screen to tell the modem what to do and where to call. The names and account number are fictitious.

At this point you will have really installed two online applications: CompuServe Information Manager and CompuServe SPRY Mosaic, one of the better variations of the Mosaic Web browser. Mosaic is an Internet browser that was originally created by the University of Illinois National Center for Supercomputing Applications. It was released on the Internet in early 1993 and many versions, designed for specific companies, are available. What's nice about this version of Mosaic is that it has a CIM button that lets you seamlessly move between the Web and the traditional CompuServe Information Systems environment. As I write

this, I believe that the CompuServe version is the best. On Windows 95, launching Mosaic is a matter of selecting CompuServe Spry Mosaic from the Start menu. (All you need to do on Windows 3.1 is double click the Mosaic icon.)

Using Windows to get onto the Internet and the World Wide Web, and using CompuServe as an Internet Service Provider is, as you can see, a piece of cake. Unfortunately, the same can not be said for Macintosh owners.

Macintosh

CompuServe Information Service offers full PPP (Point to Point Protocol) Internet access, but setting up your Macintosh will involve a slightly more complex setup than the average Mac user is used to. One of the advantages of using CompuServe as your Internet Service Providers is that no matter where you go—around the world—it's likely you will be able to connect to CIS or the Internet via a local CompuServe phone call.

Here are the steps required to surf the Net via CompuServe with your Macintosh:

- **Step 1**: obtain a copy of MacCIM, the Macintosh version of CompuServe Information Manager version 2.4.2 (or later). There are two ways to get this software: the easiest way is to go to your friendly neighborhood software store and purchase a Compu-Serve startup kit, which usually contains a certain number of free hours and a copy of CIM. If you're already a subscriber and use another communications program, like the popular shareware communications program Z-Term, type GO CIM and download the latest version directly from CompuServe. Even if you have an over-the-counter copy of the program, chances are CIM has been updated and you might want to use CIM's FIND function to download the latest version.

 If you're not already using MacCIM to explore CIS, you are missing out on a great online experience. In my opinion, CIM has the most user-friendly interface of its competitors at Prodigy or America Online.

- **Step 2**: get and install a copy of a control panel called FreePPP. It's needed to set up a PPP connection using the CompuServe local access number. FreePPP is not a CompuServe product but is a commonly used utility for PPP dialup. FreePPP can be found

on the Internet Resources Forum of CompuServe in the Mac Software library. As I write this, the latest version is 2.5 but—given the nature and growth of Internet software—that may well have changed by the time you read this. There is an Apple version of a similar Control Panel called MacPPP, which is available from similar online and over-the-counter sources. My experience has been that FreePPP is more stable and easier to use—in practice. And since, as you will discover, getting your Mac onto the Information Superhighway can be a decidedly un-Maclike experience, the simpler you make the process, the happier camper you will be.

- **Step 3:** check to see that MacTCP is installed. MacTCP (Macintosh Transmission Control Protocol) is a Control Panel that is bundled by Apple Computer as part of the System 7.5 (or greater) software package. MacTCP is Apple's implementation of the TCP/IP that is the official protocol of the Internet. If you have not upgraded to System 7.5 yet, this is just another reason that you should. The latest version that was shipped with Apple's System 7.5.3 update is version 2.0.6.

- **Step 4:** you will also need a copy of the CompuServe PPP Utility to set up the FreePPP and MacTCP configuration and preferences for Internet access through CIS. You can usually find it by clicking the Internet icon and following the menus until you find the place where the utility is currently available for download. After you've downloaded the file, run the CompuServe PPP Utility for Macintosh by clicking the Internet icon that appears when you first launch CompuServe Information Manager.

Figure 2-4. the Interface for CompuServe Information Manager 2.4.3b shows what a typical user will see when they launch the program. Once online, you can click the Internet icon to find net-related software, including CompuServe's PPP utility.

- **Step 5**: get a Web browser such as Netscape Navigator or any other Internet tools for the Mac. The next chapter will include information on browsers; what they are and how to find them.

At this point, you're all set to get on the Internet via a CompuServe PPP connection.

There are two places to get help setting up CompuServe as your Internet Service Provider.

- **MacCIM Support Forum**: type GO MCIMSUP and select the MacCIM/Internet and CIS PPP sections (sections 12 and 13). Help is available here from CompuServe Customer Support Representatives and is free of connect charges.
- **Macintosh Communications Forum (GO MACCOM)**: select the Macs On Internet section (section 14) to get help from Mac experts in the Forum. Regular connect time charges apply in this Forum.

If all this sounds complicated, that's because it is. The big question is: Is it worth it? If you are already a CompuServe subscriber and find, like me, that it is a worthwhile and useful service, the answer is yes. If, on the other hand, you have no online commitments and are merely looking for a way to get onto the Information Superhighway, I must say no. Because of the kludgey way that you have to slip onto an Internet on-ramp, the possibility of good connections—just getting online—are spotty. When I first started using CompuServe to seriously surf the Net in 1995, I had to try three times before I got a connection. Now, two out of three times, I make a positive connection. That's not good enough. MacCIM 3.0, which is scheduled to be available in the Spring of 1996, will combine all five of the above steps into a one step installation and set up process. As I write this, the Windows version has just been released but no release date has been set for Macintosh computers.

Finding the Right ISP

Just like finding the right commercial photographic lab, choosing an Internet Service Provider that provides the best combination of price and service can be a trial-and-error proposition. One of the best places to start your search is in the pages of the growing number of local or

statewide computer publications and journals. *Peak Computing*, published in Colorado Springs, Colorado, but distributed (mostly) statewide, publishes a weekly list of ISPs along with their phone numbers and URLs. If you don't have access to such a publication, you might want to pick up a copy of *Boardwatch* magazine's quarterly publication *Directory of Internet Service Providers*. This 180-page publication lists over 5,400 ISPs located all across the country. At $6.95 (plus shipping and handling), the book is a bargain. Contact information for the publisher can be found in the resources section at the end of this book or you can contact them through their home page at **http://www.boardwatch.com**. An online version of their publication includes a "find a local ISP" function. It's a good place to start your search.

While on the surface finding an ISP may seem identical to picking a long-distance telephone company, there is one important difference: your telephone number stays the same no matter who provides your long distance services, but your Internet e-mail is tied to your ISP. On CompuServe, my e-mail address is **FaraceFoto@compuserve.com**, but for the short time I was on NetCom my address was **jfarace@netcom. com.** Your e-mail address is just as important as your voice telephone number and making changes—because the cost of printing new business cards, etc.—can be expensive.

Selecting an ISP is personal, so be sure to use the same networked resources you would when purchasing a new camera system or lens. Talk to your photographer friends and ask them whom they are using. Better yet, join a user's group for your specific computer. Nowhere else will you find a larger group of people willing to share—often contradictory— information about every aspect of computing. In the end, the decision is yours but when making that decision ask yourself the following questions:

- **Will I be a heavy user?** If so, consider using an ISP, like NetCom and others, that has a flat monthly rate. Nothing is worse than getting your first ISP bill and seeing numbers that would make even the most avid 900-number users blush.
- **Will you be a light user?** If so, look for an ISP that offers an "occasional" user rate. ISPs, such as Marketwise Data, Inc., have an under $10 rate for people who only go online an hour or two a month.
- **Is software provided for free or extra cost?** When analyzing

costs, be sure to consider everything that the ISP may be including. If they include a copy of Netscape Navigator, that represents a real cost saving. Be sure to add any extras that are included in the package.

- **Is there a rate difference that varies depending on the speed of your modem?** Some ISPs charge more for faster access. While they can usually justify this with technobabble, I think—and this is a highly personal opinion—that the rate should be the same regardless of the modem that you use. For instance, if I have to pay a higher rate for the 28,800 bps modem in my Power Mac, will the ISP give me a rebate if I log onto Kodak's home page with the 14,400 bps modem in my PowerBook 180? I don't think so. Price shoppers are advised to visit Jay Barker's Online Connection at **http://www.accessone.com/~shwaap/onlinec/index.html.** He maintains a Website that compares online service costs as well as comparing the ISP costs. He rates the costs two way: one for low-level use and one for high-level use. As I write this the best deal appears to be AT&T's WorldNet, but, if cost is an issue, check with Jay before plunking down you money for an ISP.

Figure 2-5. Jay Barker's Online Connection regularly compares the cost of online services and Internet Service Providers too. Here, he takes a look at a recent chart comparing ISPs and declares AT&T the winner. The browser is part of Apple Computer's Cyberdog, which is covered in the next chapter.

Low Usage	3 hours	5 hours	10 hours
AT&T WorldNet	Free	Free	$12.50
GNN	$14.95	$14.95	$14.95
InterRamp	$9.00	$9.00	$10.50
Netcom	$19.95	$19.95	$19.95
Pipeline USA	$19.95	$19.95	$19.95
SPRYNET	$4.95	$8.85	$15.80

High Usage	20 hours	30 hours	40 hours
AT&T WorldNet	$19.95	$19.95	$19.95
GNN	$14.95	$34.45	$53.95
InterRamp	$25.50	$30.50	$45.50
Netcom	$19.95	$19.95	$19.95
Pipeline USA	$19.95	$19.95	$19.95
SPRYNET	$19.95	$19.95	$19.95

As this table indicates, AT&T WorldNet has the lowest prices in most cases. For high usage, SPRYNET, Netcom and Pipeline USA offer unlimited Internet access for $19.95 along with AT&T WorldNet.

3 Surfing Software

Let's go surfin' now, everybody's learnin' how, come on a safari with me. . . .

—Brian Wilson

The World Wide Web is a big place. I have heard—perhaps overly optimistic—estimates stating that two thousand Web-sites are added each day. No matter how many home pages are out there, even a cursory cruise around the WWW will convince you that you'll need some kind of help in finding your way through the Internet maze. Since this is the world of high tech communications you probably will not be surprised that there are solutions to finding your way to the Emerald City, right there on the World Wide Web itself.

Introduction to Browsers

Browser software is your ticket to the Internet and World Wide Web. It provides the gateway to Web surfing, e-mail, and all of the other aspects of the Internet that have kept you reading so far. There are two terms you need to be familiar with when looking at browsers: "client" and "server." Within the context of the Internet, a "client" is software that requests information. A WWW browser is often referred to as client

software. A shared computer on a local area network (or the Internet) that interfaces with a client in the form of Internet software and/or hardware is called a "server." A server acts as a storehouse for data and may also control e-mail and other services. Got it? Now let's move on.

Unlike your choice of ISP, your selection of a Web browser can be more causal—more like your choice of a word processing program. If something better comes along don't be afraid to make a switch. Sometimes an ISP will provide a browser, sometimes not. Nevertheless, you're going to need one. This section is not intended to be a comprehensive analysis of all of the browsers available (if I've omitted your favorite it is unintentional). Instead, think of this section as an overview of the category of browsers with some specific examples given. No category of software is updated and revised faster than Internet browsers; the pace can be dizzying for both the companies and consumers. What you'll find here is a look at browsers and how to find the one that best fits your needs.

Figure 3-1. Netscape Navigator, shown here in version 3.0b4, provides all of the tools that most users need to get the most out of browsing software. Here it is shown in the "frames" version—which may be disabled. Some Websites make the most of the frames option but even though Netscape introduced the feature, they did not implement it well on their own home page. That's why most other Netscape screenshots in the book will be in non-frame mode.

How They Work—What They Do

A browser has a simple function: you type in a URL, it takes you there, and displays a home page. In many ways a basic browser is a lot like Microsoft's original MS-DOS; it does its job without a lot of muss and fuss but relies on your memory and skills to maximize it efficiency. For

many surfers all that is needed is a Model T browser, while others might prefer a Lexus. A Web browser's main function is to connect you to your Internet Service Provider and take you to a common home page that serves as a jumping-off point for your Web explorations. The first time most users encounter a browser they are disappointed; they expect more. Unlike a starting screen for the CompuServe or America Online online services that provide a cornucopia of information pointing to different parts of their services, browser home pages are full of self-promotion—or nothing. Unlike CompuServe or America Online, you need to know where you are going or, at least, what you are looking for.

What to Look for in a Browser

One of the most important things a good Web browser can do is serve as a spring board (surf board?) to finding what you are interested in on the Web and where it is. This boils down to a simple feature: convenience. How convenient (as the Church Lady used to say) a browser is to use is the first measure of its usability.

Bookmarks

This convenience first shows up in how a browser manages "bookmarks." These are the digital equivalent to the X-Men bookmark that your kids gave you for a holiday gift and you used to mark your place in your copy of *The Long Good-bye*. When you find a home page that you want to visit, your browser should provide a convenient way to digitally tag the site so you don't have to remember the cryptic URL. CompuServe Spry Mosaic does this by having an Add button to click, which then places the Website in a menu called Personal Favorites. Instead of typing **http://www.dcn.davis.ca.us:80/~bang/peanuts/**, you can just select The Peanuts Collector's home page (a real Website, by the way) from your Personal Favorites menu to visit the home page of the Peanuts gang and America's favorite beagle. Since this is a feature that you will use constantly, check out the bookmark feature to see how easy it is to use—especially when you accumulate over twenty-five bookmarks.

Java

Whatever browser you choose, you should get one that is Java-aware. Sun Microsystems' Java is an object-oriented programming language

that utilizes the features of other languages and was originally created to produce software for systems for the consumer electronics market. It began as a subset of C++ but is different from traditional C-based languages because it is portable. And that's the aspect of Java that makes it useful for Website and browser designers. Java 1.0 enables Webmaster to write small applications (applets) that can be embedded in a home page using standard HTML and can transfer these applets from a server to a user's Web browser where they can be viewed on-screen. On the most basic level, this means that type can be designed to scroll or move around a Website. While this may be cool and fun, it has little to do with gathering information but has a lot to do with selling the sizzle, and that's what marketing—photographic or otherwise—is all about.

Access to Search Engines

One thing that a browser can help you with is to provide easy access to Web search engines. Since the actual number of Websites on the World Wide Web is big and getter bigger every day, finding the Exacta Collectors home page might be impossible without a way to search for the word, "Exacta." That's the function of search engines: you type in a word, or words, and a list of Websites whose descriptions contain those keywords appears. Later in this chapter, you'll find a comparison of various Web search engines. As part of access to search engines, your browser should be able to keep track of sites that you have already visited. Typically, this is handled by displaying previously accessed sites in a different color text. By flagging previous Websites, you can either remember if they were worth visiting (in which case you would have already added them as a bookmark) or not worth visiting. This can save time when your search engine produces over a thousand matches in response to your request. Tagging previously visited sites may seem like a small thing, but the more you use search engines, the more you will come to appreciate this feature in a browser.

Navigation Tools

Your browser should include a toolbar or simple commands enabling you to navigate back and forth through the many Websites that you may visit during a session. I prefer buttons on a toolbar because it's a fast and a more natural way of surfing the Net, but everyone's taste is different—that's why they make more than one kind of camera—so pick one that has an interface that feels "comfy" to you. The obvious buttons

Figure 3-2. Netscape Navigator's toolbar includes a "Net Search" button that, when clicked, brings you to this screen, which provides access to fourteen different search engines. Each day and each time you access this function, a different search engine is featured and can be accessed immediately.

(or commands) are "backward" and "forward" but the "stop" button is important too. Often you will encounter a Website that, as it draws itself on your screen, turns out not to be what you where interested in. While you can always click the back button to back up to where you were last, a safer way to operate is to hit the stop button to stop the screen draw, then click the back button. (Like a VCR, you can hit the rewind button while a videotape is playing and after some moaning and groaning the tape will start going backward. But it's better to hit the stop button, then the rewind.)

One button you won't find on a VCR is "reload." The Internet—and browser software for that matter—are not perfect and often a home page being displayed will hit a glitch or two and stop. (A good browser will also display some kind of status indicating how the download is proceeding, at what speed, and any error messages.) Or perhaps you inadvertently hit the stop button and would really like to see the entire Website. Clicking the reload button reinitializes the home page being displayed on your screen.

Use the Browser the ISP Gave You or Buy Your Own

Some ISPs, such as NetCom, will provide a browser when you sign up with them. NetCom's browser, called NetCruiser, is quite basic in its function (a true Model-T browser), but does allow you to navigate the World Wide Web and for the casual user it may be more than adequate. If you want to change to Netscape Navigator or even CompuServe Spry Mosaic, NetCruiser will create links to these other programs and even

places a button in its toolbar giving you access to another browser. You can then launch NetCruiser to get you to the World Wide Web via NetCom's home page, but quickly switch to Netscape Navigator for your Web explorations. Some ISPs make it easy by providing Netscape Navigator, or in the case of Microsoft Network, by providing Microsoft's Internet Explorer.

Netscape vs. the World

While the name Netscape is thrown around by some users in a generic way, the company doesn't just make one product. It produces a family of products. Here's a quick look at some of them in what I think will be the order of their appeal to the average photographer.

The current release of Netscape Navigator 3.01 offers corporate administration and security enhancements, real-time collaboration through an Internet telephone tool and shared whiteboard, and integrated 3D, audio, and video capabilities. In addition, Navigator 3.01 offers a new level of object-interaction that makes Web pages come alive.

Here's how Navigator works in practice. Launching Navigator takes you to Netscape's "look-at-me-I'm-the-greatest" home page, where the company provides lots of information about its products and services. While it is a good place to find out about updates to the software (and download it), you can change it to the personalized "My Page" that Navigator lets you create by specifying the URL in the Preferences menu. Since one of the general criticism of browsers is that "once you're there, where are you?" Navigator includes a hot link to Yahoo!'s (more on this oddly-named but competent search engine in the next chapter) Website "Pick-of-the-Week." To give you an idea of what you might expect, these were the picks the week I was writing this: The Museum of Modern Art; Looney Tunes Karaoke; Clinical Challenge—part of Reuters Health Information Services; RealAroma—SmellU SmellMe, Aroma Text Markup Language; GlobaLearn's Black Sea Nations Expedition; Alive! Global Network—from Manhattan to Morocco, Helsinki to Hong Kong, Belgium to Brazil, and in-between; Hoops Nation Basketball Tour; *Ulysses* for Dummies; **TVplex.com** (read about *Home Improvement*, *Nowhere Man*, and *Ellen*, download video clips and photographs, or check out film reviews from Siskel and Ebert); True Southern Family Recipes.

This should give you some indication of what's available on the Internet, but you may be asking what does that have to do with photography? The short answer is nothing. That's why you will need to take advantage of the search engines that are available through Navigator's Net Search button. More on using search engines in the next chapter.

Navigator has one difference in the way it loads Websites when compared to browsers based on NCSA Mosaic, like CompuServe SPRY Mosaic and Microsoft's Internet Explorer 2.0: as soon as another site is contacted, it starts displaying whatever bits and pieces are available. Most Mosaic clones start downloading the information, display the fact they are doing so at the bottom of the screen, but waits until 100 percent has been received until the home page is displayed. I prefer Netscape's approach and often know whether I want to hang around after 25 percent has been loaded. If it looks like it's not for me, I'll hit the stop button and surf elsewhere.

I'm not crazy about the way that Navigator handles bookmarks. It's better than nothing but has spawned a cottage industry of plug-ins and additions that make bookmark management easier. Add-on products, like Web Ninja, are covered in the next chapter. Users of programs like CompuServe Information Manager may, initially, be disappointed with Netscape Navigator and wonder what the fuss about the product is all about. Part of the difference between the way Navigator and CIM behave has to do with the Internet itself. CIM manages the finite resources of the CompuServe Information System, while Navigator has to contend with an exploding World Wide Web. That's part of the reason that, since version 2.0, the program started accepting plug-ins. Using plug-ins provides a flexible architecture that allows Netscape and third-party developers the ability to customize Navigator the same way that acquire, functional, and filter plug-ins allow photographers to customize Adobe Photoshop to fit how they work with digital images.

Other Netscape products that may be of interest to photographers include Netscape Navigator Personal Edition. This product takes an older version of Navigator and adds easy, automatic dial-up connection to your choice of Internet service providers. If you want to get on the Internet but need help getting started, Netscape Navigator Personal Edition makes it easy—something frustrated Macintosh owners will appreciate.

Another product, Netscape Navigator Gold, adds an easy-to-use

WYSIWYG (What You See Is What You Get) HTML editor and a secure one-button publishing feature. It also adds a host of capabilities for enterprising users, including corporate administration through the Netscape Administration Kit, enhanced security features, support for digital certificates, and real-time collaboration. It enables users to view live documents and allows developers to build applications that integrate 3D, audio, and video.

Mosaic Clones

Three browsers, CompuServe SPRY Mosaic 2.01, Internet Explorer, and NetCruiser, are based on NASA's Mosaic. You would think they would all look the same, but part of the difference is that the commercial development of Mosaic is being handled by Spyglass, Inc. Let's take a look at these clones in, what I think is, their order of descending usefulness.

(Author's note: at the time I was working on this book, CompuServe had promised a major upgrade of CompuServe Information Manager to version 3.0. The same is true of Microsoft's Internet Explorer. A beta of version 3.0 was available for Windows 95, but the latest version for the Macintosh was 2.01.)

CompuServe SPRY Mosaic 2.01

Clearly the best implemented version of Mosaic is the CompuServe SPRY version 2.01, which is available for Windows users only. It has a functional toolbar across the top of the screen, coupled with a "Favorite Places" bookmarking system that I find easier to use—and keep using—than Navigator's. One of the items on the toolbar is a link to CompuServe Information Manager. CIM has an Internet button that allows you to pass seamlessly back and forth between the dedicated Compuserve Information System—home of the Photo and Photo Pro forums and the Web. Since it provides double the access compared with other Web browsers, this makes, I think, CompuServe Mosaic better and more practical than its competitors. The downside is, of course, that you must use CompuServe as your ISP. While I have problems accessing the Web through CompuServe with my Macintosh, I have had fewer problems with my Windows computer. I think my problems stem from the convoluted ways Mac users have to access the Internet, in general, and with CompuServe in particular.

The Interface of CompuServe SPRY Mosaic is clean, functional, and

Figure 3-3. If you use CompuServe's SPRY Mosaic to get to the CIS home page (**http://www.compuserve. com**) this is what you see: the most full-blooded version of Mosaic yet produced.

easy to use. Moreover, it's free. While not filling up your mailbox with disks the way America Online does, it is hard to attend any kind of large computer show without someone handing you a set of disks containing SPRY Mosaic. (That's exactly how I obtained the software in Figure 2-3.) CompuServe SPRY Mosaic seems to do a better job of "caching" than Navigator. Because some Websites take so long to load, most browsers save a temporary file—a "cache"—containing graphics information allowing you to load that page quicker the next time you visit the site. Mosaic calls this an "autosurf" feature and it works great if you have a slower than normal network connection or 14,400 bps modem. While Netscape Navigator may win the "bells and whistles" browser comparison war, CompuServe SPRY Mosaic is capable and the price is right.

Microsoft Internet Explorer

Next in the Mosaic freebie sweepstakes is Microsoft Internet Explorer. This browser, in the Macintosh version anyway, seems the most unstable. I found that it would crash at various times, most unusually when I tried to browse Microsoft's own home page (**http://www. microsoft.com**). The current version of Explorer manages bookmarks—just barely. It will keep track of the places that you would like to visit but even semi-serious Web surfers will want something more. If you find the price (free) attractive and are a Mac user, you can add a freeware bookmark utility like Web Ninja, which is covered in the next chapter.

NetCruiser

Despite it's cool name, NetCom's NetCruiser is anything but a red '57 Chevy convertible. It's more like a brown Chevy 210 four-door sedan;

68

The Photographer's Internet Handbook
. .

Figure 3-4. Microsoft's Internet Explorer 2.01 browsing *Slate,* a new Microsoft e-zine, on it's first day of issue. The attractive interface makes browsing easy, but the current Mac version seems crash-prone.

it's functional but not flashy. In short it *is* your father's Oldsmobile. NetCruiser is bundled with NetCom's attractively priced Internet service and, yes, it will get you on the Internet. It is the least-capable Mosaic clone but all the time I used it, it was trouble free. Its greatest claim to fame is that it allows you to add other browsers to its toolbar. You can add CompuServe's Mosaic and use NetCom's services, if that appeals to you.

Apple Computer's Cyberdog

Cyberdog is not a browser, per se, it is a package of interrelated components that try to make net surfing—not just Web browsing—more intuitive than it is with other browsers. Created by Apple Computer, this set of Internet-related components has a consistent interface. If you double-click on an Internet address, Cyberdog opens the object, whether it's a Website, a picture, or a file.

Figure 3-5. Cyberdog's deceptively simple start-up screen provides access to all Internet functions—including Web browsing. Moreover, since the components of the package are based on Apple Computer's OpenDoc architecture, they are replaceable allowing each user to customize Cyberdog to fit his or her work style. For a look at the Cyberdog browser, see Figure 2-5.

Cyberdog gives you integrated access to all services on the Internet (including FTP, Gopher, Telnet, World Wide Web, NETNEWS, and e-mail) with the ability to display the full capabilities of each service. If you use a browser optimized only for the World Wide Web, you're forcing other services and data types to be displayed in a way that's not optimal. Cyberdog is a bare-bones browser, but provides many functions not present in other software. Bookmarks? You "don't need any stinking bookmarks!" Cyberdog provides a Notebook and a Log to keep track of where you've been. As you work, the Notebook stores Internet references: you can drag any link into it, or any file saved as a URL. You can drag any text that has the form of a URL into the Notebook and it will be accepted as a legal Internet address and will be represented with an appropriate icon. You can have multiple Notebooks, so you can easily organize a large volume of links and mail addresses for quick access. The Log can be displayed alphabetically, chronologically, or hierarchically. Objects can be dragged from the Log into the Notebook, mail, or any document, or to the Finder. Log files can be saved and the Log can be erased.

Cyberdog provides a standard browser window for different Internet services with forward and back arrows, display of the URL as both an object (an alias and icon) and a text string, a pop-up History, and a stop button. Inside the browsing window, each data type is displayed by a different Cyberdog component that gives the best display of that kind of data. This window has Grow, Zoom, and Close boxes. Pictures are opened in their own separate windows, sized to the picture. Text is opened into a window with slider bars, and Grow and Zoom boxes. Movies and sounds are opened into the Cyberdog "Player" window.

Cyberdog supports the popular Internet standards: Telnet (vt102), FTP, Gopher, World Wide Web (http protocol and HTML HyperText language), Newsgroups (NNTP), mail (POP/SMTP), and MIME 1.0. Cyberdog provides viewers for text, TIFF, GIF, JPEG, PICT, QuickTime Video and VR, .WAV sound, and .AIFF sound

Cyberdog will be distributed free over the Internet from Apple's Web and FTP sites (for more information, visit the Cyberdog Website at: http://cyberdog.apple.com). The final version will be bundled with Apple Macintosh computers and Mac OS releases. There will be a retail version for current Power Macintosh and Mac clone owners.

Since nothing ever stays the same in the browser arena, I was not surprised to find, as I was finishing this book, that Cyberdog was

changing. Apple Computer, Inc. and Netscape Communications Corporation announced that they have signed an agreement for Netscape to develop a new version of Netscape Navigator that supports Cyberdog, Apple's Internet Suite, and OpenDoc. To be called Netscape Navigator for Cyberdog, Netscape will develop a custom component developed specifically for the Apple Cyberdog Internet Suite. In addition, Apple will distribute Netscape Navigator for Cyberdog with its Macintosh operating system as the default browsing component for Cyberdog. What this means for Mac owners is that future version of the Mac OS will include a Netscape Navigator component.

The above was just the briefest of introductions to browsers. Finding the right browser is an evolutionary process; as you gain more experience, you will discover those features that are most important to you and home in on a browser that highlights those features. Unlike an ISP, you're not married to your browser; try all the free ones and make your own evaluations based on your own work habits.

Netscape Meets Norton Utilities

If you use Symantec's Norton Utilities you know that one of its best modules is FileSaver. It automatically finds recent files that you tossed in the trash can—or recycling container. Netscape Navigator "caches" some of the home pages that you visit, so it doesn't have to completely rebuild them every time you visit the home pages. Since it can't keep saving these cache files forever, periodically it alerts you to the fact that it will be dumping some of these files—usually a hundred or more at a time. Enter Norton Utilities FileSaver. The current version of this utility that protects against accidental erasure of files has a limit of five hundred files it can "unerase." That seems like a reasonable number until, during a busy two or three day stretch of Internet surfing, Netscape dumps four hundred or so cached files. This happened to me recently, and after I went searching for the files that FileSaver is supposed to protect from destruction, all I found was Netscape cache files. What happened is that FileSaver's buffer of restorable files is constantly being filled with cache files as Netscape deletes them, leaving little room to protect your other, more important files. Symantec is aware of the problem and is working on a fix.

Browser Plug-Ins

Plug-ins are small, and sometimes not-so-small, software applications that can be used to increase the functionality of, and to customize off-the-shelf programs. A popular analogy, and an overworked cliché, is that plug-ins are similar to blades or tools on a Swiss Army knife. McGyver never went anywhere without his Swiss Army knife. One of the main features of plug-ins is that they are easy to use and easy to install. All plug-ins are installed in the same way: they are simply copied into the "Plug-In" directory or folder of a particular program. Sometime, as in the case with graphics programs, they appear as menu items in that program. They are, in effect, "plugged into" the software and after installation become an integral part of it. Plug-ins shouldn't be confused with "helper applications," used with programs like Netscape Navigator, that permit you to access every type of file on the Internet. When your browser encounters a sound, image, or video file, it hands off data to a helper applications to run or display the file. Unlike plug-ins that, depending on the program, appear in various places, you configure helper applications in a dialog box found under Preferences in Navigator's Options menu. Most helper apps are shareware or freeware and can be found at various archive sites.

The back story: in 1986 a Macintosh application called Digital Darkroom set a new trend in software design by integrating what the developer called the "DD Pouch." Inside were stored add-ons that broadened the application's capabilities and one of the folders inside the Pouch was called "Plug-Ins." When Photoshop was introduced in 1990, Adobe Systems expanded the plug-in concept and made it an integral part of the program's design. Third-party developers were able to create new and exciting add-ons, allowing Photoshop to quickly become the *de facto* image-enhancement program for the Macintosh. Netscape added plug-in capability to Navigator 2.0 allowing third-party developers to add support for new file formats—among other things. In doing so, Netscape created a plug-in standard, much as Adobe had done six years ago, and most Navigator plug-ins are also supported by version 2.0b3, or later, and by Microsoft's Internet Explorer. Netscape sometimes calls their plug-ins "in-line" plug-ins but they are inconsistent in that usage. A plug-in is a plug-in is a plug-in.

If you're not already familiar with software plug-ins, you should be. But what are plug-ins anyway? How do you use them and why should

you even bother? Plug-ins are little applications that can be used to increase the functionality of your browser and be customized to match the way you work and produce on-screen effects you would like to see. Navigator's plug-ins extend the browser's capabilities, giving computer users, for example, the ability to play audio samples or view video clips. But what happens when you run into a Website that requires a plug-in you don't have? That's when you'll encounter Navigator's Plug-In Finder page. You'll have arrived there because you loaded a page that contains information that can be viewed only with the help of a specific plug-in—and you don't have it. Navigator will show you a list of plug-ins that can be used to display the missing audio/video/text information. You can choose the plug-in you want to install, click the download button, then follow the instructions to download and install the software to your system. When you're done, you'll have to relaunch Navigator and reload the page you wanted to view. Plug-ins are available in cross-platform versions but, as you will see, sometimes are developed for specific operating systems.

Software companies are developing plug-ins at warp speed. Generally, they fall into six categories: 3D and Animation, Audio/Video, Business and Utilities, Image Viewers, and Presentations. Here are just a few packages, in each of these groups, that will provide an introduction to what Netscape Navigator plug-ins do and how they work. Many of them are free, some are beta versions, and others may be demos.

3D and Animation

ShockWave For Director By Macromedia is available for Windows 95, Windows 3.1, and Macintosh. While one nationally recognized expert has written about conflicts with Navigator 3.0 beta versions, ShockWave, and RAM Doubler while running under System 7.5.3, I have been using that same combination with no problems whatsoever. It may be that he has a conflict with an Extension or Control Panel that I do not have installed. The ShockWave plug-in lets users interact with Director presentations right in a Navigator window. Animation, clickable buttons, links to URLs, digital video movies, sound, and more can be integrated within the presentation to deliver a rich multimedia experience. Download a copy from **http://www.macromedia.com/ shockwave.**

The following plug-ins are integral parts of Navigator 3.0's

functionality, but are not included in the minimum download version: Live3D, which is available for Windows 95, Windows NT, and Windows 3.1, allows you to experience interactive 3D scenes. This high-performance 3D platform lets you fly through VRML (Virtual Reality Markup Language) worlds on the World Wide Web and run interactive, multi-user VRML applications written in Java. Live3D features 3D text, background images, texture animation, morphing, viewpoints, collision detection, gravity, and RealAudio streaming sound. LiveVideo lets you enjoy AVI-formatted movies that are embedded in any Web page without requiring a separate movie player. LiveVideo gives you complete playback control with play, pause, stop, rewind, fast forward, and frame by frame movement buttons.

Whurlplug 1.0.4, by Apple, is available for Macintosh. Whurlplug allows you to view and act upon 3D models on the Web. It relies on QuickDraw 3D, Apple's 3D graphics API, for rendering, picking, and navigation. You can download it from: **ftp://ftp.info.apple.com/ Apple.Support.Area/QuickDraw3D/Test_Drive/Viewers/Whurl- plug1d6.hqx.** Whurlplug, created by John Louch, is a Power Macintosh native Netscape plug-in for viewing 3D models. Whurlplug relies on QuickDraw 3D, Apple's 3D graphics API, for rendering, picking, and navigation. It is currently under development and should be considered demoware. At this time the plug-in has simple keyboard navigation, with mouse control coming in a later version. Whurlplug requires QuickDraw 3D. If you don't have QuickDraw 3D, you can obtain it through the QuickDraw 3D Web site (**http://www.info.apple.com/qd3d**).

Audio/Video

The Talker plug-in from MVP Solutions lets your Website talk to Macintosh users. The plug-in's speech synthesis technology uses less bandwidth than recorded audio and you can change the words your Web page speaks simply by editing a text file. Talker plug-in allows a Web page to be read aloud with the help of Apple's Text to Speech Software. The latest version lets Web pages talk (or sing) using many different voices. Download Talker plug-in at **http://www.mvp- solutions.com** and then visit one of MVP Solutions' Websites to hear it in action.

Some plug-ins you don't even have to go looking for. The following components, for example, are integral parts of Navigator 3.0: CoolTalk turns Navigator into a real-time telephone using the Internet. You also

get a chat tool and shared whiteboard for easy data collaboration around the globe. Apple's QuickTime plug-in lets you experience QuickTime content directly in the browser window. You no longer need a "helper application," like MoviePlayer, to view QuickTime content over the Internet. You can also view QuickTime VR (Virtual Reality), Panoramas, and Objects in your browser. The QuickTime plug-in works with existing QuickTime movies and with movies prepared to take advantage of the plug-in's fast-start feature. The fast-start feature presents the first frame of the movie almost immediately and begins playing even before the movie has been completely downloaded. Netscape Navigator 3.0b7 (or later) uses the QuickTime plug-in automatically to play any QuickTime movie while browsing the Internet. The plug-in can play many kinds of .MOV files including movies with text, MIDI, and other kinds of data. The QuickTime extension and the QuickTime VR component can be downloaded from **http://quicktime.apple.com/sw/sw.html**.

Business and Utilities

AboutPeople from Now Software is available for Windows 95. AboutPeople is the first address book plug-in that lets you browse and search dynamic address books on the World Wide Web from within Navigator. AboutPeople seamlessly integrates with Now Up-to-Date Web Publisher, letting you access employee lists, vendor contacts—even hotel and restaurant listings for major cities. You can download it from **http://www.nowsoft.com/plugins/about_people.html**. AboutTime from Now Software for Windows 95 is a calendar plug-in that lets you view familiar, dynamic calendars on the World Wide Web from within Navigator. AboutTime also integrates seamlessly with Now Up-to-Date Web Publisher, letting you access company meetings, training calendars, project schedules, entertainment, sporting events, and other useful information. Download it from **http://www.nowsoft.com/plugins/about_time.html**.

Adobe's Acrobat Reader plug-in is available for Windows 95, Windows NT, Windows 3.1, Macintosh, Power Mac, Sun Os, Solaris, Hp-Ux, and Irix. Acrobat Reader 3.0 beta (formerly Acrobat Amber) lets you view, navigate, and print Portable Document Format (PDF) files right in your Navigator window. PDF files are extremely compact, platform-independent, and easy to create. They offer design control, print-ready documents, and an endless array of authoring applications.

Ichat, available for Windows 95, Windows NT, Macintosh, and Power Mac, is the first plug-in to integrate chat capability directly into Netscape Navigator. When Ichat users visit an Ichat-enabled Website— or even a page with links to IRC (Internet Relay Chat)—the Ichat plug-in opens a frame in the lower part of the browser window. Within that frame, Ichat displays a real-time, ongoing chat session among all the visitors to the Web page. Visitors can communicate with each other while continuing to browse the Website. Visitors can also lead friends, family, and colleagues on tours of the Web using Ichat's Web-tours capability. Download from **http://www.ichat.com/ichat2/download. html.**

The PointCast plug-in is from PointCast Incorporated. The company was founded in 1992 to provide current news and information to anyone on the Internet. The PointCast Network broadcasts personalized news, stock quotes, weather, and more directly to your computer screen. Currently, the PointCast Network runs on Windows 3.1 and Windows 95 operating systems. Macintosh and Windows NT versions are coming real soon now. The service is free. Download from: **http://www. pointcast.com.**

TruDef by Advanced Multimedia Concepts is available for Windows 95, Windows NT, and Windows 3.1. This plug-in lets you view and share graphics with friends and colleagues through e-mail and display high-quality graphics on your Website with a fraction of the usual storage requirements. TruDef products are designed to achieve maximum compression consistent with an image that's indistinguishable from the original. Decompression is inline. Download the 2.0 release of AMCI's TruDef plug-in from **http://www.amci.com/trudef/tdpi.html.**

Based on Quick View Plus from Inso Corporation, the Word Viewer Plug-in gives you the power to view any Microsoft Word 6.0 or 7.0 document from within Netscape Navigator 2.0. It's quick and easy to download (700K), and it's simple to install. Best of all, it's absolutely free. Currently the plug-in is available for Windows 95, Windows NT 3.5, and Windows 3.1. A Mac version is coming soon. FYI, Quick View Plus lets you view, copy, print, and manage virtually any file without launching—or even having—the original application. Quick View Plus gives you cross-platform support for over two hundred different types of word processor, spreadsheet, database, graphic, and archive files, including HTML, PKZIP, and UUE. You can try Quick View Plus free for thirty days. Download from **http://www.inso.com/plug.htm.**

Viewers

ABC QuickSilver from Micrografx is available for Windows 95 And Windows NT. This plug-in is an extension of Micrografx's ABC Graphics Suite (more on this product in a bit) and allows users to place, view, and interact with object-graphics inside Web pages. QuickSilver's object-graphics technology has been designed to make creating and viewing Internet graphics easier and faster. Download the latest version from **http://www.micrografx.com/download/qsdl.html.**

Pegasus, from Pegasus Imaging, is available For Windows 95 and Windows 3.1. The plug-in supports JPEG, Progressive JPEG, and PIC (Pegasus's enhanced JPEG), offering fast decompression and viewing of images on the Internet. The Pegasus plug-in also gives Web developers the ability to create thumbnail representations of an image with partial image data, so redundant data is downloaded only once. Download the free Pegasus plug-in from **http://www.jpg.com/product.html.**

Presentations

Astound Web Player, by Gold Disk, is available for Windows 95 and Windows 3.1. This plug-in that plays multimedia documents created with Gold Disk's Astound or Studio M software. These documents can include sound, animation, graphics, video, and interactivity. The Astound Web Player features dynamic streaming; each slide is downloaded in the background while you view the current slide. Download from **http://www.golddisk.com/awp/index.html.**

PhotoBubble Viewers allow you to experience any Omniview destination with Macintosh or PC platforms. These viewers can be downloaded free of charge and configured for your system. Netscape Navigator 2.0 plug-ins are available for Windows 95 and Macintosh PPC. Download PhotoBubble from **http://www.omniview.com/viewers/viewers.html.**

Microsoft's PowerPoint Animation Player and Publisher for Windows 95 and Windows NT provides computer users with the fastest, easiest way to view and publish PowerPoint animations and presentations in your browser window. PowerPoint users can take advantage of the animation, hyperlinks, sound, and special effects they are familiar with to create animated Web pages. Download the Animation Player from **http://www.microsoft.com/mspowerpoint/internet/player/installing1.htm.**

Happy plugging!

WWW Utilities

ABC QuickSilver Pack

At Spring COMDEX 1996, Micrografx introduced ABC QuickSilver Pack for the Micrografx ABC Graphics Suite. ABC QuickSilver Pack consists of software components that extend Internet capabilities to the applications that are part of the ABC Graphics Suite. The best news is that ABC QuickSilver Pack is available for free and can be downloaded from Micrografx's Website located at **http://www.micrografx.com** or may be ordered on CD-ROM for $9.95 shipping and handling by calling 1-800-640-2049.

The package contains the following:

- ABC QuickSilver Plug-in, a software plug-in for Netscape Navigator 2.0 or higher
- ABC QuickSilver ActiveX Control, an ActiveX Control for
- Microsoft's Internet Explorer 3.0
- ABC WebCharter, which provides visual WWW site charting
- HTML page templates for corporate Intranets
- Scripting samples

Curious about ABC Graphics Suite? The Suite integrates Microsoft Office 95–compatible versions of Micrografx Designer, ABC FlowCharter, Picture Publisher, Instant 3D, and ABC Media Manager. ABC QuickSilver Pack works with these applications to enhance existing graphics with interactive properties, as well as to create new interactive object-graphics. Photographers using ABC Graphics Suite will find extensive importing capabilities, making it ideal for creating Internet content.

Micrografx Picture Publisher

If you're not familiar with Micrografx Picture Publisher 6.0, you should be. ABC Graphics Suite is a 32-bit, Windows 95–compatible package includes a drawing program, media manager, flow charter, and Picture Publisher 6.0. The image editing program's toolbar and palettes feature a number of interesting features. When you select the text tool, a second toolbar is added to the top of the screen, allowing you to choose font, point size, style, justification, angle, and transparency. When clicked, many of the tools in the palette expand horizontally to show additional choices. This works for most of them, but having choices in the

magnifying glass seems more complex than simply clicking the tool and using a control key to toggle between plus and minus the way Adobe Photoshop does. Opening Photo CD images is expedited by the ImageBrowser dialog box that also displays thumbnails of all of the images on a disc. To open one, all you have to do is double-click the thumbnail. With a Photo CD this brings up another dialog box that allows you to select the image resolution, crop it, and adjust color balance and saturation before the photograph is opened within Picture Publisher. Hidden at the bottom of the Image menu, you will find an Effects submenu that opens an EffectsBrowser allowing you to apply and preview thirty-five different effects, ranging from photographic tweaking to the far-out. If you want to tweak brightness and contrast you select that option from a scrolling window and the EffectsBrowser morphs into a brightness/contrast windows—all the while retaining the scrolling Image Effects window. All of your third-party plug-ins can be accessed by specifying their location in the Options window. All of the program's operations are abetted by a Help system that actually helps. When looking for how to create those trendy "fading out" effects, you'll get a window detailing the step-by-step of how to produce the effect using Picture Publisher's masking and Ruby(lith) overlays.

The ABC QuickSilver Plug-in makes creating interactive graphics a simple process; minimizes the necessity to learn, know, and apply HTML to create that interaction; and speeds up graphics on the Internet considerably by reducing file size. The plug-in is provided as an ActiveX Control with all the capabilities of the Netscape plug-in. All of the programs within ABC Graphics Suite support the ActiveX document architecture and their documents can be viewed and edited inside Internet Explorer.

ABC WebCharter creates a high-level view of WWW sites inside of ABC FlowCharter and uses the Microsoft's extensive OLE (Object Linking and Embedding) capabilities to drive the automated process of charting WWW sites.

The ready-to-use Web content that's included allows the experienced and novice WWW user to create their own Website quickly. The content incorporates HTML formatted sites and pages which include backgrounds, interactive graphics, and hotlinks and provides photographers with a starting point for creating WWW pages instantly, allowing them

to focus on what they want to communicate, not the process of building a Website.

Web Ninja

Web Ninja is a Macintosh application and system extension that automatically monitors your activity on the World Wide Web when using Web browsers such as Netscape Navigator, Microsoft's Internet Explorer, Spyglass Mosaic, Anarchie, or Fetch. Web Ninja keeps track of where you go, how many times you go there, when you go, and how much time you spend. The Web Ninja application displays this information, and allows you to jump to any location in the list.

Web Ninja allows you to set up as customized lists of WWW and FTP sites you wish to visit in a manner similar to the bookmarks feature used by many browsers, including Navigator. You can also establish a download list, a list of Web pages or FTP files to download in a single batch operation to disk.

Installation is simple. Just place Web Ninja Extension in the Extensions folder in your System Folder. The Web Ninja file can be placed anywhere you like. When you're done, restart your Macintosh and Web Ninja will be installed ready to monitor your Internet activity.

Web Ninja works by watching you on the Web. The extension works in the background using little of your system resources. Once installed, your Web activity is automatically monitored. Web Ninja monitors the data collected by the extension and a Web Ninja window contains a list of all the URLs you have visited since installing the utility, including the number of visits, date and time of last visit, and total hours, minutes, and seconds of time spent at that location. You can click on any of these titles to sort the data in the list according to that title. Below the list is shown the number of items currently in the list and the total number of URLs that are available. Above the list is the date and time that the list was last updated.

When you are online, the word "Online" appears in bold in the lower portion of the window below the list. "Offline" is displayed in italics if your browser is not running. As you use your browser, the Web Ninja log will be updated shortly after you leave a location. Web Ninja will track as many browser windows as you have open, but it can only track one browser at a time. The Web Ninja window contains a pop-up menu in the upper left corner that allows you to choose the type of URLs to display in the list. Choose the "Web Pages" item to display only

Web pages; choose "FTP directories" to display only FTP sites, and choose "All Items" to display all items in the list. This includes locally loaded pages (items that begin with **file://**). The filter box is used to limit what is displayed in the list and to allow you to quickly find an item in the list. By typing letters in the filter box, only those items that match the text pattern typed will be displayed. The search is not case sensitive. The URL list is rebuilt each time you type a key. You can quickly jump your browser to any place in the list by clicking on the item, then clicking the "Open URL" button in the upper right corner of the window. This will cause your browser to go to that URL. Note that the Open URL button will be disabled unless you are currently online.

In addition to the Web Ninja Log window, you can also maintain any number of custom URL lists. Choose New Window from the file menu, name the new window something descriptive, such as "My Favorite Sites," then click "OK." A new window is opened with a blank URL list. You can now drag URLs from any other Web Ninja window and drop them down in your new list. You do not have to worry about saving custom URL lists to disk. This is done automatically. You can remove a custom window by selecting it and choosing "Delete List" from the edit menu. Individual items in a custom list can be removed by selecting them (clicking on them) and hitting the delete key. Windows with no items in the URL list are also removed when you quit the program.

You can drag and drop URLs between all of your custom lists. Hold down the option key while dragging to copy rather than move the item. You can also Cut/Copy/Paste items to copy or move URLs around your various URL List windows. To add the URLs present in the file to the list, drag text files and drop them into a URL list window. You can drop bookmarks and history files from your favorite Web browsers as well. When dragging text, a valid URL is searched for and extracted from the text. This allows you to be casual about which text you drag. If you visit a Website and find the text, "go to **http:/www.albany.net/~wtudor** for some great software," you can highlight the whole thing and drop it into a URL window. The URL (**http:/www.albany.net/~wtudor**) will be extract from the text clipping and added to the list.

Web Ninja maintains a window named "Items to Download." You can place as many URLs as you like into this window. This window is special in that the URLs listed here are items you wish to download to

disk in an automatic fashion. When you click on the "Download" button to start the download process, the files will be placed in your Downloads folder, which is set up by choosing the Preferences item in the Edit menu. Once downloaded, you can view them at a later date. If required, Web Ninja will issue multiple requests to download the file or files. Choose Preferences from the Edit menu to setup your download options.

You can drag and drop URLs into most applications that support drag and drop. Rather than clicking on the Open URL button, you could drag a URL into a Netscape window and drop it there. Netscape will take you to that URL. If you drop a URL onto the desktop, you will create a text clipping. If you drop a URL into a text processor you will get the URL text. Choose "Export List . . ." from the File menu to save all of the URL data in the current list to a file. This file will be in HTML format, suitable for loading into a Web browser, including links for all of the items in the list. As I write this, the current version of Web Ninja is 1.0.3, but given the nature of shareware updates it will surely be higher than that by the time you read this.

Special Note: you may find additional information about Web Ninja at **http://www.albany.net/~wtudor.** MacUser's Web Ninja is Copyright 1996, William H. Tudor and Ziff-Davis Publishing Co. and is not in the public domain or shareware. You may make copies for personal use. You may not upload this utility to any online service, network, bulletin board, or the Internet or make copies for any commercial purpose. Distribution is limited to Ziff-Davis Publishing's online services and electronic publishing projects.

CyberFinder

Aladdin System, creators of the StuffIt family of compression software, produced CyberFinder as a method for navigating the Internet from within the Macintosh Finder, which lets you organize bookmarks like files in the Finder. Here's how it works: CyberFinder lets you create Internet bookmarks for all your favorite Internet Websites in the Finder. All you have to do is double-click on a bookmark icon and CyberFinder will automatically launch the appropriate application to take you there. This means that you never have to leave the desktop to access your favorite Internet locations or Websites. You can go any place you want to on the Net and from within any application you happen to be working in. CyberFinder relies on the helper applications already

installed on your computer. So whether you use Netscape Navigator or Mosaic, Archie or Fetch (or any other popular Internet applications),just select any Internet address (in e-mail, newsgroup, or anywhere), press a user-definable "HotKey," and you're instantly and automatically there.

CyberFinder also lets you catalog your bookmarks however you wish. Instead of storing bookmarks across multiple applications, you can keep them all in the Finder. CyberFinder also lets you share Websites with other CyberFinder users by letting you send friends and colleagues CyberFinder bookmarks. To get to that site, all any other CyberFinder user needs to do is double-click the bookmark. That makes it a handy tool for anyone who need to distribute Internet locations to other users on a regular basis.

Web Buddy

DataViz, well known for their file translation utilities, introduced a useful Internet utility collection they call Web Buddy. Web Buddy assists users of Web browsers in collecting, converting, organizing, and sharing the information they find on the World Wide Web. It also automates the collection of Web pages or entire Websites, allowing users to browse the Web later—even when not connected to the Internet. Its toolbar provides access to functionality from within browsers like Netscape Navigator, Microsoft Internet Explorer, Mosaic, and others.

Using Web Buddy's Page To Go and Site To Go utilities, users can download selected pages and entire sites onto their hard drive and view them later. For instance, a user could take the Kodak Website "to go" and browse it on their laptop while flying to an assignment. And the pages will look exactly the same as they did online. All graphics and links are retained so browsing locally is virtually the same as browsing on the Web—only faster. Web Buddy can be scheduled to automate information collection by taking pages from the Web anytime. While not a new concept—CompuServe's Navigator software introduced a similar concept many years ago—Web Buddy surfs the Web while you are busy doing other things, such as sleeping. Users can have Web Buddy retrieve pages from high traffic Websites during off-peak hours, which will save time and money by avoiding lengthy dial-up sessions.

Because Web Buddy is part of DataViz's family of file conversion utilities, you can convert a Web page or graphic and use it—bearing in mind any appropriate copyright considerations—in your favorite word processing or graphics programs. Virtually all formatting features of the

original home page are contained in the resulting file, including graphics, tables, and character styles. Hot links can also be included as footnotes in the resulting files and can be referenced for later visits. Web Buddy includes a central filing area, Web Buddy Central, where collected Web pages, sites, graphics, and bookmarks can be stored. Using toolbars, tab folders, and drag-and-drop, users are able to easily categorize, organize, and access their collection of Web information. Users can also access scheduling, conversion, and other functionality from this location.

Sharing Web pages and sites with others can be a nightmare. Users often experience a loss of graphics, broken links, and missing files. Web Buddy changes this and allows users to copy pages and sites with all necessary files to another location on their computer, networks, or removable media. Users can save an entire site to a floppy disk and allow colleagues or clients to browse the pages right from the disk. If your browser bookmark menu is as crowded as mine, you can use Web Buddy's toolbar to add and retrieve bookmarks in customized categories. That way you can separate your photographic-oriented Websites from your non-photographic ones. Web Buddy is available for Windows 3.1 and 95, Macintosh, and Power Macintosh.

4 Now You're There . . .

Sometime in 1989, you stopped asking people if they had a fax number. In 1996, you stopped asking people if they had an e-mail address.

—Michael Kinsley, editor of *Slate,* Microsoft's electronic magazine

Compared to conventional online services like CompuServe and America Online, the Internet may appear disorganized and even chaotic in structure. To make the Internet work for you and your photography studio, you will need more than a good browser and a few add-ons and plug-ins. For openers, you'll need to understand about the other, older aspects of the Internet and how they can help you maximize your online productivity. This include tools and other uses for the Web beyond the obvious information-gathering and marketing uses. In this chapter, you'll be given an introduction to these other items in preparation for the creation of your own Internet presence—we will get to that starting in the next chapter.

What's Next?

There's more to the Internet than the World Wide Web, and even the Web has some uses other than the obvious. In this chapter we will look at other aspects of the Internet that photographers may find useful.

Other Sides of the Web

Here's an introduction to a few other areas that photographers may want to utilize.

- *FTP.* If you've been keeping track of Internet acronyms you already know that FTP means File Transfer Protocol. Nit pickers may point out that it also means File Transfer Program. Another usage of FTP adds the word "site." "FTP site," means any computer system on the Internet that maintains files for downloading. FTP sites are great places to get public domain software. A site address looks like the following: **"ftp.fhru.com"** and most accept anonymous login. By that I mean that you use the word "anonymous" as a login ID, and your e-mail address as a password. The most famous online database is called Archie and contains a list of software available from anonymous FTP sites. Archie can be reached at **http://archie.mcgill.ca** or **archie. sura.net.** (More on Archie in a bit.) Chances are the best place to get Apple's Cyberdog is at a FTP site. The same is true of much shareware and freeware. That's not to say there aren't places to download software on the Web—there are plenty—but without

Figure 4-1. When you point your Web browser to **http:// archie.mcgill.ca**, this is what you will find. It's a veritable digital library of "anony-mous" FTP download sites.

the bells and whistles overhead of a Java-enabled Website, an FTP download will be simpler and more straightforward.

- **Telnet.** Telnet was originally developed for ARPANET and is part of the TCP/IP communications protocol. It is a tool to allow you to log onto remote computers, access public files, and databases, and even run applications on the remote host. When using Telnet, your computer acts as if it were a terminal connected to another, larger machine by a dedicated communications line. Although most computers on the Internet require users to have an established account and password, many allow you access to search utilities, such as Archie or WAIS (more on these terms in a bit). You don't have to buy any new software to access the Telnet function. Browser software, Wollongong Group's Emissary, and Quarterdeck's Mosaic, seamlessly integrates e-mail, FTP, and Telnet into Web browser activities.

- **Gopher.** This is a software tool that enables you to browse Internet resources. It was developed by programmers at the University of Minnesota—home of the Golden Gophers—and features a menu that allows you to "go for" items on the Internet, bypassing the typical complicated addresses and commands. You can navigate the Internet using Gopher by selecting the desired item from a series of lists and continue through a series of lists until you locate the information you are seeking. While Gopher is a software program, Gopher sites are often called simply "gophers." (Yes, it *can* get confusing.)

- **Archie.** This is an acronym based on "ARCHIvE." Until the World Wide Web came along, if you wanted to search the Internet you only had a few choices: Archie, Veronica, and WAIS. It's an Internet utility that is used to search for file names. Over thirty computer systems on the Internet act as Archie servers and maintain catalogs of files available for downloading from FTP sites. On a random basis, Archie servers scan FTP sites and record information about the files that they find. Several companies, such as Hayes, offer software that provides a menu-driven interface that lets you browse through Archie servers on the Internet. Archie locations can be accessed using standard Archie client programs.

- **Veronica.** Very Easy Rodent Oriented Netwide Index of Compu-terized Archives (someone is definitely hung-up on *Archie* comics,

here), Veronica locates Gopher sites by chosen topics and prompts users to choose key words for searching, generating hundreds of references on the subject. A user can chose a reference and instantly view the information. There are a limited number of Veronica sites and a plethora of users. Veronica is a tool to help you find the Gopher servers containing information you need and you can browse a Veronica menu just like you would a Gopher menu.

- **WAIS.** Wide Area Information Server is a system to search Internet databases. You can do a keyword search using WAIS to retrieve all of the matching documents and then read them.

Photographers and the Net

I'll say it again: the Internet is big. This bigness can be the Net's undoing when new users launch their browser, point it at a home page, and ask "what's next?" What's next in this book is a quick overview of what's available for photographers on the Internet.

Other Aspects of the Web

Little did the small group of Swiss scientists realize what they were creating when they drew up the original specifications for the World Wide Web. What they imagined—and what was used in the international debunking of "cold fusion"—was a place for scientist and engineers to communicate. What they didn't expect, I'm sure, was home pages—digital shrines, really—for Sandra Bullock. That said, there's still much for photographers to find on the Web. Here are a few categories that should give you an idea of what I mean.

Technical Information and a Whole Lot More

When the Advanced Photo System was introduced to the world, photographers were able to download specifications, press releases, and even images on the Websites of the consortium partners before it was in the newspapers, on CNN, or in the pages of your favorite photographic magazine. That's why the Web is *the best* place to get technical information. When the Nikon F5 was announced, you could read about it both on Nikon's home page, which you might expect, but also at *HyperZine*'s Website at **http://www.hyperzine.com.** *HyperZine* is an

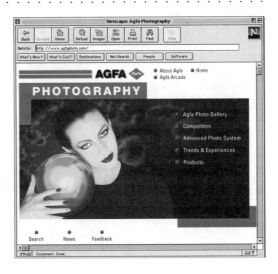

Figure 4-2. Agfa's home page for traditional film, paper, and chemistry is found at **http://www.agfa.photo. com.** They have a separate Website for their scanners, digital cameras, and other electronic media.

online photographic Webzine (more on web magazines later) that is a digital version of popular photographic magazines. The first thing you should do when you go online is to point your search engine to your favorite camera of film manufacturer's home page. After the APS announcement but before the launch of the F5, I was interested in Agfa's new black-and-white transparency material. The best place to get information about the product, including technical specifications and processing information, was at their home page. The Web is your best source of current information about silver-based or digital imaging information. It's like having your own personal photographic C-Span channel, providing information twenty-four hours a day.

Online Digital Imaging Services

One of the most exciting new online products found on the World Wide Web for photographers is Seattle FilmWorks' PhotoMail. This service is designed for online delivery of digital images, called "Pictures on Disk," when you have film processed at this particular photo lab. Seattle FilmWorks is not the only lab to offer this service, but they were the first. This fact, along with their PhotoWorks Plus software product, make a formidable combination. (Please note: the image resolution of the SFW format images used by Pictures on Disk and Photomail is 640 × 480 pixels. This is right on the edge for professional use, but I have been able to create digital "sell sheets" using Pictures-on-Disk images, if I kept the final image size at 3 × 5 inches or smaller.)

Figure 4-3. The Seattle FilmWorks home page may not be the only place to download digital images from a photofinisher's Website, but they were certainly the first. This is the screen that starts the download process.

To get started, all you need to do is go to Seattle FilmWorks home page at **http://www.filmworks.com** and register to receive online delivery of your images. While you're on the home page, you might want to take a few minutes to download a few sample images to see how easy it is to receive your digital images totally electronically.

Here's how it works: you send your exposed film to Seattle Film-Works, which processes your film and digitizes the images. Originally, the lab would mail the floppy disk containing the images to you. Now it is done electronically. (The service costs $3.95 plus film processing and printing.) When your photos are ready, you'll get an e-mail message with complete instructions for downloading the images. Because this message contains both your customer number and roll number, it's a good idea to print this e-mail message and file it until you physically download the images. Allow two to three business days from the time you mail your film. You'll have up to fourteen days to download your photos. Your prints or slides will be mailed as you requested.

When sending film in for processing, be sure to specify that you want "PhotoMail" processing service. You can do this by simply making a note on your order form, preferably near the "Pictures on Disk" section or by checking the PhotoMail box on the new order forms. If you need an order form, you can always download one from Seattle FilmWorks home page.

Downloading PhotoMail

When your photos are ready, you will see the following messages.

To download the file, do the following:

- **Step 1.** From the Seattle FilmWorks home page, select the PhotoMail option. From the list of PhotoMail options, select the option to download your photos.
- **Step 2.** The next screen you see (Figure 4-3) is where you provide the information that begins the download. The first part asks you to enter your customer number. You will find this in two places: first, it is on *every* piece of information that you get from Seattle FilmWorks. Second, it is on the automated e-mail message you received telling you your images were ready for download. (See, I told you to print that message!)
- **Step 3.** Click the button to download your photos.
- **Step 4.** When prompted by your browser, save your file to your hard disk. Note which directory the file is in, so you can tell PhotoWorks where to find it later.

Waiting is always the hardest part. And the hardest part of using PhotoMail is the time it takes to download your photographs. How long it takes will depend on how fast your modem is and how fast your Internet provider is operating. In tests for this book, I downloaded three files: two on my Macintosh and one on my 486 IBM-compatible. Not surprisingly, the faster modem, in my Macintosh downloaded my twenty-four pictures in about a half-hour, the 14,400 modem in my PC took a little over an hour. Is that too slow for you? The post office can't get your images to you in an hour.

E-Mail

Using e-mail sounds much like the electronic version of writing a letter to Granny; you think you already know how to do it. Or do you?

E-mail is not a panacea and there are times when you have to pick up the phone. That's because e-mail provides less context than other methods of communication, making e-mail not the best method for resolving conflict. In fact it has been my experience that it can *worsen* conflict. Nevertheless, like the Internet, e-mail is here to stay. I recommend you read *Using Email Effectively* from O'Reilly and Associates—after you've read the next section.

Free E-Mail

One of the biggest factors inhibiting some photographers from using the Internet is cost. It's not just the cost of the modems; modems keep getting faster and cheaper. It costs much less to purchase the 28,800 bit per second Supra FaxModem 288 I use on my Macintosh, than the first 300 Apple modem I bought many years ago. It is the additional expenses that add up. First, there is the cost of buying and upgrading the software required. Second, there are the costs associated with opening and maintaining an account with a local or national Internet Service Provider. For many photographers the Internet means access—being able to communicate through e-mail with suppliers, colleagues, equipment manufacturers, and maybe just a note to yours truly. For all of you who have been waiting for some kind of price breakthrough in this area, I'd like to introduce you to a *free* Internet e-mail service from Juno Online Services.

I Thought That Was in Alaska?

With more than 35 million users, e-mail is the most popular Internet service. It's even more popular than the World Wide Web, which boasts about eight million surfers. Hard as it may be for all the computer skeptics out there, Juno Online Services offers a free Internet e-mail service. It is truly free. Nada, nothing, zip, zero! There are no monthly fees, no hourly fees, and no sign-up fees. The software is free and Internet access is free through a local or toll-free 800 telephone number. What's the catch? So far there are only two and both of them are relatively minor. One, the free software is designed only for Windows-based computers. Juno expects to have a Macintosh version available sometime in 1997, so this one reservation will be short lived. Two, the software displays commercial messages. Anyone who has ever surfed the Internet with software that they bought and paid for, using an ISP that sends them a monthly bill, already knows there's nothing unusual about that seeing your Internet rambling interspersed with ads from everything from colas to sneakers to automobiles—and computer stuff, too.

The software is yours for a free phone call to (800) 654-JUNO. It comes in a CD-ROM–like envelope containing a floppy disk and all the information you need to get started. Establishing an account and installing Juno's software was a snap on my Windows 95 machine. After you run the setup program and launch it, the program asks for some

basic information then automatically configures your system and modem. It took a guess at the kind of modem I have inside my PC and one of the guesses was correct. I clicked OK and moved to the next step. Then you get to pick your e-mail address and a password. The e-mail address is **"whateveryouwant@juno.com"**; you're on your own for the password but don't—whatever you do—use "password." OK?

Next we get to the "member questionnaire" which might be the only semi-controversial aspect of the process. If you've ever filled out a warranty card for your computer or VCR you will recognize this for what it is: market research. None of the questions seemed particularly intrusive to me but they did want to know my annual household income and how many stock or bond trades I've made over the past year. This might bother the security-minded amongst you but not me. All of this information is all to easy to obtain from other sources, so what's the secret? H-m-m-mm? In case you're wondering, Juno uses these profiles to decide what commercials they will display when you log on. After that, it's just a matter of launching and using the software.

Reading, Writing, and E-Mail

If you've ever seen or used any company's online software or browser you will be amazed at the easy-to-use design of Juno's software. There are two large tabs that let you switch back and forth between the service's two main functions: reading and writing e-mail. After that everything has been designed to make the e-mail process an intuitive one, starting with spelling. Next to garbage in–garbage out, the most popular expression on the Net is that "nobody can spell online." That's usually because your replies are written in much the same way as conversations tend to be held, i.e., in a less structured way. One of the victims of this lack of structure is spelling. Some companies have developed software plug-ins and add-ons (that you have to pay for) to add spell-checking capability added to an Internet browser, such as Netscape Navigator. Here, a spell-checker is built into the free software that Juno provides so you can quickly spell-check your reply before letting it drive off onto the information superhighway. Juno's software also contains a full function address book allowing you to build up a personal mailing list of friends', colleagues', suppliers', and clients' e-mail addresses. To send a message to someone that's in your address book, all you have to do is click on the person's name, click the "send to" button, then click "OK." In addition to being able to send a message

to anyone on the Internet, you can also send e-mail to anyone using a major online service such as CompuServe, Prodigy, and America Online. When mail arrives it is stored in a folder and you can read it, respond to it, or file it in another folder.

One of the hottest trends in e-mail is the appending of an electronic "signature." Most users use this to add their name and some additional information about themselves, such as their street address. Some users use it to call attention to their achievements, such as a new listing in *Who's Who*, the awarding of a master's degree in Photography, or just to add a pithy saying. A word of warning here. My friend, Steve, is currently adding little snippets onto his signature. Currently he is using "R2D2! You know better than to trust a strange computer!" This can be mildly amusing for a short time, but your regular e-mail recipients may get tired of it quickly if it is not changed regularly.

When it seems that nothing is free these days, it appears that e-mail is.

Communicating Around the World

E-mail is one of the best things about the Internet. For the price of your monthly Internet access, you can send electronic mail anywhere in the world. Communicating with a photography professor in Haifa, Israel, is just as simple as communicating with one in Rochester, New York. According to Ziff-Davis Online, the quantity of e-mail online users receive is growing astronomically and is expected to increase thirty times current volumes by the end of the century. But for all of the convenience and benefits of e-mail, there is a down side.

I have a theory about the "communications hierarchy," which suggests that people (read "photo buyers and clients") tend to pay the most attention to the latest communications marvel. The first thing to drop out of the communications hierarchy was US Mail. Here's a true story: I was talking to a potential client about doing some work and he asked me to send some images and promotional material, which I did. When I called him back, he said he never got the material. I ended up sending him the package two more times but the result was always the same—he never received it. It turned out that his secretary sorted his mail and anything she didn't think was of interest, she tossed into the trash. Whether she did this on his order, who knows? Next came the fax. There was a time that the best and quickest way to get a potential clients attention was to send them a fax. Sending a client an assignment confirmation/estimate by fax within moments of discussing on the

phone always resulted in signed agreements being returned. Ah, those were the good ole days. With the advent of broadcast fax and junk fax mail, the curly output of the fax machine became the next victim of my theory. E-mail, it seemed, would be the ultimate answer. It had everything. It was almost instantaneous, it was paperless, and it was cool. Sorry Charlie. Within a very few years e-mail lost its luster too. I started noticing this recently when fully one third of the e-mail I sent to people, from whom I expected a response, went unanswered. To get another opinion on this, I spoke with someone who gets much more e-mail than me: Steve Deyo, editor-in-chief of *ComputerUSER* magazine. Here's what he told me about e-mail (via e-mail):

"There are always stories about people (of whom, I confess, I think unkind thoughts) who confess that they delete most of their e-mail unread. [Author's note: in *Using Email Effectively*, the authors tell of a person who allows his queue of e-mail to reach six hundred messages, then deletes the oldest two hundred.] So it's not a problem of the technology or its convenience or its benefits, it's that some people are too damn lazy . . . or just overworked, partly through others' misuse of e-mail (cc-ing of newsgroup humor, chain letters, etc.). I think that until we have true internetworked receipting of mail when it's actually been read (not just received) and digital authentication and security, we can't rely on e-mail as solidly as US mail. And how much Pony Express mail gets read anyway? (I prefer to use "Pony Express mail" rather than "snail mail" because ground mail has a noble tradition—"neither rain nor snow" and all that—plus I prefer to disgruntle our postal workers as little as possible.) Appropriate use of the technology—and personal investment of time in a phone call for really important matters—seems to be the rule of the day. Until that day comes, e-mail really is a convenience for the sender—especially if you're a junk mailer—and an informal communications tool. E-mail is less formal than the fax, and less secure, but cheaper too. It's a tradeoff, as always with any mass-market technology."

The truth is that e-mail has all of the problems of postal mail with the added frustration of an enhanced level of expectations. People can ignore your e-mail as easily as they ignore your paper letters. And like junk mail, they can toss your lovingly crafted letters into the digital trash or recycling bin. Even worse, like politicians being asked tough questions, they can be selective in what they will answer. When combined with the high expectations that new e-mail users expect—

quick delivery and response—the frustration levels can be quite high. The reason I have included what is mostly a negative look at e-mail is that new users expect e-mail to be a panacea for their written communications problems. As you can see it's not, but there is—

The Other Side of E-Mail

Just as a USPS letter carrier carries more than letter, the Internet allows you to send files containing text, graphics, audio—even video. Any binary file such as graphics, sound, or video can be encoded as ASCII text for transmission over the Internet. If you're wondering why you should even care about this concept, it is the perfect way to e-mail a photographic image—and a text message—to existing and potential clients anywhere in the world. The most popular methods for encoding and sending binary files over the Internet are MIME, UUcode, and BinHex.

- *MIME.* Rather than an annoying white-face painted Marcel Marceau wannabe, MIME is an acronym for Multipurpose Internet Mail Extension and was developed by the Internet Engineering Task Force for transmitting mixed-media files across TCP/IP networks like the Internet. To turn a MIME message into the original format, you need a conversion utility. There are utilities for Macintosh, Windows, and UNIX machines that will decode MIME files. I use MPack 1.5, a shareware utility available from all the familiar online shareware sources.
- *UUcode.* UUcode software allows you to convert a binary computer file into an ASCII format for sending across the Internet (or any other e-mail service), then converting it back to binary. In UUcode or MIME form, a file may be visible and readable by your word processor, as ASCII text, but will look like gibberish on the screen. Some e-mail services, such as CompuServe, allow you to attach a binary (graphic, audio, video clip) file to a message without ever affecting the message. The person receiving your, now combined, message can read your e-mail and then convert the file into its original, intended form.
- *BinHex.* BinHex is an algorithm for representing non-text Macintosh files (such as software, graphics, spreadsheets, and formatted word processing documents) as plain text so they can be transferred over the Internet. The file-name extension ".hqx" designates a BinHex file, which can be decode with Aladdin

Software's free ware utility StuffIt Expander. It is also available as part of commercial product called StuffIt Deluxe.

Newsgroups

USENET, or USEr NETwork, began in 1979 as a bulletin board that was shared between two universities in North Carolina. It has grown—in 1994, daily volume exceeded 50GB of data—into a public access network, maintained by volunteers on the Internet, that provides user news and e-mail services.

News traveling over the Internet is called NETNEWS, and a newsgroup is a collection of messages covering a particular subject. Which can be anything from digital photography to politics and even silly topics like the cult TV show, *Mystery Science Theater 3000*. There are seven newsgroup topic hierarchies that are called "trees": computers, miscellaneous topics, news or newsgroup information, recreation, science, society, and talk. Each tree branches into different sub-topics. Newgroups abound on the Internet; as I write this there are ten thousand newsgroups on the Net. In order to read the text of a newsgroup, you need a newsreader, which is software that organizes your USENET conversations and allows you to read and participate in newsgroup discussions. While you can use your browser for this, there are dedicated programs, such as TIN (Threaded Internet Newsreader) that allow you to read newsgroup messages.

Figure 4-4. Using the Infoseek search engine, you can search USENET newsgroups as well as the WWW. On the day I entered "photography," I found almost five hundred newsgroups discussing photography covering topics that included a sale of Photography Books from the 1930s, a group of Irish photographers wishing to establish a studio co-operative in Dublin, astrophotography, and the Emmy nomination of the sci-fi TV show, *Babylon 5*.

Search Engines

Search engines are not engines at all in the conventional sense of the word, but are really database managers that manage content of the World Wide Web. As with any database, how well they do their job depends on the talents of the database designer and program, as well as how the parameters of the program were set forth in the first place. Some search engines are free and contain advertising on their home pages, that I, personally, find unobtrusive. If this blatant commercialism bothers you, there are search engines that lack advertising but charge a fee.

How They Work

A search engine, well, searches. They cast a net out onto the World Wide Web to help you find the particular home page you are looking for. Each search engine is different and uses different search techniques to locate that special Website you're looking for. How they search can be important, especially when you're looking for a Website of a service bureau or professional color lab that can help you when your on the road. Here's an overview of the different kinds of searches that can typically be done.

- **Boolean:** a search for specific data that gives you the ability to specify conditions and allows you to use one or more of the Boolean expressions "AND," "OR," and "NOT." Don't let the term, Boolean, scare you. It comes from Boolean logic in which an answer is either true of false. It was developed by English mathematician, George Boole, in the mid nineteenth century. An example of a Boolean search request would be "find a photo lab that processes black-and-white film AND Kodachrome." Database programs typically allow you to make Boolean searches for data and so should a good Internet search engine.
- **Contextual:** the most common type of search for home pages or Websites is based on the text you enter in a "search" keyword. The search engine uses the data that you enter to match with other data in the Website description database. It looks for Websites whose descriptions contain the word you have specified. If you're looking for a lab to process Agfa's new Scala film and you enter "Scala," you might find listings that include labs but also a photographer's Website that has used Scala to create images.

- **Fuzzy:** the least common type of search uses "fuzzy" logic to look for data that is similar to that which you are trying to find. (Fuzzy logic was originally conceived in 1964 by Lotfi Zadeh, a science professor at the University of California at Berkeley, while trying to program computers for handwriting recognition.) A fuzzy search is the best approach when an exact spelling may not be known or to find co-related information. If you're looking for information on the images of Jerry Uelsmann and don't know how to spell his name (I always have to look it up), you type in "Ulesman" and a fuzzy search could lead you to the correct location.

A Comparison of Popular Search Engines

Like Web browsers, there are many, many search engines that you can use. The ones listed below are the most popular, but that doesn't mean that by the time I finish writing this book there won't be ten more really good search engines. Consider this list to be the Fortune 500 of search engines for now. More importantly, don't be discouraged about trying to find the perfect search engine. Just as you have different lens, film, and filter combinations that are used for specific projects, you will quickly discover that there are search engines you prefer and those that you don't. One trend in browser design is the inclusion of metapages. This is usually a place in the browser's design that gives you access to

Figure 4-5. Netscape Navigator includes a toolbar button called "Net Search." When you click, it takes you to a screen that has five search engines available, with one of them randomly displayed. Here the Magellan search engine is available, but if you wanted to use another one, they are just a button click away.

more that one search engine from the same place—usually with just one click of the mouse button. Netscape Navigator's current version includes a "Net Search" button that, when clicked, takes you to your choice of thirteen different search engines. This is a good place to start if you have this kind of browser. If not, take a look at the sidebar on page 104 that lists the URL's for many popular Internet search engines.

Yahoo!

Yahoo!, despite its somewhat silly name, is the Honda Accord of search engines; it is the search engine that all of its competitors compare themselves with. It uses a contextual search mode, so you should be specific when searching for a particular Website; searching "photography" is not enough. Instead try "art photography" and see what happens. When I did, here is what I found among the first twenty-five Websites that Yahoo! located.

- William Henry Jackson: an online bibliography of photography, books, and multimedia resources.
- Eadweard Muybridge: innovative stop-motion photography, re-animated with Macromedia ShockWave. (You'll find more information about ShockWave and similar plug-ins in the next chapter.)
- Haaland Showcase for Photography, Art, and Music: showcasing new and emerging artists, photographers, and musicians.
- Robert Free—Grafman's Gallery: 3D Virtual Reality world displaying original art and photography.
- Scott Petill: photosurrealistic computer art, photography, sculpture, and drawings.
- New York Web Expo: features photography and art exhibits as well as multimedia documentaries.
- Daguerreian Society: dedicated to the history, science, and art of the daguerreotype.
- *Communication Arts* magazine: creative hotspot for graphic design, advertising, photography, multimedia development, illustration, art direction, from the world's top visual magazine.

This example does two things: it shows the breadth of information about photographic art that is available on the WWW, and it shows the weakness of contextual searches. The last entry contains both the words, "art" and "photography," but while *CA* is a fine publication, it is a

Figure 4-6. Yahoo!'s home
page (http://www.yahoo.
com) looks like this when
viewed with Netscape
Navigator. It has its own
family of products, including
a children's version called
Yahooligans and a print
magazine called *Yahoo Life*.

design-oriented publication, not a fine arts one. To overcome the
limitations of contextual searches, Yahoo! includes another search
window at the bottom of first twenty-five home pages listed. When you
see the possibilities, you might want to change them and re-search using
another combination of words. When I tried "fine arts photography,"
I had a list more focused on the subject of art photography.

Yahoo! features inoffensive on-screen advertising that keeps the
service free. The search engine is fast and responsive, and displays its
bounty in a clear, readable form. It the first place I start, but not
necessarily the only search engine I use.

Lycos

Almost as popular as Yahoo!, Lycos sports what I feel is a more attractive
interface. The search interface offers two choices: contextual and one
that could loosely (fuzzily) be called fuzzy. You can access this second
mode by clicking the "customize your search" link, below the area
where you would normally type in your contextual text information.
Clicking the link takes you to another screen that gives you (what may
be for many users) too many choices. Under the place to enter your text
there are two pop-up menus: the first lets you vary the number of
matches to the text you entered from match all terms to match up to
seven terms. The next menu lets you specify how literal a match you
want from "loose" to "strong." The next two menus allow you to specify

how you want the results of your search displayed: you can display from ten to forty results per page and they can be in summary or detailed form. Entering "astrophotography" for a loose match brought up 737 locations. By the way, when the same term was entered into Yahoo!, it only found seven URLs. Given the fact that there is always some redundancy in the way that search engines display—sometimes they show more than one page from a Website as an entry—that is still a significant difference in results. Here are a few of the results it showed along with Lycos's assigned relevancy factor.

- Re: Astrophotography. Patrick Newton (**pnewton@Gateway. Uswnvg.COM**) Wed, 11 Jan **http://www.netsys.com/mapug/ JAN95/0095.html** (4k) [100% relevant]
- mapug: Re: First attempts at astrophotography. John Fraser (**jfraser@fox.nstn.ns.ca**) Wed, 14 Feb 1996 18:18:52 -0400 (AST) Messages **http://www.netsys.com/mapug/feb96/0215.html** (6k) [98% relevant]
- Re: Astrophotography. Stephen Edmondson (**steve@iris.c-chem. siu.edu**) Thu, 12 Jan **http://www.netsys.com/mapug/JAN95/ 0104.html** (4k) [97% relevant]
- MEADE_USER: Re: Astrophotography Scope, John Persichilli (**johnp@enet.net**) Wed, 16 Aug **http://www.netsys.com/ mapug/AUG95/0316.html** (5k) [97% relevant]

Magellan

Magellan is another popular search engine that allows some flexibility in searching. While based on a contextual search, it includes an option to only search sites that the Magellan staff has researched and rated—instead of just kicking back word matches. When it finds a match it displays the number of pages of information found—by page number—allowing you to do your own nonlinear search of the Websites located. Even when doing a "nonrated" search, Magellan displays the ratings using a five star system, next to the Website information. Instead of just repeating information provide by the Webmaster, all rated sites includes information from the ratings reviewer giving more detailed insight into the quality and content of a site than you normally get from a search engine. This makes it easier for the new Web surfer to check out a sight with a high rating instead of spending their time, and money, looking through less than useful Websites. In addition to the rating system, Magellan, like Lycos and other search engines, assigns a relevancy

Figure 4-7. Lycos's search engine provides a way of refining a search and providing more than a simple contextual search. You can vary the search by the number of matches and the specifics of the match, along with how the results are displayed.

number by percentage of conformity to your search criteria. Although this is a feature of all search engines, I find most less useful than Magellan's in terms of performance of their rating systems. Most search engines have a general photography category and on the day I accessed Magellan's here's what it displayed.

- 24 Hours in Cyberspace, Review: the frontier of cyberspace is the focus of this project by Rick Smolan and his team of over one hundred photographers and online artists worldwide. What does it mean to be "wired"? How are human beings using the Internet to enrich their lives? **http://www.Cyber24.com/**
- Ansel Adams: Fiat Lux, Review: Fiat Lux is an online exhibition which contains photographs of the University of California by Ansel Adams. The exhibit contains a brief introductory essay, "About Ansel Adams." **http://www.book.uci.edu/AdamsHome. html**
- Art Online, Review: at present, Art Online offers a collection of images titled *Five Artists: Five Approaches to the Web,* a group show of HTML, conceptual art, painting, and photography. The artists Richard-Eric André, Susan Litecky, Will Greenspon, Susanne Oellinger, et al. **http://interport.net/~jimtuite**
- Black Star, Review: Black Star is a company that specializes in photography for corporations and others in need of photography professionals. Users can find out about Black Star, as well as browse a large collection of stock photography.

Figure 4-8. Magellan offers the useful option of only searching sites that it has rated and reviewed. This can dramatically cut down on the number of home pages that are displayed during a search.

Crawling the Web

Like everything else on the Internet, the number of search engines varies over time as new ones are added and old ones are improved. To help you get started with your own searching, here's a quick overview of some of the search engines that I am familiar with:

Accufind: **http://nln.com**

Alta Vista: **http://www.altavista.digital.com**

Byte magazine: **http://www.byte.com**

CiNet's ShareWare.COM: **http://www.shareware.com**

DejaNews: **http://www.dejanews.com**

The Electric Library: **http://www.elibrary.com**

Excite: **http://www.excite.com**

IBM InfoMarket: **http://www.infomarket.ibm.com**

Infoseek Guide: **http://info.infoseek.com**

LYCOS: **http://www.lycos.com**

Magellan: **http://www.mckinley.com**

Open Text Index: **http://www.index.org**

Point: **http://www.pointcom.com**

Starting Point: **http://www.stpt.com**

Web Crawler: **http://Webcrawler.com**

Yahoo!: **http://www.yahoo.com**

A Few Final Thoughts on Search Engines

The biggest question that most Internet newcomers ask about search engines is which one is the best? Answering a similar question about camera systems is much easier. You ask a few question about how the person plans to use the camera: ask what focal length lenses are important; find out if they need leaf-shutter lenses; determine the importance of format, interchangeable backs, and close-focusing accessories; and you can make an educated recommendation. Even though most European and Japanese manufacturers have accelerated the level of technical advances in the past few years, nothing compares with the light-speed advance of technology associated with the Internet. The best search engine? That is a much more difficult task. The people who operate search engines are rushing forward with changes that occur on a *daily* basis, and they are being pushed by the competition to be better and different. Nevertheless, I'm willing to stick my neck out and recommend Yahoo! It's one of the older search engines, and I like the way it displays it's searches. It also seems to find more locations than the others; but I still use other search engines because more often than not, they turn up Websites that Yahoo! (for some reason) doesn't know about. That's why I like Netscape Navigator. At the touch of a button, its Net Search feature provides access to many different search engines.

What you have just read is an introduction to search engines and how they work. I've provided a few examples, but the best way to find out which one you prefer is to use the URLs in the sidebar to give each search engine a visit. Be careful not to write off a particular engine if you aren't happy with part of its interface. Nobody's perfect. Visit it occasionally; you may be surprised at the changes that have been made since your last visit. I was. During the several months that this book was being prepared, all of the search engines included in this chapter were improved—some dramatically. Like improvements in film emulsions, which are just a tool for photographers, improvements in search engines are improvements in tools to help you find what you're looking for on the Internet or World Wide Web.

5 Websites You Shouldn't Miss

Toto, I don't believe we're in Kansas anymore.
—Dorothy Gale in L. Frank Baum's *Wizard of Oz*

In this chapter, I want to introduce you to some home pages that are of particular interest to photographers. At the time I wrote this—and this number has surely increased by now—the Infoseek search engine showed that there were 21,466 Websites that contain the key word "photography." So that you won't have to look at every one of them, I have prepared a guide to photography home pages on the Internet. This should be considered a highly subjective look at Websites—comparable to movie reviews—of special interest to photographers. The sites were selected for the same reasons that a movie may appeal to one reviewer but not another. Siskel may love it, Ebert may give it a big thumbs-down. I have given all of these sites a thumbs-up, not for their great design or graphics—some are downright plain—but on the basis of usability to the professional photographer. That benefit may be in the form of information about a product, tips on creating digital or silver-based images, or—in one case—a source of information on outdoor shooting locations.

Since there are many aspects of photography, I have tried to cover as many of them as I could but there are some that may be lacking. If

you are interested in forensics, photomicrography, or astrophotography, you will be disappointed in my selection. So use the search engines described in the last chapter to find Websites that feature your specialty!

You will also not find Websites for the major film and camera companies. As photographers, we often become possessive about our cameras and films to the exclusion of others, and my inclusion of information about a Kodak or Fuji home page seems both too personal and redundant. But rather than throw you to the search engine to find the Agfa home pages, I've collected the URLs for many photographic camera and film companies in a sidebar. No content is provided, but having the addresses will save you time in looking them up. If you are interested in information that will help you take better photographs, a camera company's Website may not be the most objective. While you can get the specifications on the F5 from Nikon's home page, you may find field tests and hand-on testing in one of the recommended Websites, like *HyperZine*. Likewise, there are no camera stores or mail-order dealers listed in this chapter. We all have our favorite companies that we prefer to deal with, and rather than show any preferences, none are listed. To locate the home page for the many camera and film dealers that have Websites, use your trusty search engine. Modesty prevents me from including the Website for a magazine that I am widely identified with, but *Photo>Electronic Imaging* (formerly *Photomethods*) magazine does have a great Website and you should check it out at **http:// peimag.com.** Lastly, I have tried to find some Websites that can easily be compared to that "great little restaurant that's hard to find." So, mixed in with some sophisticated home pages with great graphics, you will find some that make up in content what they lack in panache.

A word of warning is due here. Because of the democratic nature of the Internet, there are many home pages that were created by individuals, not manufacturers or retailers, that contain a combination of uninformed opinion and bias about particular equipment or film. Within the WWW format, this can easily be passed off as fact not opinion. When using search engines to develop the manufacture's sidebar, I was sidetracked by a home page that was supposed to contain a comparison of two leading camera manufacturer's products. What I found were some nicely prepared charts comparing many out-of-production models, coupled with fanlike (and biased) enthusiasm for one of the manufacturers. Yes, the Internet and World Wide Web contains information, but there is a difference between opinion and fact

and often the line between the two is blurred by the way that information is presented. No sites of this type are listed below, and my advice is included only as a general warning that, when bouncing from Website to Website, it's easy to get lost. Information, as I have stated before, is not wisdom. *Caveat Wilsoni*—let the surfer beware.

Photography and Imaging Manufacturer Websites

The following is a list of many camera and film manufacturers that currently have Websites. There may be more—there probably are more—but I was unable to find all of them due to limitations of time and the sheer size of the World Wide Web. If your favorite equipment manufacturer's home page is missing, drop me an e-mail message and I will be sure to include it in the next edition, along with thanks to you for helping.

- Agfa digital imaging (scanners, digital cameras, etc.): **http://www.agfa.com**
- Agfa film and conventional imaging products: **http://www.agfaphoto.com**
- Bender Photographic, Inc.: **http://www.cascade.net/~jbender/index.html**
- Bogen Photo: **http://www.bogenphoto.com**
- Bronica: **http://www.tamron.com**
- Paul C. Buff, White Lightning: **http://www.edge.net/buff**
- Canon USA: **http://www.usa.canon.com**
- Canon Computer Systems: **http://www.ccsi.canon.com**
- Chimera: **http://www.chimeralightning.com**
- Dicomed: **http://www.dicomed.com**
- Eastman Kodak Company: **http://www.kodak.com**
- FUJI Imaging & Information (digital imaging): **http://www.fujifilm.co.jp**
- FUJI Filmmaterialien (Germany): **http://www.fotoline.ch/firmen/fuji/fujifilm.htm**
- Fuji Photo Film USA: **http://www.fujifilm.co.jp/usa/aps/smartcity**
- Fujitsu: **http://www.fujitsu.com**
- Konica Corporation: **http://www.konica.com**
- Leica: **http://www.leica.com**
- Minolta: **http://ny.frontiercomm.net/~minolta**
- Nikon: **http://www.klt.co.jp/Nikon** (provides pathway to information

from both photo products division and electronic imaging division)

- Novatek (enlarger timers): **http://www.foothill.net/~novatek/**
- Olympus Camera: **http://www.plus.at/olympus**
- Pentax Corporation: **http://www.pentax.com/645.htm**
- Polaroid: **http://www.polaroid.com**
- Ricoh: **http://www.ricohpg.com**
- Scitex: **http://www.scitex.com**
- Sinar-Bron: **http://www.wowdigital.com/sinarbron/sinarbron.html**
- Sony: **http://www.sony.com**
- Tamron/Bronica: **http://www.tamron.com**

Ten Top Photography Sites

After I got started on this quest, I realized that a "ten best" might not be enough. So I grouped what I felt are the best and included an honorable mention section at the end. The top-rated sites are listed in no particular order and are grouped by type. I also recommend that, since at this point you should already be doing some cursory Web surfing, you make a note of the URLs of the sites listed here and visit them—even if you are not interested in the topic. Why? Now is the time when you should be looking at what photography Websites look like and how they work. Don't compare yourself to home pages created by Microsoft or Netscape, using teams of programmers working night and

Figure 5-1. Fuji's Website uses a city analogy (much like Apple Computer's late, lamented e-World) to help you navigate through information on its film, cameras, and digital imaging services. If you're looking for information about Fuji film and products, this is the place to start.

day. Most likely your own resources will be more modest. So the best place to see what can be done in your chosen field is to scope out what other photographers and photo related companies are up to.

Information

As is often mention on *The Prisoner*, "I want information." Patrick McGoohan's cult TV series was made well before the Internet had developed into what it has become today and, if it were available, his character would have used the WWW to look for information. The Internet contains a wealth of information about many subjects—including photography. Some are created by equipment and camera manufacturers and some are private enterprises—webzines, if you will. All provide a way for today's photographer to keep up to date with both digital and silver-based technology.

Link Pages

Some Webheads are preoccupied with the need to create link pages. A link page is a Website that contains links to other Websites and is often grouped by category. I don't know what compulsion leads individuals to do this, but their hard work in seeking out, listing, and posting links by specific subject is largely an unappreciated task. To reward these un sung heroes, I would like to include two—it's a tie—in my "ten best" list.

- *Online PhotoWeb* [http://www.Web-search.com/photo.html] This link page contains links to other pages and is grouped by photographic specialty. Right now link groups include: Commercial Photography, Personal Photography, Photo-journalists, Scenic, Travel, Sports, Collections, Clubs, Schools, Products, Equipment Repair, Photo Finishers, Cameras and Film, Digital Imaging, Resources, Digital Photography, Imaging Software, Commercial Graphics, Design, and How To. What is more, the site includes links to obtain freeware, shareware, and demo software, related to digital imaging and photography.
- *Photography and Digital Imaging Resource* [http://www.best. com/~cgd/home/pholinks.htm] This is a collection of links by photographer Charles Daney. His philosophy about link sites is that "just like the images one makes, [a link page] is a reflection of one's own interests and tastes, so this is not intended to be an exhaustive listing. You may find it useful, to the degree you share

these interests and tastes." The pages open with one of Daney's dramatic landscapes but his modesty precludes him from having "the effrontery to list my own Photography Pages in the Outstanding Sites section." Nevertheless, he provides a link to his personal page, just as he does other photographers.

Like any good link page, new Websites appear all the time, of course, and Daney states that he is actively looking, enough so that the list is updated weekly. My advice is that you make this page, along with Online PhotoWeb, one of your first stops when Web surfing for photography home pages.

Travel Photography

Photo Traveler On Line [http://home.earthlink.net/~photo-travel] If you're looking for the answer to those age-old questions: where to go? when to go? what to photograph? Looking for new outdoor-oriented stock or assignment locations? This is the Website you should start with. This is the home page that helps you discover the best places to take pictures in North America with travel guides written especially for photographers. The Website is the online home of the publisher of *Photo Traveler Newsletter* and *Photo Traveler Guides* that cover national parks, scenic areas, wildlife locations, slot canyons, and little-known areas. *Photo Traveler* has been publishing information on photo opportunities since 1985 and there's a lot of material available, including:

- *Photo Traveler Newsletter*: one of the best sources for finding exceptional places to take photographs, updates to guides, reviews of information resources and a listing of hundreds of upcoming photo tours. Back issues are also available.
- *Photo Traveler Guides*: detailed photo travel guides to national parks, scenic areas, slot canyons, and wildlife compiled from previous issues of *Photo Traveler Newsletter.*
- *Photo Traveler Field Notes*: short articles, updates on photo destinations, and information resources contributed by readers.
- Index to Publications by National Parks, Scenic Areas and Wildlife Subjects: If you've been looking for a particular subject or place? Go to the index to find what you need.
- *Photo Traveler On Line:* includes guides to the Canadian Rockies, Banff National Park, Glacier National Park, Monument Valley,

Redwood National Park, Tucson and the Sonora Desert, and Yellowstone National Park.

Digital Imaging

The Web is the perfect place to find information on digital imaging. The equipment manufacturer's sidebar includes the URLs of popular camera and electronic device companies and previous chapters have included information of photofinishers and service providers, such as Seattle FilmWorks.

MetaTools [**www.metatools.com**] Let's face it, Kai's Power Tools and the digital imaging products that they spawned have changed the face of all—not just digital—imaging. This is due in large part to the vision of Metatools (formerly HSC Software) and one of its founders, Kai Krause. Krause and his team of software designers are always coming up with something new, and that's the main reason you should stop by their Website for an occasional visit. Here's what you will find when you do.

The MetaTools Website contains all the information that a user or potential user of their software could want. All of the elements that you would expect to find on any commercial entity's home page are here along with a few surprises. There are Product Overviews (in English and German), a gallery displaying digital images created by Kai Krause as well as MetaTools product users, and FAQs about their products and product line. But one of the most useful aspects of the home page is its educational content. In the section called MetaTools University, you will find twenty-three of Kai's Power Tips for Macintosh and twenty for Windows. These are basically tips and techniques for using Kai's Power Tools with Adobe Photoshop and have been written in the breezy yet informative style that is Kai Krause. Webheads will also find the nine (at this time) World Wide Web and Multimedia Tips that are posted. There is also information on MacSummit at the University of California, Santa Barbara, as well as on Washington DC's renowned Corcoran School of Art, whose students are exploring the digital world with KPT Bryce. MetaTools is involved in the "MetaCommunity;" for example, it recently sponsored the Teen Digital Movie Making Contest. Results are available on its home page.

Kai's Power Tools was the foundation of MetaTools and many, many companies make Photoshop-compatible plug-ins that readers of this

Figure 5-2. The MetaTools Website is a combination of product information and how-to tips for users of Kai's Power Tools and all of the other products created by the company. It has news, images, and everything you ever needed to know about MetaTools (formerly HSC Software) digital imaging offerings.

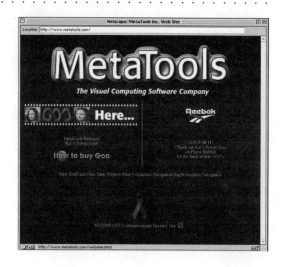

book will find useful. MetaTools Net surfers looking for more information on plug-ins should check out Werner D. Streidt's home page at **http://www.teleport.com/~ccox/plug-ins.html**. Mr. Streidt is a young German gentleman (that's why they call it the World Wide Web) who has created an interesting link page. In this case the links all relate to third-party plug-ins that can be used with Adobe Photoshop. The most popular cross-platform standard was created by Adobe Systems for Photoshop, but compatible plug-ins can be used with other image manipulation programs including U-Lead Systems' PhotoImpact 3.0, Fractal Design's Painter, PixelPaint Professional 3.0, Macromedia's xRes 2.0, and Live Picture 2.5. I consider Werner D. Streidt's home page an Honorable Mention and give it a big thumbs-up.

Art and Publishing

Twin Palms [http://www.sfol.com/sfol/books/palms/twinpalm.htm]
Since photographers do not live by technology alone, I've found it's always a good idea to recharge your batteries by spending time turning the pages of a good photography book. Not a book about the nuts and bolts of photography, but one that shows the work of a particular photographer or genre. If that describes you too, I urge you take a look at Twin Palms–Twelvetrees Publishers' home page. In 1995, Twin Palms published its fifty-fourth book. These were not namby-pamby books with pictures of cute kids and dogs. No, these were cutting-edge: often sexual imagery was combined with the finest book craftsmanship available. Some of their books were condemned as pornography while

others were celebrated as classics. Here's what the critics have to say: "Twin Palms has produced the year's most deluxe photography books, calm in design and voluptuous in content"—*The New York Times Book Review*; "Twin Palms has succeeded in bringing a number of unlikely books to the foreground of American art book publishing"—*The Print Collector's Newsletter*; "Twin Palms developed out of a commitment to extraordinary artistic quality"—*Publisher's Weekly*; "Perhaps the biggest success story in the field of art book publishing during the last decade"—*Photo Design*. Whatever you can say about their books, they're not boring. High quality papers, printing, and award-winning design assure the long lasting value of each volume. Some of the books posted on their Website the last time I was there include:

- *F. Holland Day, Suffering the Ideal* by James Crump. During his short-lived career, nineteenth-century artist F. Holland Day moved to the forefront of American photography with his portraits and nude studies. Crump offers insights into his activities as a publisher and photographer.
- *Lengthening Shadows Before Nightfall* by John Dugdale. From the muted blue luster of his cyanotype prints, Dugdale's imagery emerges in a mist of loss and remembrance, invoking a world of light-filled chambers and sensuous bodies.
- *Drew & Jimmy* by John Patrick Salisbury. Salisbury has relived the past vicariously, photographing his two cousins. The result suggests nothing less than a Gothic portrait of rural boyhood.
- *The Last City* by Pablo Ortiz Monasterio. The artist chronicles the distinct character of urban life in Mexico City. Working in the tradition of committed documentary image-making, Ortiz Monasterio reveals the fragmentation of the "last city" of modernity.

Clicking on any of the listings gives a detailed explanation of the book's contents and often includes excellent-quality scans of some of the images in the books.

Photography Products and News

HyperZine [http://www.hyperzine.com] *HyperZine* is a combination of the traditional photographic magazine with the best of interactive technology that the World Wide Web allows. A creation of Lancelot L. Braithwaite and Lawrence R. White, *HyperZine* was designed "for

cyberspace from the ground up." They like to think of the e-zine and as, according to White, a "living work, constantly changing as new products are introduced, and as our knowledge base changes."

HyperZine's basic appeal is shared by other Webzines. There is no waiting for monthly issues. The editor and staff post new information as they gain experience or when additional information about a subject, product, or technique becomes available. One of my favorite aspects of the e-zine is that it provides multiple points of view. *HyperZine's* digital pages include information from their contributing writers—many of whom are our world-renowned experts—plus information from the manufacturer and readers. There's a direct feedback through an e-mail system that allows readers to leave messages for the writers. Right now the writing staff includes Mason Resnick, Tim Wetmore, Stan Pinkwas, Tim Liebe, and Cliff Roth. One of the best features of *Hyper-Zine,* compared to conventional print media, is that it features a relational database, which guides you through the catalogs to find a subject or product that you are interested in, and displays the relevant articles.

HyperZine is edited by Elinor Stecker-Orel, former managing editor of *Photomethods* and former senior editor of *Popular Photography*. Elinor has been writing about photography, film, and video for many years. She is the author of *Slide Showmanship,* about putting an end to boring slide presentations, *How to Create High-Contrast Images,* a book on the creative uses of litho film, *Trick Photography,* a fun book on special-effects techniques, and other books on photography. Her photographs have appeared in magazines, posters, and books and she often shoots video and stock photography with her photographer/videographer husband, Mano. Now this classy lady is at the helm of *HyperZine*—a new breed of photo magazine.

Technical

Darkroom On-Line [http://www.sound.net/~lanoue/] This Website's goal is to provide an information resource for darkroom enthusiasts and photographers. Darkroom On-Line is maintained by Dr. Darkroom himself, Mike Fuger, and although it is sponsored by Ilford's Midwest District Sales Manager, it is not an official Ilford site. As the Doctor, states "we just like Ilford products."

Unlike other Websites, they provide information that helps you view it better. For example, they include information on monitor setup. The

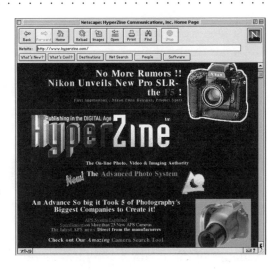

Figure 5-3. The look of *HyperZine*'s home page is even reminiscent of a traditional photographic magazine with headlines proclaiming the latest innovations in traditional and electronic imaging technology. By the time you read this, the Advanced Photo System and Nikon F-5 may be old news, but the day I made this screen shot it was "hot news."

site has been designed with screen resolution set at 640 × 480 and 256 colors so that images and graphics will load as quickly as possible. Netscape 2.0 was used to design the site and the Doctor recommends that it is best viewed by going to the options menu and deselecting Show Toolbar, Show Location, and Show Directory buttons to free up screen space. Photographers using a text-only browser might find viewing documents using tables to be impractical.

Darkroom On-Line includes many different areas covering many different topics of interest to the darkroom worker. Here's a sample:

- The Black-and-White Darkroom
- Black-and-White Film Chemistry
- Black-and-White Products
- FAQ Darkroom Tips Common to Color and Black-and-White
- Converting Film Developer Times for Different Temperatures
- Optimizing Your Exposure Index and System Development Times
- Directory Document for Home-brew Black-and-White Formulas
- Darkroom Home-brew Cookbook by Keith Dowsett
- FAQ Tips on Black-and-White Film Processing
- FAQ Tips on Processing Black-and-White Film
- FAQ Tips on Black-and-White Special Techniques
- Building a Darkroom
- The Color Darkroom
- Glossary of Photographic Terms and Definitions

The above list represents less than 20 percent of what can be found

in *Darkroom On-line.* If you're a darkroom worker and would like to know more about film, paper, and chemistry—especially Ilford's products—this is the place to be.

Commerce

The World Wide Web can be a source of business referrals, too. Tying for the best commerce-oriented Website are: Photographers On the Net and Professional Photographers on the Web.

Photographers On the Net [**http://www.mindspring.com/~jdsmith/plist.html**] This Website is maintained as a personal service for photographers on the Internet. Its intended use is to foster the exchange of information and ideas among photographers. According to the Webmaster, "inclusion of a photographer in this list is *not* an endorsement of the quality of their work nor is it a recommendation of any services they may offer. Furthermore, no claims are made as to the correctness of the information provided nor is there any guarantee that submission of information will result in its inclusion here on this list. I also reserve the right to limit the amount of information added to the list or do away with it entirely if storage space and/or communications bandwidth limitations arise." Here's an example of the information you will find.

- Name: John Doe
- E-mail Address: jdoe@anywhere.com
- Primary Photographic Specialty/Interest: Commercial
- Secondary Photographic Specialties/Interests: Fine Art, Landscape, Portraiture
- Experience Level: Serious Hobbyist (serious amateur but never works as a paid photographer), Semi-Professional (occasionally works as a paid photographer; earns less than 20 percent of income from photography), or Professional (full-time occupation; earns greater than 20 percent of income from photography)
- Geographical Region: Portland, Oregon
- Company: Doe's Studio
- Phone: 123.456.7890
- Home Page: http://www/doesstudio.com

Professional Photographers on the Web [**http://www.mindspring. com/~jdsmith/plist.html**] This list of professional photographers—

unlike many found on other home pages, where only pros are allowed to be listed—is being provided by the Webmaster as a complimentary service to the photography community. Their caveat: "This listing should not be interpreted as any form of endorsement or recommendation as to the quality of the services offered or the accuracy of the information provided. But hey, at least you can view most of their portfolios online and make an informed decision for yourself." What they provide is basic information about a photographer, including a URL for their Website location.

Here's an example of what a listing looks like:

- Charlton Heston Photography
- Specialties: Corporate executives , stock, industrial, architectural, and catalog photography.
- Location: Boca Raton, Florida
- http://www.michaelangelo.com

My recommendation is that you register with both of these sources—especially if you have developed your own Website. Developing your own home page is easier than you think and will be covered in an upcoming chapter.

Figure 5-4. Professional Photographers on the Web is an online directory of commercial portrait and wedding photographers that potential clients can access when looking for a photographer in a specific location. For the pro who already has a Website, this is similar to having a free listing in a photographic source book.

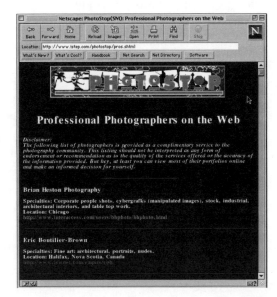

Experimental

Omniview [http://www.omniview.com/viewers/viewers.html] I've always been a fan of the OmniMax theater in Caesar's Palace in Las Vegas. If you've never experienced OmniMax it is different from large screen IMax movies, because the films are projected on a full 180-degree domed screen and you sit, recline actually, in a seat that gives you a view that almost fills your field of vision. Experiencing a similar effect is what OmniView and PhotoBubbles are all about. That's why you should check out this Website.

PhotoBubbles are spherical photographs. PhotoBubbles capture the entire contents of any location in 180- or 360-degree immersive representations that can be reproduced for viewing on a computer. This interactive photography technique allows the user to be immersed inside a 360-degree digital image representing any environment that can be photographed. The user, via a mouse or keyboard input, is able to navigate in any desired direction in the interactive photograph, magnifying or exploring any part of the image. PhotoBubbles provide a virtual visual experience for a customer, student, or game player. PhotoBubbles offer advantages for viewing the inside of homes (real estate), the inside of resorts (travel agencies), the inside of museums and galleries, the inside of vehicles (cars, boats, mobile homes), experiencing remote sights (national parks, monuments, scenic locations), or even rendering places that don't exist for an immersive experience. Specific examples of applications include new sales communications for pages on the World Wide Web, creation of CD-ROM product catalogs and tours, and interactive broadcast services where the viewer picks the angle of view.

PhotoBubbles can be taken with a standard 35 mm camera attached to a fisheye lens, including the 8 mm Nikon (180 degrees) or 8 mm Sigma (180 degrees). The film is processed and electronically scanned to create a digital file. The digitized images are then processed to properly remove distortion and correct the perspective as the PhotoBubble is viewed. A unique file is created that can be interactively viewed by the user. A single fisheye shot can capture a hemisphere (180 degrees) or a sphere (360 degrees) which is created from two opposing shots. An appropriate fisheye lens (see above) is a must. If you want to create total spheres, a rotator is available from Omniview. This custom-made fixture mounts to a standard tripod, assuring that the images are precisely captured. Once the images are captured, Omniview provides

all the necessary processing of the images, returning a set of digital PhotoBubbles for your use.

Creating PhotoBubbles involves three distinct aspects:

1. Photography costs range from free (you shoot) to several thousand dollars per day for high quality studio-based photography. Omniview charges an average of $2,000 per day for its photography services. If you plan to do your own PhotoBubble photography, you need an 8 mm 180-degree Nikon lens and OmniView's patented rotator. Rotator cost: $500, Lens and rotator rental: $100/day or $500/week, PhotoBubble Photography training: $1,000 (one day at Omniview).

2. Post-processing costs range from a few hundred dollars per bubble to a few thousand per bubble depending upon factors such as complexity, volume, and the kinds of "bells and whistles" included with your bubbles.

3. Distribution costs range from free for Internet bubbles (by linking to their Website to download the viewer) to several thousand dollars for published titles, depending upon the breadth and depth of bubble usage and use of Omniview integration tools.

There are no resolution limits inherent to PhotoBubble technology itself; however, there are practical developer and user considerations involved. Photography using a film-based camera provides far greater resolution possibilities than many of today's digital cameras. If film-based cameras are used, certain decisions must be made as to what resolution to digitize the image at during the scanning process. The greater resolution you select, the larger the file size, which proportionately increases storage space used, downloading time, and the viewing machine RAM requirements. Each of these variables impacts the total image quality. At this time, reasonable performance is obtained from the 486, Pentium, 68040, and Macintosh PowerPC platforms. The responsiveness is directly affected by the size of the window on the screen (smaller is faster) and the image file size.

If you want to just view PhotoBubbles for yourself, go to the Website and download PhotoBubble Viewers plug-ins that will allow you to experience any Omniview destination with Macintosh or PC platforms. These viewers can be downloaded free of charge and configured for your system. Netscape Navigator 3.0 plug-ins are available for Windows 95 and Macintosh PPC.

WJ's Home Page [http://www.a1.n1/phomepag/markerink/ mainpage.htm] "It being now evident that there was a refraction of rays coming from the sun, which though not fit for vision, were yet highly invested with a power of occasioning heat, I proceeded to examine its extent as follows." This quote from William Herschel, upon the discovery of the "thermometrical spectrum," opens the innocuously named WJ's Home Page. What this Website contains is "everything you always wanted to know about" infrared (IR) photography—both black-and-white and color.

Many photographers, maybe even most, are interested in infrared photography, but they have always been stymied by the lack of real-world information on the nuts and bolts of actually using this stuff. WJ's Home Page takes the mystery out of it by providing information on the hardware and film (software) that WJ uses to create black-and-white and color infrared images. Like many low-key homes pages, WJ's approach is folksy and includes information about the optical gear he personally uses, including his thoughts on the ideal camera. The Web pages contains items for sale, such as some special and rare IR filters! But then he gets down to specifics by providing information on how you can develop Ektachrome IR in C41 chemistry, how to process Kodak HIE film in T-Max and T-Max RS, and how to develop Kodak HIE as a 1600 Exposure Index slide. Experienced darkroom workers will be interested in the section that explains how to process Konica 750 IR and Kodak HIE in Agfa's Rodinal film developer. Other sections include explanations on how to get a preview of the IR effect on black-and-white film and how to get better results with Kodak HIE by using pyro developers. Since filters are a big part of infrared photography, he includes spectral data for Wratten IR filters (#3 and #87A) and a comparison table for several other brands, such as Schott, B+W, and Heliopan.

The home page also has some infrared caveats and warns about which Canon EOS bodies can cause problems with infrared film and why some modern Minolta bodies also cause problems with Kodak HIE. An apparent problem with infrared photography is focusing. That's why WJ includes a note on focusing for IR and UV, for different lens designs—simple lens, achromat, apochromat, mirror. Since infrared products are still being introduced, albeit more slowly than conventional film, you'll find an introduction to Ilford's new infrared film: Ilford— SFX-200— along with a look at IR film sizes. And like any good Website there are links to other sites, some of which are about infrared.

Photographers

There are many photographer's sites on the World Wide Web and picking one as the best wasn't easy. The one I chose was not selected because it has the best photographs. The images are interesting but there are other Websites with photographs that are as interesting. This Website was chosen because of its unique combination of design, functionally, and—the factor that sets a good photograph apart from an ordinary one—impact. Stacy's Home Journal has impact combined with a level of interactivity that I think should be the goal of every photographer's site.

Stacy's Home Journal [http://www.users.interport.net/~sr/ etc.html] Stacy's Home Journal is an example of what a simple, yet elegant, photographer's home page can look like. I urge you to visit it because it's time you got a look at a real photographer's home page. Stacy Walsh Rosenstock's home page contains several images and an excellent interactive design that lets you move between its three major areas: images (her own), photo sites and resources, and New York on-line—a page of links to sites related to the cultural scene in the Big Apple. You might consider this a link page with an emphasis on image making contrasted with sites concerned with the technical aspects of photography. She has managed to round-up more photo-related sites than any other place on the Web. Check it out! Currently her major categories include: events, resources, other photographers' Websites, on-line publications (more about Webzines in a page or so), exhibitions, organizations, commercial sites, educational sites, government sources, newsgroups, and e-mail lists. What's great about this site is the eye-appealing design and the way that clicking on something—not a button, but often an image or just some attractive text—takes you to another part of the site. For example, clicking on her e-mail address text sets up your browser to send her e-mail, while clicking on her name gives you the equivalent of an "About Stacy" page, where you will find that as a photographer, the Webmaster freelances for the *New York Law Journal* and places her work with the Photoreporters agency. She even gives you some insight into how she created the home page: "The images were scanned with a Nikon Coolscan and cleaned up with Adobe Photoshop." That's about as technical as it gets. Stacy's Home Journal combines a level of elegance and interactivity that belies it apparent simplicity. If your Website ends up looking as great and

working as well as Stacy's Home Journal you will have accomplished
something.

Honorable Mention

The first two honorable mentions may have something to do with the
fact that I'm a bit of an anglophile, but I can't resist a photographic
organization that, at 143 years of age, is almost as old as photography
itself and has such a cool coat of arms. There is even a US–based affiliate,
located on the West Coast.

The Royal Photographic Society [http://www.rps.org] The Royal
Photographic Society (RPS) is open to everyone with a real interest in
photography—and that includes newcomers to photography, teachers,
historians, and scientists, as well as dedicated amateurs and full-time
professionals. It doesn't matter where you live. The Society has sixteen
regions in Britain, each with its own Regional Organiser and a full local
program of local lectures, workshops, and seminars. It also has members
in more than forty countries overseas, many of whom have their own
Society representative.

As a member of The Royal Photographic Society, you can work
towards internationally recognized distinctions—Fellowship (FRPS),
Associateship (ARPS), and Licentiateship (LRPS)—at your own pace and
in your own time but always with support and encouragement.
Scientists can also apply for a formal Imaging Scientist Qualification.
You can explore the work of the pioneers and pace setters of
photography; sharpen your own creative and technical skills and
techniques through workshops, master classes, courses, conferences,
meetings, and field trips; keep in touch with the technology that is
adding a twenty-first-century dimension to photography. You can also
stay up to date with the latest skills, techniques, and technological
advances through two highly respected publications, the *Photographic
Journal* and the *Journal of Photographic Science*.

You can follow your personal photography interests through mem-
bership to one or more Special Interest Groups. Members are
encouraged to join one or more Special Interest Groups as each has their
own newsletter, events, and meetings specifically aimed at their interest.
You may also be able to enter work for Group exhibitions or postal port-
folios. These Groups give advice and guidance on how to improve your
photographic skills. Groups include: Archaeology and Heritage, Audio

Visual, Color, Contemporary, Creative, Digital Imaging, Film and Video, Historical, Holography, Imaging Science and Technology, Medical, Nature, Pictorial, Travel, and Visual Journalism (photojournalism).

Royal Photographic Society of the Pacific [http://www. epicentre. co.uk/rps] Founded in 1853, the Royal Photographic Society of Great Britain is the oldest photographic organization in the world. RPS is also the only one which awards its distinctions entirely on the basis of a body of meritorious work in photography. Many US members of the Society felt the need for a West Coast chapter to enable members, not resident in Britain, to participate more closely in the society's activities and benefit from local programs. RPS-Pacific was set up in the San Francisco Bay Area with the purpose of promoting excellence in photography through education and co-operation rather than competition, and of providing a forum for discussion of members' work. On their Web page they state their goals as follows: "If you have already acquired and honed your skills either professionally or through participation in a camera club and want to prove yourself in a new and discriminating milieu, either by fellowship with other photographers or by entering for the RPS Distinctions (Associateship and Fellowship), RPS-Pacific may be the next step for you. Meetings take place following a buffet luncheon in a downtown conference room in San Francisco." Their Website keeps you up to date with the US affiliates activities and displays members' work—pretty good, too.

Webzines

Webzines or e-zines—call them what you will—are never going to replace *Playboy, Fortune,* or even the *Brighton Standard-Blade* any time soon. You can't take an e-zine to the bathroom with you and if you fall asleep under your laptop while reading the latest monkeyshines in *Primates Monthly* on the World Wide Web, you're liable to wake up with some dents in your physiognomy. Nevertheless, a Webzine, such as a hypothetical *Imaging Monthly,* offers some advantages over a conventional paperbound publication. There is immediacy. Late breaking changes in a new standard—like the introduction of the Advanced Photo System—could be rapidly updated depending on the latest information and rumors, without waiting the two or three months a print deadline normally imposes. Multimedia is another

advantage. Digital video clips can show a camcorder's performance and being able to download a digital camera's output will let you evaluate the camera's performance on your own computer's screen. Webzines are interactive. Readers can immediately respond to mistakes an author— or editor—may have made in a story on digital imaging techniques via e-mail, with no stamps to lick. E-zines are cool. That should be enough for most high-tech oriented photographers to check them out. Lastly, Webzines are here to stay.

There are many kinds of sites on the World Wide Web that answer to the name Webzine and even some sites that masquerade as Webzines. These non-mainstream Webzines include *Partners in Health* (**http://www.kaiserpermanenteca.org**), which is the official Website for Kaiser Permanente of California and is an interactive Webzine offering health and fitness information for teens, seniors, new parents, and adults. This might be thought of as an in-house Web publications for members of this HMO. Then there is *CyberGirls* (**http://www.cybergirls.com**, for those of you who were going to look it up in Yahoo! anyway) which is a thinly disguised pitch at online soft-core pornography. They call it a Webzine. Outside this area are those Webzines that appeal to a wider audience. Since Webzines may represent a new market for your images, here's a round-up of several e-zines with the URLs so you can see for yourself.

HotWired [**http://www.hotwired.com/frontdoor**] This online version of *Wired* magazine has an attractive design using a front page filled with subtle but sufficiently trendy graphic embellishment to make it fun to read. Like the best of the Webzine genre it is updated frequently and like any good magazine, there are feature stories and columns— and lots of colorful advertisements. The focus of the stories and columns are on technology, although that may encompass everything from Web browsers to digital camcorders. The columnists provide insight and gossip without the self-conscious drivel often found in *MacWeek*'s "Mac the Knife." You have a feeling that the information they are passing on is the kind of insider information you might hear if you were hanging out in Silicon Valley. There's politics here too, although the spin is decidedly on the high-tech side. The Website makes effective use of Netscape Navigator's frames, even though in a recent issue, columnist Jeffrey Veen stated "So why do I feel so empty inside? Here I am surfing the bleeding edge of browser technology, and I feel . . . well . . . like not

all that much has changed." Hats off to columnist Veen on taking a realistic position on the new Navigator that has received a reaction by some journalists similar to the Second Coming. Some of the regular columns include: "Club Wired" featuring live chat, scheduled guests, hot discussions; "Netizen," highlighting new political ideas; "Pop" which has arts and entertainment news, reviews, and features; and "Webmonkey," a service station for the wired world. This part of the Webzine's interactivity includes a real-time assessment and tune-up of your browser. The Webmonkey tune-up will test your browser for everything essential to the total Web experience. Right now, that includes frames, Java, and a few good plug-ins. For those who are caffeine-dependent, there are some Java animations but the overall impression of *HotWired* is one with an emphasis on content and interactivity—not frills.

Destination: Beer [http://www.n-vision.com/beertravelers] *Destination: Beer* is a Webzine devoted to the search for all the places in America serving flavorful beer. Like any self-respecting magazine, *Destination: Beer* includes feature stories and regular departments that are about the search for every establishment in the United States where men and women can enjoy flavorful beer. The feature stories here change monthly, the indexes are updated weekly, and your questions are answered in as timely a manner as the editor's travels allow. *Destination: Beer* is created and maintained by Stan Hieronymus and Daria Labinsky, two freelance writers who "brew beer, drink beer, and write about beer." In case you are wondering where the ads for Pig's Eye Beer are in this Webzine, the answer is that there are no ads. That's because the editors think that the entire Webzine is an advertisement for *Beer Travelers Guide*, a book they wrote. But the Webzine is more than an infomercial. For example, you'll want to check out the brew pub finder, which, the last time I checked, listed 703 brew pubs. Then there are the different departments, which include "Carryout Giants," those retail outlets with beers galore, "Walls of Taps," a listing of those bars with the biggest draught beer selections; "Single-Malt Friendly," some of these specialty bars that offer good beer and a good selection of single malts; and "Beer Festivals," a listing of these events. You can even nominate a bar and check out a good selection of beer links. *Destination: Beer* is the first place a beer connoisseur should stop on the World Wide Web.

STIM [http://www.stim.com] *STIM* (short for STIMulation—the concept of information as a drug) is free, they provide all plug-ins that you need to view their pages, along with human-friendly instruction. It's a relatively new Webzine/virtual community for the Web, from (believe it or not) Prodigy. Jam-packed with articles, interaction, and visual treats for anyone with a browser (Netscape Navigator is recommended—*STIM* is not on the Prodigy service). Designed to be "essential reading and fun for the Web-savvy/BBS-savvy pop culture junkie," the Webzine features a funky, cutting-edge design that is a treat for the jaded Web surfer's eyes. Recent issues included the following stories: "Beatniks and Beat Flicks," the *STIM* staff creates their dream fall TV lineup; a guide to Philip K. Dick's film legacy (called "The Dick Factor"); Margie Borschke invites you to read "For the Love of Cheese" and "The Lost Upland"; and staff writer Gareth Branwyn goes gaga over "The Adult Baby Fetish Catalog." The *STIM* Bullet-in-Board is full of intelligent discourse, controversy, and a few yucks. Yes, there are ads—after all this is Prodigy, remember—but they are not of the screaming banner type, more like the "click here for some information" type, so they do little to intrude on the design and mood of this pop culture oriented Webzine. Give it a visit.

REXtra! [http://www.rextra.com/Webzine/expert.htm] Movin' on up? Check out this Webzine for homeowners and people looking to relocate. There's information here for real estate agents too. Regular departments include "Agent's Angle." The current issue includes information about real estate photography, ways to improve an agent's property ads, and how to create a new slogan to improve business. There are also links to other useful agent sites. For all you Tim Taylors out there, be sure to read the "Hammer and Nail" section. This is full of home improvement tips, advice on finding an honest contractor, along with a scoop on a great new line of paint. There are links to other great home improvement sites too. The "House Dressing" department features helpful home decorating and cooking hints. The last time I checked this section, it was telling how to dress up your house for entertaining with some great recipes and a new coat of paint. The "Green Thumb" section includes the kind of gardening tips needed to give your garden a makeover. Yup, there are links here too. "Moving Van" is the relocation section and includes a pre-selling checklist, a worksheet to see how much you can afford to spend on a monthly payment, and

information on hiring a buyer's brokers. The Mortgage Corner provides a glossary of real estate terms. Ever wondered what "PITI" means? Lastly, there's Ask Lucy, a place you can post questions concerning home buying, selling, maintenance, and everything in between. Does Charlie Brown know she's moonlighting on the Web? (Note: *REXtra!* makes wide use of tables. If information appears jumbled about on your screen, then your browser is probably not capable of using tables. The Webmasters recommend using either Netscape Navigator or Microsoft's Internet Explorer for viewing *REXtra!* The Webzine works fine at screen displays of 640 × 480 pixels. However, they recommend using a 800 × 600 pixel resolution for maximum enjoyment.)

The Sci-Fi WEBzine [http://www.sci-fi-mag.com]; *SF Times* [http://www.spirit.com.au/acm/sftimes.html] Since most computer users (and I'm no different) have an above-normal interest in science fiction, I couldn't resist the *Sci-Fi WEBzine.* It's a new e-zine dedicated to science fiction stories, that publishes the work of new and as yet unpublished authors. Departments include: Editorials, Mainstream Fiction, Fantasy Fiction, and Poetry. Considering the concept, the design is competent but not outstanding. Nevertheless, the reason you are there is for the words. A recent issue featured the following stories and authors: "Family Business on Mars" by Frances Taira RN, "Indifferent Fire" by Wes Platt, and "BabyStar 1 Network" by Michael P. Mahony. Here's the opening from "Indifferent Fire": "Yardley Deats, security chief of the Tharsis Mons terraforming colony, muffled a yawn with his fist as he followed the stumpy custodial supervisor down a gently sloping ramp into the claustrophobic incinerator chamber." I don't know about you, but it got my interest. The *Sci-Fi WEBzine* is a free publication that is funded by unobtrusive on-line advertising. Science Fiction fans might also want to read the Australian Webzine *SF Times.* It contains not just fiction, but book and movie reviews, graphics, multimedia, and short films that are all related to the science fiction genre. Since the best part of many science fiction conventions is the dealer room, *SF Times* has an "Online Science Fiction Shop" devoted exclusively to science fiction products. Currently they only have a video list, but more is planned.

Snarl [http://www.america.net/~jns/snarl.html] Then there is *Snarl,* a bimonthly Webzine for the permanently grumpy. In a good mood? Want to get out of it? Visit *Snarl.* This Webzine may be the first

attempt at a digital vanity press on the Internet. Anybody with twenty dollars a month can publish anything they want and the whole world will be able to see it. Editor James Spielberg's intention to provide "thoughtful short stories, a few biting editorials, some artwork, plenty of stabs at the Internet, and anything else of interest that crosses my desk. It may be many things—bad, childish, aggravating, offensive—but I hopes it won't be boring." Current politically incorrect features include: "HIV+ Me," a comic strip by Chris Companik about living with Aids; The "Obsessive/Compulsive Cafe" by Mark Baldridge; "Navel Gazing," artwork by Scott Marshall; "Comments O Rama"; and a comic-book commentary by Jason Sacks. If you go, don't miss the "Gratuitous Airhead of the Month" department, which appears to be a parody of bimbo photographs and profiles, in which the editor is desperately seeking candidates. *Snarl* is short on multimedia and animation—OK, maybe even the design's a little stale—but it's an oasis of curmudgeon-lyness in a desert of optimism.

If this has stimulated your interest in Webzines, I suggest you make a visit to one last site. It's not a Webzine, it' a home page called Joe & Mindy's Webzine Links and you can find it at **http://www.nhn. uoknor.edu/~howard/zines.html.** In addition to their basic page, they have other link pages for different topics, such as Astro, Gardening, Sci Fi, and Computer Stuff. While every site they have showcased is not specifically a Webzine, they are all worth checking out. And so is Joe & Mindy's site. It has way cool graphics, some animations, and a great sense of color and design. (Author's note: the author is not the Joe of Joe & Mindy's Webzine Links.)

6 How to Promote Yourself on the Web

Pizza delivered in thirty minutes or take two bucks off.
—Domino's Pizza

If you're wondering what pizza has to do with photography, read on.

One of the most important aspects of creating your own Website is the marketing potential, that allows you to display your work to the (computer-using) world. The Web can be used for image marketing and product marketing. How you design your Website will have a bearing on how it achieves either of these goals. Conventional wisdom has it that the WWW's greatest asset is its ability to market your image, and for some photographers that may be enough. It's easy enough to include your Website on your business card and casually to mention to a potential client that they should "drop by my Website and take a look at the images that are there." They may never look, but the mere mention that you are *au courant* enough to have a home page on the World Wide Web may improve your chances of getting an assignment. On the other hand, don't expect an art director not to ask to see a conventional portfolio before an assignment is given. So if you're going to use the Web as a sales tool you have to be sure your design includes two important functions. First, there must be an uncomplicated buying

process. As Pizza Hut found out—the hard way—people don't want to order pizza by using a computer. The same is true for most commercial photography assignments. While existing clients may use e-mail to communicate, don't expect too many assignments to come in electronically. Just like a person who's hungry for a pizza, they want the instant response of talking with a photographer and going over the details of the assignment—including getting an estimate—before the assignment is given. On the other hand, a properly designed Website is the best way for a client to find the stock photos they are looking for. And the best part is that the client does the searching not you. As FedEx discovered with their Website, people are more than happy to use the Internet—at their own expense—to check on when a package is delivered and who signed for it. The same is true for someone looking for a photograph of dinosaur bones. Let them do the searching on your Website. They can either download an FPO copy and leave you a message to send the original transparency so they can download a useable version of the image—after supplying a credit card, PO, or similar payment information.

Second, you must be able to measure the results. The simplest measurement is the use of the "hit meter" you often see on Websites. This can be impressive to the client who discovers he is the 12,435th person to visit your site, but will be far less impressive if they are the third. A far less than glamorous method is to simply ask people if they called you as a result of visiting your Website.

Home Page: An Online Brochure?

That's what it is, all right. An electronic version of the same kind of print-oriented material you've been showing and mailing to clients and prospective clients. As the late Don Petersen never got tired of reminding photographers: "You never get a second chance to make a good first impression." And so it is with your home page. That's because it is the first page that potential photo buyers will see on your Website. You can also think of your Website as an electronic store front or store window. The home page is your welcome mat; it says welcome to my site, my studio. A well-designed home page typically contains a table of contents or a summary of the kind of information that anybody visiting the site will find. This listing can be as simple or as complex as your operation is. If you sell assignment photography, you want to show

the breadth of the work you do—location work, for example. If you also do on-location executive portraits, include a section on that too. In other words, a Website is a reflection of the work you do—or want to do. There is no law stating that your Website cannot be used to promote an activity of your studio that you want to increase. If you want to move your operation from assignment-based to stock photography, focus the Website on the kind of stock images you have and be prepared to show samples. If you're concerned about digital theft, how to do what you can to prevent someone stealing your images will be covered later in the book. I would also recommend that you include a little blurb (or even an image or two) that says "oh, by the way I do assignments too." You still have to make a living and pay the bills so never miss a chance to plug your bread-and-butter work.

How a Home Page Can Promote and Sell Your Images

A home page on the World Wide Web has many advantages over a conventional portfolio or printed promotional piece. First, a Website is less expensive to change and update than conventional, non-electronic media. Four-color printing is expensive and if you order 5,000 brochures it may take some time to distribute all of them. By the time you're down to brochure number 4,989, you've probable created even better images than the one's on the brochure. Changing the images on a Website is a matter of scanning the new images (or having someone do it for you) and posting them on your home page. (I'll show you how in the next chapter.) And have you checked the prices to have a custom print made and laminated? Second, you only need one Website. There's no need to print 5,000 brochures or to have duplicate portfolios made so you can ship the images to several different places at the same time. Your single Website will be accessible to thousands of photo buyers around the country—even around the world.

Before you construct a Website you need to first establish the parameters for the site—what you hope to accomplish and how you intend to accomplish it. Without clear goals, a Website will be just as wasted as a brochure that's full of pretty pictures but doesn't ask for the sale. Here are a few ideas on ways to establish the content and orientation of a Website. In the next chapter, I will show you how to construct a few sites based on these guidelines.

Stock Photography

When photographers tell me that it's too complicated for them to produce a Website, I tell them four words: "picture of the month." One of the simplest ideas for stock photography is the picture of the month concept. This type of home page can consist of a simple photograph along with some basic information about the image and contact information—including e-mail address—for the photographer. This kind of home page has two edges: since it contains a single image, the Website is easy to set up and maintain. Because it is easy to set up and maintain, the images can be changed on a regular basis allowing you to always have something fresh for potential buyers to see. If you have several fields of concentration, I would suggest you use a picture of the week concept and feature each specialty once a week. A variation of this theme is to add additional pages to your Website which would archive previous pictures of the week (or month) so that you can tell buyers "Oh, you want a ski shot? That was my picture of the week on October 2." Make sure you advertise the fact that your Website has a featured picture that changes regularly and include that information on your business card, letterhead, source book ad, and any verbal communication you have with potential photo buyers.

Photographic Services for Assignments

Assignment photographers will need more depth than the average stock shooter—who tends to be more specialized. You remember how it goes: the Art Director says "I *know* you can photograph right-handed baseball players, but can you photograph *left-handed* ones?" An unfortunate reality of this business is that you are constantly having to prove to potential photo buyers that you can produce—and have already made—images just like the one they need right now. Therefore, an assignment shooter's Website should reflect their ads in source books and their laminated portfolio; it's even possible to combine both in a well-designed Website. That means more images—a striking example in each of the photographer's specialties. The danger here is that trying to use so many images, which means more smaller images, diminishes the effect. You might be better off using a few images on the first page, that occasionally change along with a listing of your specialties, such as food or architecture. Browsers would them click a button to go to another section of your Website to find examples of images along with tearsheets and lists of awards one for particular images. Caution is needed to keep

from overdoing it. As my mentor, Eddie Bafford, used to say that "you need someone in the darkroom with you with a two by four to hit you upside your head" when you get too carried away with an effect. The same kind of restraint is called for a studio which is involved in many kinds of discipline, such as portrait photographers who do weddings, families, and high school seniors. "Less is more"—Mies Van der Rohe.

Fine Art Photography

What the fine art photographer's Website needs is, in many ways, similar to the stock shooter. The images they sell have already been created. Unlike the assignment shooter who is always pitching their next shoot, the fine art image maker is selling photographs that have already been created. A Website can be an extension of an existing print brochure or can even be a replacement for it, since color JPEG images are less expensive to produce than four-color separations. A good way to establish a home page for the fine art photographer is the "picture of the (whatever)" concept. One of the differences in this home page is that galleries and art purchasers are often interested in a photographer's background and pedigree, so there should be an extensive section on degrees and awards so that a potential buyer knows they are getting "the good stuff." This home page should feature elegant simplicity.

Photographic Products

If, in addition to your photographic services, you also produce a product or service that photographers, or others, might use, a Website provides a continuation of your customer service operations, especially if you produce software for studio management or something similar. Updates can be posted on the Website, so that users can download upgrades to their software without having to call your studio or office. The other side of the coin: a home page can save you the cost of creating a disk and mailing it to your customers when changes or bug fixes are made. It's also a great place to place a FAQ (Frequently Asked Questions) section that minimizes the amount of hand holding you need to provide and, unlike typical customer support, is available twenty-four hours a day, seven days a week. If your product is a more traditional commodity, such as camera bags, you can still use the Internet.

Take Photoflex for example. A leading manufacturer of lighting equipment and camera bags, the company created the Photoflex

Institute of Photography on the World Wide Web. The institute is a virtual school that has three departments, photo lessons, a student book store, and a faculty. The school will have lessons readily available for any photographer desiring to become better informed about a particular aspect of professional photography. For example, a beginning photographer might want to learn how to take pictures indoors, using available natural light. A professional studio photographer might be interested in learning about shooting stock. There's information for non-professionals too: a parent who wants to take pictures of their children or people who want to shoot good slides when they go backpacking. All will benefit from photo lessons at the Photoflex Institute. The School Store acts somewhat as a follow-up to the lessons. Students can purchase books and videos relating to the lessons they have taken. For the most part, these related materials will have been created by the same person who taught their class. Unlike any other bookstores, this one provides a whole Web page for each item—book or video tape—and the user will not only be given the title, author, and publisher, but also a synopsis and review on the item, a review on the author, and a list of the authors credentials.

The school's faculty is comprised of many of the editors and columnists from leading photography, film, video, and digital magazines. The institute houses departments of basic photography, portrait photography, commercial photography, business of photography, outdoor photography, photojournalism, sports photography, lighting and special effects, the darkroom process, digital photography, fashion photography, and travel photography. Each of these departments are broken down further into more specific subjects related to the department. For instance, commercial photography breaks down to a school of food photography and catalog photography. Each of these schools has at least one expert teaching lessons about that specialty.

Also available are free photo lessons on basic lighting using soft-boxes, reflectors, and umbrellas in the studio and on location. These lessons are available to anyone, enrolled or not. Every month the school will be updated. Most, if not all, of the colleges will be expanded with more lessons. More faculty will be added. More books will be available from the bookstore. In order to cover the costs of running the school, tuition will cost two dollars for a month, ten dollars for six months, or fifteen dollars for a year. The fee can be paid by credit card when a user enrolls online. Enrollment will not only grant the user unlimited access

to the lessons, but it will also entitle them to the student discount when purchasing anything in the student book store. The Photoflex site is located at **http://www.photoflex.com.**

There's More

Yes, there's a little more to the promotion of your Website. This section provides information on getting ready to produce your Website. In the next chapter, you will see how easy it is to actually build a home page, and chapter 9 will get back to promotional information for your new Website.

7 Building Your Own Home Page

The time has come, the Walrus said, to talk of many things . . .

—Lewis Carroll

Just as in photography there is more than one way to create an image, there is more than one way to create a home page. In this chapter, you will discover one approach: the simplest, least-expensive method for producing a Website. The software and techniques, that you will see, have been designed to enable you to get a home page up and running in a few weeks. Overachievers may be able to do it in a few days. More importantly, any photographer who already knows how to use his or her computer will be able to construct a rudimentary Website after reading this chapter.

Home Page Basics

The World Wide Web is really a collection—a big one—of Websites stored on computers called Web servers that store home pages and respond to requests from browser software. Common Gateway Interface (CGI) scripts are programs that run on a Web server to process all this activity and extend the capabilities of the server. Browser software

enables computer users to view your home page. The glue that hold all this together is HyperText, a computer language that enables Web surfers to move between Websites by selecting (clicking) on links. The ability to link one Website to another is one of the reasons it is called a Web. A Website consists of several parts: a home page is the launching point for any Website. You can consider it the table of contents because it lists the various items or images that can be found at the site. Websites are really collections of Web pages—individual files that make up a Website. The pages within a Website are linked together so that surfers can move easily between them, often in a non-linear fashion. Web pages are written in HyperText Markup Language (HTML), a simple, yet powerful programming language, which allows you to structure your Website to include:

1. Links to other Websites
2. Links to other Web pages (within your Website) or even to a specific element within a page. For example, to provide a large version of an image displayed on a Web page.
3. Structural elements such as (pricing) tables or (client) lists
4. Graphic elements, like photographs

Get Ready

There's an old expression that states "Prior planning prevents poor performance." That's just as true for Website design as it is for the rest of your studio's activities. Keep in mind that these steps—including the construction of the Website itself—can be undertaken before you even are online or have contracted with an Internet Service Provider. So you have few excuses for putting off getting started.

The Photographs

The first and most important step is deciding what images you want to display. The images that you use will have an effect on both the site's design and text content. Advice: make the first page of your Website contain a single signature image, perhaps with bits and pieces of other images used as design elements. If you've been around for a while, you know what images clients respond to positively, so the decision is not too complex. If you're a newcomer, don't ask your family and friends which images to include; they know you too well and don't want to hurt your feelings. Try asking the manager of your local color lab which photo-

graphs he or she thinks would catch a potential buyer's eye. Lastly, use your own gut feelings about which images you want to display. Remember that the image shown should reflect the kind of work you want to do, not just what you have been doing. This may require that you shoot some of this work on spec or for free to accumulate the images.

After the images have been selected you need to have them digitized. If you have a film or flatbed scanner, you can do it yourself; otherwise have them digitized by Kodak's Photo CD or Pro Photo CD process. The cost of having the images placed on a CD-ROM is modest and you will be able to use the digital images to prepare marketing materials and other means of visual communications, so the cost of producing the disc will be spread over more than one application.

The next step is to prepare the images for use on the Web. There are two approaches: first, using Adobe Photoshop (or whatever your favorite images editing program is) open the Photo CD images and size it to match your Website, keeping in mind how many images can be viewed on a fifteen-inch monitor at one time. Second, since Photo CD images come in groups of five (six if you're using Pro Photo CD), you can select one—I suggest you start with the Base size—to use for your Website. A Base image has a resolution of 512×768 pixels, which still might be too large for some Websites, but it provides a one megabyte image (at 300 dpi, but you will change the resolution before using the image) that is 2.56×1.707 inches in size. If that's too small for you, go up to the next size—4Base. This image size is 5.12×3.413 inches and has a file size of 4.5MB. This is probably too large but you can resize—and lower the resolution— to make it fit your Website.

Once your images have been selected, you need to optimize them for the Web. To do this you'll need some kind image enhancement program. (You can always use images in the sizes that Photo CD provides, but as you will see tweaking them will help users access the site easier.)

1. Use the Image Size (or whatever) command to make the image the size you want. This only has to be a ballpark size since our examples using WYSIWYG Web tools will allow some, limited control over image size.

2. Next, change the image's resolution to 72 dpi. Since these images will be viewed on screen, saving them in any other resolution means the file will be larger, which translates into longer time to display on screen—without improvement over looking at a 300

dpi one. Smaller files load faster, which prevents any potential surfer from getting bored and clicking his or her browser's stop button.

3. Next save the image file in some form of compressed format. (Remember I talked about Web formats back at the beginning of the book.) This can be GIF, JPEG, or PNG. One photographer told me that he switched from JPEG to GIF for images on his Website because they loaded faster but a 150K file, in any format, is going to take the same amount of time to load. Your choices of format may be determined by the software you are using. If you don't have an image enhancement program, look into a file translation program such as HiJaak Graphics Suite for Windows and DeBabelizer for the Macintosh. Both will allow you to adjust resolution and save in one or more of the above formats, and DeBabelizer will let you adjust image size as well.

The Text

After you've gotten your images ready, it's time to think about what the text will be. My suggestion is to use yet another cliché to guide you: keep it simple. Tell them who you are, what you do, and why they should hire you or purchase your images. Anything else is superfluous. Nevertheless, here are several additional items that you should include in the text, which may seem obvious but are sometimes left off photographer's Websites.

1. Your address—including city and zip code
2. A phone number to contact your studio
3. Your fax number
4. Your e-mail address. (Most photographers include this one but leave off the others expecting that if anyone is surfing their sight they will contact them by e-mail. It is more likely that the surfer will contact them later—and to do that, they might prefer a phone number when they need to get hold of you right away.)

I would limit any mention of awards to big ones or the inclusion of your images in the collections of major museums. Getting the "Good Citizen's Award" from the Kiwanis may be important in your local market but with your Website, you are marketing to the world. A photo buyer in Tel Aviv may not know where Brighton, Colorado, is but he's probably heard of the Museum of Modern Art in New York.

Construction Tools

Although your new home page can be constructed by writing HTML code using a simple text editor software, few photographers may be willing to spend time to learn the programming language—although it is simpler than other computer languages, such as C—to become proficient programmers. The easiest way to construct a home page is through the use of WYSIWYG Website construction software. The programs you will be introduced to are readily available, inexpensive programs that work with Macintosh or Windows computers. They are by no means the only software available and are representative of the current generation of WYSIWYG Web construction programs you can buy. These two programs were selected because they are from companies that have a track record for producing practical and useful software.

Here are a few tips before getting started. While some people create home pages using storyboards I would like to suggest another approach. Storyboards are fine when creating linear video or multimedia presentation but not as handy as when producing a home page that is non-linear. A better paradigm is the flowchart. Flowcharts show how events (or Web pages) are linked together making it a better model to follow.

Organize the files that will make up the site. Create a Root folder (or directory) on your hard disk as a place to store all of the Web pages and images that will be used.

Create an Images folder (or directory) as a place to store all of the GIF or JPEG images. This folder should be located inside your Root folder.

Adobe PageMill

One of the first programs to popularize WYSIWYG Web page creation was Adobe PageMill. As I write this, the current version is 1.0.2 but a beta version of 2.0 was available for download from Adobe's Website (**http://www.adobe.com**). The shipping version of PageMill 2.0 should be available by the time you read this. The Macintosh version of PageMill 1.0.2 was used for the creation of this sample Website. Care was taken to make sure that although Mac terms may be used, Windows users will be able to follow the process too.

The first Website that I will create will be one for stock and fine art photography.

- **Step 1.** After launching PageMill you will see the "Page View," which is the WYSIWYG editor that lets you manipulate objects.

Figure 7-1. PageMill's basic workspace is the "Page View" and the location where you create Web pages. Clicking in the icon in the upper right-hand corner lets you toggle back and forth between Edit and Preview modes.

There are two modes: Preview and Edit. The globe at the upper right-hand corner indicates you are in Preview mode, which simulates how your Web page will look when viewed by a Web browser. When you click the button it changes to a "pen and paper." Then you will see a toolbar across the top which gives you access to PageMill's tools and commands. In Edit mode you can enter and edit text, manipulate images, and create links. Let's start there.

• **Step 2.** Before jumping in, I went to the Preferences command in the Edit menu and set my Images folder in my Root folder as the place for PageMill to place any files it needs or uses. Then I opened my Scrapbook and dragged my studio logo that is stored there onto the Web page. Since most Web browsers only display GIF or JPEG images, PageMill automatically converts the graphic into a GIF file and places that new file in your Images folder. (Windows users can place the graphic using the Paste command to copy the image off the Clipboard.) To center the logo, I clicked the center align button in PageMill's toolbar.

Where did my logo come from? The original art, created by designer Jeannie Nuanes, was scanned used an Epson ES-1000C flatbed scanner and originally as a PICT file. The PICT file was copied onto the Macin-

Figure 7-2. Using PageMill's Out-of-Place image view, select the transparency tool to make the background invisible.

tosh Scrapbook so that it could be pasted into any, Web or non-Web, promotional material. Windows users can use a similar approach and save the file as a BMP (or whatever file format you prefer) file and store it anywhere on your hard disk. PageMill will do the GIF conversion and store the newly created file in your root directory or folder.

- **Step 3.** Since the original logo is black-and-white, the next step is giving the logo a transparent background. This is done by double-clicking the graphic, which opens up the Out-of-Place image view. Select the transparency tool (it looks like a Magic Wand) and click on the background of the image and the white area disappears. When you close the Out-of-Place image view you will be prompted to save the changes in the GIF image; don't forget to do it. Now, let's add some text.

- **Step 4.** Before entering text, open the Attributes Inspector window, which is found under Window menu. Then clicking the Insert Text tool (it looks like a box with the letters T and X in it), I typed "FARACE PHOTOGRAPHY." Highlighting the text allows me to use the Attributes Inspector to change how text looks. In this case I selected the "Larger" heading from the pop-up Format menu and clicked "Strong" in the Styles area of the dialog. This is the way text will be handled within PageMill. Next, I added another line with the tag "Stock, Digital, and Fine Art Images."

Figure 7-3. Using PageMill's Attributes Inspector you will have access to controls over the images size. Here it's used to resize an image to a specific size—in pixels.

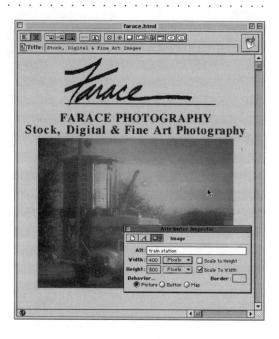

The next phase will be adding a photograph to the Website. PageMill allows many different ways to place a photograph and you can use any or all of them depending on which format you already have the images stored in: A. you can drag & drop an image from another Web page; B. you can copy and paste a photograph from another page; C. you can also use PageMill's Pasteboard to store frequently used graphics, such as logos, and drag or copy them from the Pasteboard to your Web page (This is excellent for Windows users who don't have access to a graphics storage device like the Mac's Scrapbook.); or D. click the insert image button on the toolbar. This option gives you access to images that may be stored elsewhere; that's what I used in the next step.

- **Step 5.** I clicked the Insert Image button which brought up a dialog box asking where the image was. I specified the location on my hard disk and the image was placed on my new Web page. The only problem is that it was too big. Clicking on the image and selecting Attributes Inspector brings back the familiar box used to control text style and appearance. By clicking the right-hand icon on the mini-toolbar, you will have access to controls over the image's size. The file I selected was 832 × 634 pixels—too big for some browsers and overpowering for this Web page. By clicking the Scale to Width checkbox and changing the image

Figure 7-4. Using the Attribute Inspector to change colors: in this example, the background was changed to white.

size to 400 pixels, a 300 × 400 pixel image was placed on the page. By entering a number of pixels (I chose two) in the Border data box, PageMill drew a border around the image. Next I wanted to add some color to the page.

- **Step 6.** Adding color to your Web page is done by using the Attributes Inspector. Start by clicking the Page icon (it looks like a page with a dog-eared corner). This dialog box give you control over the color of text, background, and links. The default color is a soft gray and will be used for the rest of this example. The colors used may not reproduce well in grayscale, but I did change the background to white to make it easier to see the rest of the operations.

Here's a tip: when inserting text (and images too, for that matter), it is easy to keep on typing and placing. That's convenient but makes controlling the color of each item different. Unless you plan on keeping most text black, create separate text entries.

- **Step 7.** Let's create other pages, starting with a biography. I started by choosing New Page from the Edit Menu and saved it as Bio.html. Next step was to import an image of myself. The photograph of me was created from a scanned negative made by

Mary Farace and was enhanced by using Auto FX's Photo/Graphic Edges using Adobe Photoshop. Using Photoshop, the file was sized to fit the Web page, saved as a JPEG image, and placed in my Images folder. I clicked the insert image button to place the photo, then insert text to place my name under it.

Tip: web browsers display images in GIF or JPEG format. If you have images in PICT, for instance, PageMill will automatically convert it into GIF format and save a copy as a file in the Images folder. Usually this conversion works OK, but there is the possibility of some image degradation. A 24-bit PICT file may not as good as the original, when converted to GIF because GIF is an 8-bit format. To prevent this from happening, use the JPEG format which will preserve the 24-bit depth.

While you can use an image editing program, like Adobe Photoshop, there are some shareware conversions available that can do file conversion. One of the best for the Macintosh platform is GIF Converter. The current version, 2.4D17, is available from user groups, online services, and the Internet (**http://www.kamit.com/ gifconverter.html**).

Next step was to place the bio itself. The text was originally written using Claris MacWrite Pro, but any Mac or Windows word processor would have worked. I selected the text, then copied it onto the Clipboard. Once there, I switched back to PageMill and pasted the text under the heading. Once in place the text can be edited as if you were using a simple word processor. So feel free to highlight text, copy, cut, and paste to make changes any time you want. This becomes part of the maintenance of your Website. If you receive an award or if a major museum accepts one of your pieces, get over to your Website and update that bio! Using the Attribute Inspector I set the format to "Paragraph" and I was now ready to create a link between my home page and the bio Web page.

- **Step 8.** I liked the way the links were lined up on the sample home page Adobe packages with PageMill, so I just selected the line of text and dragged it into my own.

Tip: feel free to copy and paste artwork that is included with tutorials in whatever software you use. Just keep in mind that thousands of other people are thinking the same thing.

To be sure, I wouldn't need all of the items that they had (Home,

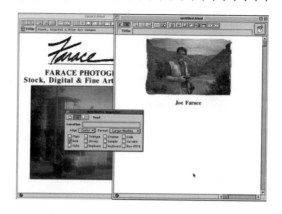

Figure 7-5. Using the New Page command, a biography page was created and a JPEG photograph was imported and placed at the top of the page.

Corporate, Products, Calendar , Support, Employment, Feedback) and expected to change them. The important point is that I wanted to make sure that each page in *my* Website contained links to all the other sections. This is something that successful Web retailers already practice but not all the photography sites I found allowed complete interactivity with all sections from every Web page in the site.

By simply selecting the text in the "link line", I changed the names to Biography, Digital Images, Books, Stock, Fine Art, and Feedback. When I copied the link line I also copied the links, which obviously wouldn't work with my Website. Before creating links within my site, I needed to use the Remove Link command in the Edit menu. Once done, the links change color from blue (indicating a link is there) to black. To link my home page to the bio page, I just dragged the page icon (it's in the upper left-hand corner of each page, just under the toolbar) onto the "Biography" link on my home page. When I did, it turned blue. An alternate way would be to click on the linked word and type the linked page's URL into the Link Location Bar in the lower left-hand corner of PageMill's working window.

Adding more pages, links, text, and information using Adobe PageMill is simply the result of applying of all of the above techniques. The result will be an attractive Website that should be "up and running" in a matter of days or even hours for the more determined reader.

Let's raise the ante and create another home page for photography assignments and make it a little fancier than the previous one. Many of the techniques used can work with Adobe PageMill but for the next step I'll be using another program.

Claris Home Page

Before you get started using Home Page, you'll need to set preferences, such as the folder that will store your images. Another preference to set is what browser you will use to preview your Website. That's right. Instead of having to switch to the Preview mode of your Web authoring program, Claris Home Page lets you preview it, using whatever browser you prefer. For purposes of this chapter, I set Netscape Navigator 3.0 as the default browser. Home Page features four toolbars that you can use to perform the tasks of creating and working on your Website. These are Basic, Style, Tool, and Image Map Editor.

- **Step 1.** I started by using the New command from the Edit menu to open a blank page. Then I went to the Document Options (also from the Edit menu) to give the page a title. The words that appear in a Web page's title are important because they are used by Internet search engines to locate various sites. Make sure the title includes words that your potential clients are likely to use when doing a keyword search. The first thing I did was to set the background color. This is done using the Document Options from the Edit menu. For purposes of this book, I set the background to white.

- **Step 2.** Next I added text to the page to provide a title for the Website. You can add text to your Web page by typing directly onto the page and by copying and pasting from another Web page or application. Once in place the text can be manipulated using the toolbar. First, I used the center button to center the title and subhead. Next, I made it bold by clicking the "B" button; then, using the "A+" button, I kept clicking until the title was a big as I like. I used similar techniques but added italics to the

Figure 7-6. Claris Home Page's Document Options dialog box has a pull-down menu that allows it many functions. One is Colors and Background that can be used to set the background color. A color wheel dialog box lets you pick whatever color you like.

Figure 7-7. Using Home Page's built-in text editing capabilities, the Website title and subtitle were directly typed into the document then manipulated using the text tool button in the toolbar.

subtitle. Adding color to each text line—or even a single character—is a matter of selecting (highlighting) the text and clicking on the pull-down Text Color item in the toolbar. You can select from red, blue, green, yellow, and black, or mix your own through the "Other" color picker.

- **Step 3.** My plans for this site include using several small images—each representing various aspects of my on-location work—to be used as buttons. Visitors would only need to click on an image to see more of that type of photograph.

Tip: consider these to be mini-portfolios. As more and more search engines add image search capabilities, I think it's a good idea to create these portfolios so that if a photo buyer is looking for a specific images—such as dinosaurs—your Web page will pop up on their screen.

All of the images used on this page were digitized using Kodak's Photo CD process. Then they were opened inside Adobe Photoshop and, using the Image Size dialog box were given the same height (I wanted them to line up) and saved as 72dpi JPEG images at the maximum quality. The complete JPEG files were placed in the Images folder.

To add an image to the page, place the insertion point where you want the image to be and chose Image from the Inset menu. From the

Figure 7-8. Four different JPEG images were stored in the default Images folder and placed on the home page using the Insert Image command. All four images were centered on the page using the center button on the toolbar.

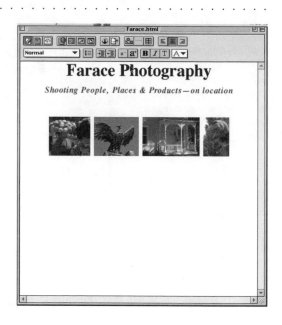

dialog box that appears select your image file and it will be placed on the page. If the image is a JPEG or GIF file, Home Page creates a pointer to the current location of the file. If the image is a BMP or PICT file, the program converts the file into GIF format and places the converted file in your default Images folder.

- **Step 4.** Next I typed the major areas of specialty under the small photographs. These are Travel, Art, Historic Preservation, and Dinosaurs. This text, plus the images themselves, will be used as links to other sections of the Website.

At this point I recommend you take a break in the process. Clicking on the browser button in the toolbar launches your preferred browser—in this case Netscape Navigator 3.0. Since any WYSIWYG Web authoring program's job is to convert the actions on the screen into HTML code, there is always is the possibility that the interpretation can vary slightly. In this case, the four images that had a space between them are now with one another. While the effect is not unpleasant, that's not what I intended, so I went back to Home Page and inserted a space between images. After the changes were made, the Website looked like I intend when viewed in Navigator. Since every browser may interpret the HTML code differently, you may want to check your finished Website with other popular browsers, like Microsoft's Internet Explorer. Or you can

Figure 7-9. When the under construction Website is viewed on Netscape Navigator 3.0, the images seemed closer together than they did when working within Claris Home Page.

do what many Websites do, they specify that the pages look best when viewed by a specific browser.

- **Step 5.** The next step was creating a page for my dinosaur pictures. Using the same techniques previously introduced, I placed a large photograph of a Brachiasaurus on the page with some text. Next step? Linking the dinosaur Web page with the small dino image on the home page. To create a link to the dino page, I selected the image. When you do, a light blue rectangle surrounds the photograph. Next, I chose Link to File from the Insert menu. This causes an Open dialog box to appear. Find the Web page, select it, and click the "open" button. This creates a link and places a colored border around your photograph, indicating that it is linked to another page. While I was at it, I selected the text "Dinosaurs" and created a link to the page too— giving surfers two ways to get to my collection of dinosaur photos. Back to the dinosaur page: I copied my group of links under the heading. I deleted the text for "Dinosaurs" and changed it to "Home." Then using the same techniques, I linked this Web page back to the home page.

- **Step 6.** Next I wanted to create an online order form, so that buyers could purchase limited edition posters of some of the images. In this case, I want to be able to sell limited edition posters of dinosaurs. First, I need to get their attention, so I created a page of small dinosaur images, using the techniques covered up to this point, and created a link back to text on the

Figure 7-10. The now-linked dinosaur Web page with links back to my home pages.

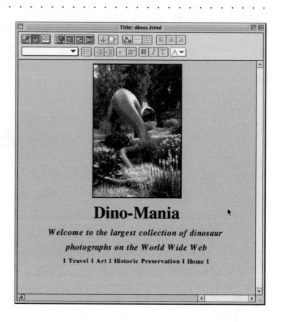

dinosaur page. Each of the images were linked to a separate page (for each one) showing the image as near full browser-size as possible. That page was linked back to the poster page to place an order. Here's where we get to take their money. To add form-like data to the Web page, I placed the insertion point, then selected Forms from the Insert menu and chose Text. Then, I used the Object Editor to enter the name of this text box (the first one being the purchaser's name) and the maximum number of characters to accept. This naming is important because the program will use it when building a CGI script to locate all of the input data. Next, I added all the kind of data you need from a purchaser—including credit card information. To make it possible for purchasers to check what kind of credit card they want to use. In my hypothetical example—I'll accept Visa and MasterCard—I used the Insert/Form/Radio Button command to place the buttons. At this point they will need to "submit" this data so the order can be accepted, processed, and mailed to the purchaser. I drag and dropped a button from the clip art library Claris supplies with the product, and surrounded it with text that says "If you want it, click here." To make this button active, chose Form Button from the Object Editor you see in Figure 7-11.

Figure 7-11. My "Buy-a-Poster" page was created using all the techniques covered up to this point.

- **Step 7.** Forms need to "call" a CGI script in order to process any data that is entered on your Website—such as, from people who want to purchase one of the above posters. You can (and need to) specify a CGI script for each Web page that contains "form" data. To specify a script for this page you need to choose Document Options from the Edit menu. To display the Document Options information, chose General from the pop-up menu. Type in the name and path for the CGI script file on the server in the Form Action text box. At this point, you need to have had a conversation with your Internet Service Provider over what you need to enter when using forms on your Website. Next, choose Get or Post from the Form Action pop-up menu to specify how you want the form data sent to the server. After you click OK, you're ready to receive e-mail from potential purchasers of the dinosaur poster set. Mac users looking for some examples of CGI scripts can find them at **http://www.uwtc.washington. edu/Computing/WWW/Mac/CGI.html.**

Updates

As I was finishing this book, Adobe Systems announced PageMill 2.0. The new version provides a single application that integrates ease of use with advanced HTML authoring features and support for animation and video. PageMill 2.0 offers an intuitive interface for creating HTML tables and frames, which will allow even novice users to create Web pages with advanced page layout without having to learn HTML code. HTML source editing enables users to switch between PageMill's interface to direct, source code mode. PageMill offers one of the simplest

ways to create Web pages that integrate animation, digital video, and other multimedia content widely used on the Web. With version 2.0, computer users can simply drag-and-drop a variety of multimedia data types, including PDF files, QuickTime movies, QuickTime VR, ShockWave, and animated GIF files, directly into a PageMill page. Users can preview these files directly in PageMill for immediate review and re-size, right or left align, and automatically flow text around objects.

You can open and import text directly from word processors, easily control size and color, right or left align paragraphs, automatically wrap text around right or left aligned objects, and PageMill 2.0 includes a spell checker with custom dictionaries. PageMill 2.0 has find-and-replace features, giving users the ability to find and replace both text and objects by simply dragging and dropping them into the Find/Replace dialog box. For example, users can change all occurrences of an image with a different image with one command.

Like PageMill, Claris Home Page is undergoing a revision. Claris Home Page 2.0, is designed for novice-to-expert Web page authors and will deliver a number of new capabilities and features designed to enhance both the look of Web pages and the productivity of Web authors. Key new features will include built-in site publishing, with auto-consolidation of files; support for popular multimedia plug-ins, including QuickTime and ShockWave; spell checking and support for multiple fonts; client-side image maps for linking to other pages and sites; and HTML editing enhancements, such as, syntax coloring. Claris Home Page 2.0 users will also be able to dynamically re-size and position frames by pointing and dragging with their mouse; preview background GIF images from within Claris Home Page; drag-and-drop tab-delimited text from spreadsheet and database documents to automatically create tables within their Web page; and specify row heights and column widths within tables. The new version will also provide concurrency between WYSIWYG and HTML modes, allowing users to go to the precise location in which they were working in the previous mode.

The sites created in the above examples are quite basic, but the idea of creating them was not to impress you with my design skills. Instead, I was trying to show you how easy it would be to produce your own home pages, and as you can see, it was not too difficult. Before creating your own Website, I urge you to read the next chapter, where you will find examples of photographers who have taken the plunge and created their own sites. They will also tell you, in their own words, how they did it.

Placing Your Website on the Net

After you have created your Website you will need to upload all of the files associated with it to a server provided by your Internet Service Provider. How this is accomplished will vary from ISP to ISP but here are a few basics. (Note: please check with your ISP for specific procedures for them before uploading.)

To get your pages onto the World Wide Web, you need to transfer them from your hard disk onto a Web server. This server can be any kind of computer: Macintosh, UNIX, or Windows NT. The first thing to do before transferring your Website to a server is to make sure that all of your files and subfolders are found in a single folder. If you set up everything this way—by creating an Images folder, for example— before creating your Website, this should be no problem, but it's still a good idea to check that all the bits and pieces are there. Be careful that you don't move files from other folders. If you move them you may be breaking links and creating problems for yourself later on. Some users may have direct file access to their server. If you do, an icon for the server will appear on your desktop. In that case, all you have to do is drag your Website folder to the server icon. Chances are most of you don't have this kind of access and will need to upload, via FTP, to the server. To do that you will need a program designed to do that. One of the most popular is called Fetch. The current version is 3.0 and is available from **http://hyperarchive.lcs.mit.edu/Hyperarchive.html.** If that's too much typing, go to **http://www.shareware.com,** and use their search function to find a place to download Fetch. What Fetch enables you to do is to make an FTP transfer of your Website file to the server of your ISP. A tip on using Fetch: if you have a space between words in a file name, Fetch will convert blank spaces into underscores breaking all your links because of a change of file names. UNIX is case sensitive and, therefore, knows the difference between **dino.html** and **Dino.html.** Be consistent in your file naming.

The safest thing to do, before you upload your Website, is to put in a call to the ISP Webmaster and have them send you instructions on how to get your site online.

8 Photographers Online

The first day I was on the Internet I received an order for one of my photographs.

—Bill Craig, fine arts photographer

Photographers were amongst the first small-business people to recognize the power that the Internet possesses to provide them with the same kind of marketing presence that Fortune 500 companies have. Since there are as many different kinds of ways of using the Internet to market photographic products and services as there are photographers, this chapter will take a look at some of those pioneers that took the plunge and established a home page on the World Wide Web.

Photographers Already on the Web

All of the photographers featured in this chapter were selected, based on a survey of the World Wide Web responding to the word "photographer," when using the Yahoo! search engine. In compiling this list, I tried to find different kinds of photographers, male and female, each with varying specialties, ranging from wedding to wildlife,

color or black-and-white image making, as well as commercial and fine art photography. I started with an initial list of sixteen photographers who I thought had interesting and well-designed home pages and contacted them by e-mail. Right away my list got smaller. One of the photographer's e-mail account appeared to have been terminated, so my list shrank on day one. But also on day one, two photographers indicated a willingness to participate in my information gathering, and, by day two, it was up to a total of three. By the time my deadline approached, a total of six photographers had responded.

The photographers that you will read about were those who were interested in sharing their experiences with readers of this book, and I want to thank all those who responded and whose stories appear in these pages. After the photographers told me they would like to participate, I asked them to respond to a set of standard questions, the answers to which I thought would help anyone contemplating establishing their own home page on the World Wide Web. Those questions were:

1. Provide a brief history of your operation. (This was included so that readers might get a feeling for the photographer, their background and experience.)
2. When did you first get involved with the Internet?
3. Did you create your own home page, or did you have a consultant do it for you?
4. If you did it yourself, please tell us about the equipment and the software you used.
5. Please talk about the process. For example: how long from the time you decided to create the home page did you have it up and running? What problems did you encounter, and how did you overcome them?
6. If you had a consultant create your Website, please describe the experience. If you had to do it over again, would you do it yourself or hire a consultant?
7. Who is your ISP and what were your experiences with them?
8. How long has your Website been in operation?
9. Is the maintenance of the site time-consuming?
10. What have been the results? Please list any intangible results as well as the tangible ones of more sales or assignments.
11. Are you pleased with the results and will you expand your Internet presence in the future?

12. Would you recommend that other photographers get onto the Internet?

The photographers were also allowed to add any comments that were not covered in any of the above questions. As you will discover, some photographers chose to answer all the questions, while others focused only on some of them. What follows is an (almost) verbatim copy of their responses to my questions. Here's a look at their Websites in random order.

Mark Surloff Photography
http://home.earthlink.net/~baxsur/

Surf over to Mark Surloff's home page to see a display of the stunning architectural photographs that he has built his business on. Click on the button labeled "black and white," and you will go to another section of his Website that features fine-art black-and-white images, along with an impressive listing of museums that have his photographs in their collection. This site shows how both commercial and artistic considerations can be combined into one home page. The bottom of the initial page features his name and e-mail address. Here's how he answered the above questions.

1. Provide a brief history of your operation.

"I began photographing architecture (primarily in South Florida) in 1981, after having worked with large format cameras for many years. I started in photography after seeing the black-and-white photos of Ansel Adams and Edward Weston."

2. When did you first get involved with the Internet?

"My first, but limited, exposure to the Internet was in 1995 through

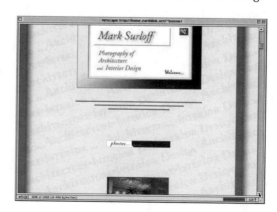

Figure 8-1. Mark Surloff's home page features interior and architectural photography along with links to his other photographs, including black-and-white, and fine art images. This shows the bottom of the page.

. .

America Online. I found this route to be an expensive one. Keeping one eye on the clock while browsing is quite distracting so I moved to an ISP (EarthLink Network) after seeing their ad in a Mac magazine."

3, 4. If you did it yourself, please tell us about the equipment and the software you used . . .

"I created my own Web page using a Power Mac 6100/60 with 40 MB RAM and 730MB hard-drive and Adobe PageMill 1.0."

5. Please talk about the process.

"After hearing about PageMill in early 1996, I immediately ordered it through a catalogue house and found it an easy alternative to HTML, as my knowledge of this computer language is limited. Within a few hours, I had my first Web page ready to go online. Really the only problem I had was uploading the file to my site. I had to be educated on the appropriate naming of files i.e., using all lowercase letters and no special characters before the file would load correctly. Using Adobe Fetch, drag and drop is a real time saver."

9. Is the maintenance of the site time-consuming?

"I really don't maintain my site on a regular basis. My current site is the second one I've created. Originally, I saved all my files as JPEG, but found, of course, that this greatly slowed my site down. Now everything is saved in the GIF format. I had tried using a page counter at one time but found that EarthLink Network has a problem with them, that is, it would reset to zero at times. This is a problem they acknowledge and hope to fix. And the traffic at my site doesn't inspire the use of a page counter."

10. What have been the results?

"The only people I've heard from are students. Generally they are on an assignment to search the Web and contact the author. I'm happy to give any help I can to those interested in learning about photography."

12. Would you recommend that other photographers get onto the Internet?

"I'm happy I'm on the Net and would recommend it to any photographer."

Joe Felzman Photography
http://www.teleport.com/~felzman/

Make sure to visit Joe Felzman's elegant home page. Joe's site has four sections: Studio, Portfolio, Clients, and Services. Clicking Studio takes

Figure 8-2. Joe Felzman's Website shows both his assignment and stock photography, using a classic design and small images that load quickly—an important concern with impatient Internet browsers and potential clients. They want to see it now!

you to another page that features pictures of the studio including its full kitchen and prop storage, located in the Pearl District in downtown Portland. Portfolio shows some of Felzman's highly stylized studio work. The Client and Service sections tell what Felzman does—and who he does it for. While viewing the site please keep in mind that he created and installed this home page in just one week.

1. Provide a brief history of your operation.

"In 1977, I began a commercial/advertising photography studio in Portland, Oregon. Specializing in product, catalog, food, and high-tech photography, and I have been working with local, national and international clients for the past twenty years."

2. When did you first get involved with the Internet?

"First involved with the Internet about one and one-half years ago."

3, 4. If you did it yourself, please tell us about the equipment and the software you used.

"Yes, I created my own home page using a Macintosh 7500/100 (213 MB RAM, 2GB hard disk) PressView 21 SR, Nikon 4500AF film scanner, and PageMill (software)."

5. Please talk about the process.

"The total time to design and install the home page was about a week. After designing the page with a storyboard-like system and deciding if I wanted a business or art type approach to it, I scanned all images in-house and used Adobe's PageMill software. Very simple to use, but I don't have a lot of complex links or large images, so things went very smooth."

8. How long has your Website been in operation?

(As of September, 1996) "The Website has been up for about six months."

9. Is the maintenance of the site time-consuming?
"No maintenance at all."

10. What have been the results?
"The main results were nine or ten requests for stock photography and fifteen or so requests for my CD-ROM portfolio, but no assignments as of yet. We look at the home page as a business card for people, to let them know that we're here."

11. Are you pleased with the results and will you expand your Internet presence in the future?
". . . the results are mixed. The site has been very well received with up to six thousand hits per month, *Photo District News* magazine picked it as one of the best photographers Websites and 'Cool Site of the Day and Month' by Teleport, my server. I just spend $250.00 a year for the site and get unlimited Internet use along with e/mail. Cheap!"

12. Would you recommend that other photographers get onto the Internet?
"I think it depends; if you are a commercial or a location based photographer, it can't hurt. Getting people to look at it is hard, and you must be on every search engine. Most people who look at my page are other photographers."

John Todd and David Fielding, Photosphere Studio
http://www.photosphere.co.uk

Proving that the World Wide Web is, indeed, worldwide, British photographers John Todd and David Fielding have created a Website that is quite different from their American counterparts. The home page has four on-screen buttons: Photosphere, Poster Shop, Stock Library, and Contact/Ordering. Clicking on the Photosphere button takes you to a Web page that has information about the studio, along with small photo icons, that, when clicked, take you to sample images representing the major areas of specialty (food, products, location, vehicles, special effects, models). Poster Shop is an area that lets you order original prints of some of the studio's signature images. All the information is included for placing an order, including prices, name and address information, and size of print. Even digital versions may be ordered. The Stock Library section is the most impressive. It uses Netscape and Internet Explorers' ability to create frames to display three different areas along with some animations which are displayed in the top frame, ordering information is shown in the lower, larger frame, and thumbnails from

Figure 8-3. Photosphere Studio's CyberPix home page features a bold design, animation (just below this section of the home page), and audio. When you visit CyberPix, shortly after the home page starts down-loading, a booming voice says "CyberPix!" It got *my* attention.

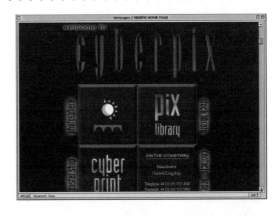

selected categories are shown in the vertical frame on the left-hand side. Clicking on a thumbnail replaces the center section with a larger version of that image along with ordering information and technical specifications. The Contact button displays ways to contact the photographers; clicking it does more of the same. Take some time to visit this interesting site.

1. Provide a brief history of your operation.

"We produce top quality studio and location photography for a variety of blue chip clients. Situated in City Centre Manchester, UK, established in 1987, we now have three drive in studios with five thousand square feet of floor space."

2. When did you first get involved with the Internet?

(In October, 1995, it was) "Approximately one year ago."

3. Did you create your own home page or did you have a consultant do it for you?

"We created our own pages, although one of our clients (a design group) came up with the initial design format."

4. If you did it yourself, please tell us about the equipment and the software you used.

"We have two PC-compatible Pentium systems installed in the studios, these are used for digital manipulation using the Windows version of Adobe Photoshop. The home pages were designed on 166MHz Pentium using various editing programs such as Hot Metal 2, the built-in HTML editor in Netscape Navigator Gold and the good old Windows notepad. All the images were scanned on our Epson GT 9000 (the British version of Epson's ES1200C) scanner and then manipulated in Adobe Photoshop."

5. Please talk about the process.

"From the conception of the visuals to the construction and final download of the home page took approximately six weeks. The first download was really a test to see how long pages with images took to download, etc. We then made adjustments, like saving JPEGs with less information, to cut down on surfing time—in the end there has to be a trade off between image quality and download time. Our site is still really experimental, as we are constantly adding things like sound samples and animation. As we are constantly upgrading it, it is quite time consuming. Our biggest problem was adapting CGI scripts to use for form replies and a Web counter, however with much perseverance, we now have this sorted out."

6. If you had to do it over again, would you do it yourself or hire a consultant?

"Do it ourselves. We like the control and it's much cheaper."

7. Who is your ISP and what were your experiences with them?

"Demon Net. UK. Helpful but technical help was somewhat confusing."

8. How long has your Website been in operation?

(In October, 1996) "Approximately two months."

9. Is the maintenance of the site time-consuming?

"At the moment yes, as we are constantly upgrading it. But when we are finally happy (never?) with it, hopefully it will not involve much time."

10. What have been the results? Please list any intangible results as well as the tangible ones of more sales or assignments.

"Presently, we have not registered the site with many search engines and other photo related sites, as we are waiting until we feel it is finished. So we have no tangible results, although most clients are impressed with the results and it is good from a techno-profile raising exercise."

11. Are you pleased with the results and will you expand your Internet presence in the future?

"We will certainly be making sites more aware of our existence in the next few weeks." (October, 1996)

12. Would you recommend that other photographers get onto the Internet?

"At this stage it has to be purely a subjective decision based on the possible potential of the Internet in the future. It is a relatively inexpensive way of promoting and profile raising of your work and

company, and has the benefit of being able to instantly show your portfolio to a prospective client hundreds (and thousands) of miles away."

Colucci's Studio

http://www.coluccis.com

Don't miss the Colucci Studio Website! If you're like me, the single image you first see will stop you cold, and it probably does the same thing to potential photo buyers. The Website links to a portfolio page that contains sample images of Colluci's commercial fashion, high fashion, location, digital, and product photography. In the middle of these small images is a photograph of an attractive model getting ready to remove her blouse; it is accompanied by text that states, "Hold onto your shirt." And for good reason, clicking on any of the small images takes you to detailed portfolio pages showing their image for a specific category of work—all of which are enough to impress an art director or photo buyer. And when you read how Joe and Lou Colucci created this page, you'll be even more impressed. Read on.

While some photographers stuck to the format question-and-answer interview style, New Jersey photographer, Joe Colucci, answered the questions in a narrative form. Here, in his own words, is Joe Colucci's experience with the Internet.

"My brother and I started Colucci's Studio in 1985. After about a year, we experienced the major setback of a fire. We had already established a small clientele and, as fortune would have it, we did a lot of location work during this transitional time. In six months we were

Figure 8-4. Colucci Studio's Website opens with a dynamic image of a semi-clad goddess being attended by cherubs—one of whom is flying. Browsers are invited to view the online portfolio or take a tour of the studio's seven-thousand-square-foot facility.

able to put some finances together and began gain in 1987. We started with a one-thousand-square-foot facility, which we quickly outgrew. We moved to our present location of seven thousand square feet in 1993.

"We work with 8 × 10, 4 × 5, 2¼, and 35 mm formats. In November 1985, we began contemplating how computers might offer further growth to our already expanding business and decide to purchase one. Soon after becoming acquainted with the computer, I was introduced to the wonderful world of the Internet! The thought of having my work viewed within moments by anyone in the world fascinated me. I pursued the research of developing my own Web page. I ran into a friend who already was in the process of creating his own home page and together we spent many evenings working out the details. I also spent many hours of my on figuring out proper image sizes, composition, and overall presentation of the Web page.

"The page was created with a Power Macintosh 9500 using raw (HTML) editing. No Web software programs were used, only Apple Computer's Simple Text. For viewing I used Netscape (Navigator). From the time I decided to create the Web page until it was actually up and running took nearly a month. The only problem occurred when I was figuring out what the proper size for an image should be in order to be viewed at the best quality while still being safe from being used without my permission. (Author's note: how readers can deal with same problem is covered in chapter 10.)

"I enjoyed creating my Website and would not hire a consultant were I to do it again. I use two ISPs: one is Webexpert.net, the other is Interactive.net. I found that if you are somewhat knowledgeable, the ISP can help.

"(In October 1996) I have been on the Internet for four months and only recently have I been getting e-mail from prospective clients seeking quotes. I have also received encouraging compliments from people who surf the net. I would definitely encourage other photographers to get onto the Internet."

Gordon Baer Photography
http://w3.one.net/~gbphoto

Be sure to visit Gordon Baer Photography's Website. A world famous photojournalist, Mr. Baer, with the assistance of a consultant, has created a site that has a distinctly "newsy" feel about it. The last time I visited the site, it was divided into distinct sections: "The Virtual

Figure 8-5. If you want to see what a world-famous photojournalist's Website looks like, visit Gordon Baer Photography's home page. Please note all materials, both writing and photographs, on this Website are copyrighted materials. © Gordon Baer, 1996.

Gallery," where you can browse Mr. Baer's photographs and sample his services firsthand; "What's New at this Site," which features additions like the Angel collection and PhotoMirage; and "The Beatles Collection," where you can sample unique Beatles photographs.

1. Provide a brief history of your operation.

"I have been in the photography business for over thirty years, serving an international clientele. I work primarily in the areas of portraiture, both corporate and personal, specializing in the environmental portrait, as well as considerable work in the corporate advertising, health care, and fine arts arenas. My work has been published in *Time, Life, Smithsonian, National Geographic,* as well as for AT&T, IBM, and countless other business publications, large and small. I have received over eighty awards including the Nikon National Press Photographers' Association/University of Missouri World Under-standing Award, for my in-depth photographic essay calling attention to the plight of Vietnam Veterans, which is available in a book entitled *Vietnam: The Battle Comes Home.* This work has resulted in exhibitions throughout the US and Europe. I have been presented other awards from corporate and fine arts establishments."

2. When did you first get involved with the Internet?

"Mid-August, 1996."

3. Did you create your own home page or did you have a consultant do it for you?

"I had the best consultant possible, Shimon Rura (**rurahl@uc.edu**) of Cincinnati, Ohio, who was the creative force in designing the Web page. Incidentally, Shimon is in tenth grade at Walnut Hills High School."

4. Please tell us about the equipment and the software you used.

"We had the images scanned by a printing firm, and my consultant used Hot Dog for HTML editing." (Author's note: Hot Dog is a family of Microsoft Windows–based Web page editors from Australia's Sausage Software that includes a Hot Dog Pro version that includes dialog boxes to create HTML code, customizable buttons and tags, and a mini-Web browser called Rover.)

5. Please talk about the process.

"We had the page up approximately one month after our decision. We had a slight misunderstanding with our Internet service which was resolved quickly. Overall, it was a smooth process."

6. If you had a consultant create your Website, please describe the experience. If you had to do it over again, would you do it yourself or hire a consultant?

"The experience was exciting, fun, and pain free, as Shimon led me through the entire process; teaching me as we went along. I would do it again if the consultant's name were Shimon Rura."

7. Who is your ISP and what were your experiences with them?

"OneNet (**www-3.one.net**) is our ISP, and we have had no significant problems with them."

8. How long has your Website been in operation?

(As of October 1996) "Almost three months."

9. Is the maintenance of the site time-consuming?

"Most maintenance has been small and not regularly time-consuming. We will be adding more images and changing the Website soon, which may take slightly more time."

10. What have been the results? Please list any intangible results as well as the tangible ones of more sales or assignments.

"We are very new at Internet marketing, and we do not seem to have hit our target market, yet. We would greatly appreciate any assistance in our Web marketing endeavor."

11. Are you pleased with the results and will you expand your Internet presence in the future?

"The results are yet to come, and any positive response will only encourage our enthusiasm for this marketing tool. We may change our Internet presence as our strategy develops."

12. Would you recommend that other photographers get onto the Internet?

"It seems that this would be a good move for any photographer, but we will see what develops."

Bill Craig

http://www.diac.com/~bcraig

Bill Craig's Website is designed as an extension of his gallery sales and allows potential purchasers to look at images and order them directly from him. His home page was still under construction when I interviewed him, but that didn't seem to stop him from making a sale for one of his fine art photography prints the first day his Website was active. But I'll let Bill explain.

"I have been an avid photographer for over twenty years. My life as a photographer has evolved, as does everything else. In the beginning I used an inexpensive 35 mm camera and photographed the scenes that I found interesting. For the first few years I did primarily color slides. Then I purchased a Leica M3 and made the transition to black-and-white images. After realizing the limitations of 35 mm for black and white, I moved to medium format, 6 × 7 cm. As I continued to work with medium format, I began to experience that nagging constraint of having to develop the entire roll of film for the contrast of the image that I most wanted to use. Thus the birthing pains of large format began. About five years ago, I bought a large format 4 × 5 camera and took some of my most powerful images. About two years ago, I decided to start exhibiting my work. A friend of mine gave me a lead concerning The Photographer's Gallery of Georgetown (Colorado). I submitted a portfolio and was asked to become a partner in the gallery. It was during this time that my interest was kindled in the area of digital imaging. In April 1996, we moved the gallery to the Cherry Creek North area of Denver Colorado.

Figure 8-6. Bill Craig was still putting the final touches on his home page when I made this screen capture, but his site was already paying dividends.

"I started dabbling in digital imaging about ten months ago after purchasing a Power Macintosh 7200. The Power Mac is a 90 MHz with 40 MB of RAM and Adobe Photoshop. I do systems design on a UNIX platform at my other job, and learning how to use a Mac when you are used to PCs and UNIX is quite a transition. Finally, I decided to get on the Internet.

"About six weeks ago I contacted a local Internet provider in an attempt to get on the Net. The process of actually getting on took four weeks. First I got the wrong instructions, then when I called tech support, I found out that their Mac person had left the company. They finally had the software developer call me. When we talked I found out that I needed an upgrade to my operating system. So I got the upgrade to my system and he called me again and walked me through the process. I would like to mention that through the entire saga the provider was very responsive and did eventually solve the problems. Once I was hooked up I spent about a week surfing in order to get ideas for my home page.

"Netscape Navigator Gold 3.0 was recommended as the software to use in order to build a home page. So I went to the Netscape home page and downloaded Netscape. Being the neophyte that I am, I downloaded the wrong package. I got Netscape Navigator and did not realize, until the package told me to edit the program with the Gold editor, that I had only gotten part of the package and needed to get Navigator Gold. Four days ago (in October, 1996) I began building my home page which ended up taking about twenty-five hours including using Adobe Photoshop to get the scanned negatives in shape to be uploaded. I found Netscape Navigator Gold 3.0 to be an easy package to learn how to use and it can be used without writing code in HTML which can be slow. I just called up Page Wizard in Netscape and it walked me through the process via filling in the blanks. It does get tricky, if you are not familiar with URLs (paths). I am still having a problem with uploading my: **index.html** file that runs the home page. With the other files, such as, the JPEG files (image files) I just enter the upload command, enter my pass word, drag the file and drop it on the file server and it uploads. However, the new **index.html** file would not overwrite the one on the host; so to resolve this problem, I have to log off then log onto the host using UNIX commands to remove the **index.html** file, then log off. Then I must go back through Netscape and upload the file. P.S. it is a pain in the butt.

"I feel that building a home page has been a learning experience with many valuable lessons. Each person will have different experiences but the end product is worthwhile. One tangible outcome is that a home page affords you the opportunity to display your art world wide with very little up-front cost. I have my Internet service provided for twelve dollars per month; this includes e-mail, access to the World Wide Web, a 10MB home page, and unlimited time on the Internet. The first day that my home page was on the Internet, I received an order for one of my photographs. I would encourage any photographer to build a home page, for no other reason than that it is fun to see your photographs on the Internet and have others enjoy them.

"I built my own home page and would not even think of having a consultant build one for me. One reason is that I plan on revising and improving my home page on a continual basis. Another reason is that I want to develop my skills in this area and the way to do that is by learning and practicing. I am now formulating ideas and plans for the next phase of the evolution of my home page. I think that I am over the shoulder of the learning curve and things will continue to become smoother as the process of building home pages becomes second nature. It is similar to photography in the sense that operating your camera must become second nature before you can focus on creating images."

9 Open for Business

> *Life is a crowded superhighway with bewildering*
> *cloverleaf exits on which a man is liable to find*
> *himself speeding back in the direction he came.*
>
> —Peter deVries

The next step, after creating your own Website, is getting the message out to the world that you have a home page. This has to be followed up with regular maintenance of the Website and an active program of letting the companies that run search engines know you're out there. But first let's start with the basics.

Getting the Word Out

If you think that all you need to do is create an attractive Website and the phone will start ringing off the hook with assignments or stock photo sales, you're in for a big surprise. The two actions are not necessarily related. Yes, having a Website can help increase your sales, but you can't expect potential buyers to find your site amongst the two thousand that are (claimed to be) created each hour. You've got to tell people where you are doing business on the information superhighway. The Website is, in effect, a new office location, so you should start by

using the same kind of marketing techniques you would use if you opened an office out of state.

Send Out an Announcement

Your announcment can be as simple or elaborate as your budget allows, but you need to send out some kind of mailing specifically informing potential clients about your Internet presence. The first group to receive notification should be your existing client database. If you don't already have such a database, now would be the right time to start one. Since 80 percent of your business comes from 20 percent of your customers, the Website should introduce your existing clients to services that you offer, but that they may not have taken advantage of. If all you're doing is studio portraits for a company, make sure the Website features your on-location work. This is the easiest group to sell to. They already know you, like you, and have proven it by sending you money. The next group to send the announcement to are potential clients that you may have pitched but that haven't yet taken the plunge. An Internet home page may provide them with the reason to take another look at you and your work. Finally, there are those potential clients who you don't know. These names can come from purchased mailing lists, Chamber of Commerce membership rolls, or "lead" groups, such as Le Tip.

New Letterhead and Business Cards

Too often, I been given business cards with the person's Website address scrawled on the back with pencil. These are usually the same people who moved two years ago and are still penciling in their new phone number. Spending money on new cards is a small investment for a piece of advertising that tells people about your new Website. Want to design good-looking business cards or promotional materials? Stop by Paper Direct's Website at: **http://www.nyca.com/paper.html.** You've already got a computer, and if it's connected to a laser or ink-jet printer, you can create professional quality marketing material on your desktop using Paper Direct's paper products and software templates.

Standard Business Forms

Add your Website URL to *anything* that bears your name and address. This includes assignment confirmation/estimate forms, rate sheets, price lists, packing lists, and transmittal forms—you get the picture.

Advertising

Take an ad out in local business publications announcing that your Website is in operation and inviting people to come see for themselves the kinds of images you can create. This technique may allow you to get potential buyers to look at your work, who may never have seen your images using conventional print portfolio methods. Don't forget to include your URL in your Yellow Pages ad!

Maintaining Your Home Page

Your home page must be dynamic. Next to not publicizing your Website, the worst thing you can do is not make changes in your site. No matter how great the first images a potential buyer sees when they reach your home page, if they visit more than once—and are on the edge of becoming a paying customer—they need to see something different the next time. That's one reason why it's a good idea to include a tagline on your Website that states "Last updated ..." If that date is a recent one, return visitors are more likely to give you a second look. Since many photographers are frugal and hate to waste the energy and time spent creating a Web "signature" image, why not create an archive of past images? That way new visitors can also see some of these images. Providing access to past images is simple. You only need to create a link to a new page that has small images from previous months, and give viewers the ability to double-click on the small image to take them to another page containing a larger version of that image.

How often do you need to make changes? One of the benefits of using a hit counter is that it helps you determine how often you need to make changes to your Website. As I mentioned before, a hit counter is a double-edged tool. It gives you a way to track the amount of people who visit your site, but, if the numbers are low, those visitors may not be impressed. Nevertheless, if you're getting a lot of hits you want to update your site on a regular basis.

Creating a Simple Hit Counter

If after analyzing the pros and cons of hit counters you decide that you want one for your Website, just follow the instructions below.

Techie Alert: The steps to creating a hit counter are spelled out in HTML. If you do not know how to write HTML code, one of the best

places to start is a document called "A Beginner's Guide to HTML" found at **http://www.ncsa.uiuc.edu/General/Internet/WWW/HTML Primer.html.**

Any reader interested in creating a hit counter should visit the above Website. And don't forget that most Web creation programs allow you to switch modes from WYSIWYG into HTML. To switch to HTML in Claris Home Page, for example, all you have to do is click the "Edit HTML Source" button in the toolbar or chose "Edit HTML Source" from the Window menu. At this point, the program will display the exact HTML code for your Web page. You can edit, delete, or customize the code while it is in this mode. In this mode, you can use all of the usual text editing operations such as typing, undoing, cutting, pasting, copying—even dragging, finding, and replacing text—that you would find in a typical word processing program. If you've screwed up your courage and are ready to enter the brave new world of HTML programming, here's all you have to do.

- **Step 1:** because your Webmaster has to create a counter file for you, send an e-mail letting him or her know that you would like to have a hit counter on your Website.
- **Step 2:** using your favorite graphics program, create ten GIF images showing the numbers zero through nine, with one number on each image and name them from **0.gif** to **9.gif**. Be sure to use lowercase letters as shown.
- **Step 3:** upload these GIF images to your WWW directory using an FTP program like Fetch, and make sure that the graphic files are placed in your WWW directory. If you don't place them there, the counter will not work.
- **Step 4:** next, you need to modify the HTML code on your home page to let it access the GIF files. At this point, you need to decide how many digits you would like on your hit counter—up to a maximum of seven. If you decide to use all seven digits, the code for your new hit counter would look like this.

This page has been accessed times!

In this example, "login" is your official login name that has been assigned by your ISP. HTML wizards already know that they can put all of this code on a single line, but this method should keep you from making a keying error.

Making Sure People Can Find You

One of the best ways of letting people know about your Website is being listed on as many search engines as possible. This service is free, and I recommend that you contact each of the search engines listed earlier in the book to tell them about your new site. While the procedures for each search engine are a little different, here's some information about a few of the most popular ones.

Yahoo!

How does someone get their information listed in Yahoo!? Yahoo! is a database of links to other sites, they do not provide any original content—they only reference sites that already exist. To get listed, you must first set up a page on the World Wide Web. Once that's done, you're ready to move to the next step.

The first step is to check for your Website's URL. Keep in mind that you cannot add your site to the top level or any of Yahoo!'s lists of "reserved" categories. If your Website is a hit, Yahoo! will do that for you. All businesses must be placed in a "Business and Economy" category, and all listings under the Companies and Products and

Figure 9-1. Adding your Website to the Yahoo! search engine is as easy as clicking "Add URL" when surfing **http://www.yahoo.com** and filling out an on-screen form.

Services categories will be listed in alphabetical order by the company or product name. Yahoo! requests that new Websites confine all business additions to *two* categories. Be sure to pick the categories that are the most valid choices. All others will be ignored. (Personal home pages must go in the Entertainment/People category. Sometimes your ISP will determine whether you are a "business" site or a "personal" one. Make sure to ask them that up front.) If your site is regionally specific, please add it to the respective Regional information category. Comments should be kept to fifteen to twenty words. And best of all, there is no charge for listing your site.

Here's how to add your site:

1. Start by browsing the Yahoo! database and find the category where you would like your listing to appear. If you cannot find an appropriate category, use the search engine to find a category with comparable information and add to that category. If you believe that your site demands a new category, submit the site to the closest related category and be sure to fill in your proposed new category in the Additional Categories field. Yahoo! will review the site and your new category proposal, but keep in mind that they will place you where they think would be the most beneficial to Yahoo! users.

2. Once you've selected the category to submit to, click on the "Add URL" link at the top of the page for that category. This will bring up the preformatted submission form. The category information should already be filled in for you in the category box. Please do not type in the category.

3. Fill out the rest of the form. Make sure to fill in all of the fields for completeness.

4. Make sure that the Comments field consists of information about the site you are adding. This comment will be attached to your link on Yahoo! and will be viewable by Yahoo! users. Please keep comments to one or two lines (fifteen to twenty words).

5. Additional categories are allowed, but the entry might not be added to all requested categories. Yahoo! tries to limit each site to two or three categories, and entries might not be added to all requested categories.

6. If all goes well, you will receive a confirmation of your submission.

Excite

The Excite search engine has an easy way to add your Website to it. Start by visiting the site at **http://www.excite.com.** Clicking on the "Add URL" brings you to Excite's "Suggest a Web Site" page. Before adding your site they suggest that you search for it first by entering a bunch of words that appear on the page into the Excite Search form. Unusual words are better, because they will help the Excite Search distinguish the page from millions of others. If they haven't discovered you yet, then it probably isn't in their 50 million-Web-page database. To get into the database, enter the URL in a simple on-screen form. Within two weeks, their "spider" (a computer program that searches the Web) will visit the site and add its full text to their database. When you are done filling out the form, click the send button. It's that easy to be on Excite.

Magellan

You can add valuable search functionality to your Website in a snap by including it in the Magellan search box. This free service will let users of your site search for the information that interests them without having to leave your site. Getting it going is a simple process—just insert the following lines of HTML code in your home page:

```
<form method=GET action="http://www.mckinley.com/
    extsearch.cgi">
<IMG SRC="type.gif" ALIGN=MIDDLE>
<B>Search for: </B> <input type=text name=query size=30
    value="">
```

Figure 9-2. Getting registered with the Excite search engine consists of filling in the information in this simple on-screen form.

```
<INPUT type=submit value="Search">
</form>
```

Macintosh Users: download the small Magellan type by pressing on it with your mouse button and scrolling down to "save this image as" to save the file **"type.gif."**

Windows Users: download the small Magellan type by clicking on it with your right mouse button and scrolling down to "save this image as" to save the file **"type.gif."**

Two Thumbs Up

Not every site gets reviewed in Magellan; their editorial staff is picky, and your site's appearance in Magellan is something to be proud of. You can announce your accomplishment by displaying a graphic that says it all.

To get your "Reviewed by Magellan" graphic, using Netscape:

1. Right-click on the graphic (above) if you're a Windows user, or hold down the mouse button for one second if you're a Mac user.

2. From the pop-up menu that appears, select Save This Image As. Then save the image (a GIF file) to a local directory or folder.

3. You can name the GIF file whatever you want. Just remember to upload it to your home directory. You'll want to link the graphic to Magellan so your users can see what the big deal is. To do this, use code like the following, replacing the phrase "YOUR DIRECTORY" with the actual name of the directory that contains your image: ****

If you're using a browser other than Netscape, the process may be somewhat different. If so, contact Magellan by e-mail if you have any problems.

10 Cyber Theft

Copyright issues are beginning to develop concerning the Internet. Currently, only three cases have been decided by the courts, but disputes are expected to increase significantly with the growth of the Internet. Industry experts contend that copyright infringement can be subject to criminal penalties, but a high number of cases are managed in civil court.

—Chris Nerney, *Network World*

The Internet presents a greater marketing and sales opportunity for photographers than any other previous technological breakthrough, but it is not without its problems. First and foremost in many photographer's minds is the possibility of digital theft of copyrighted images.

Ali Baba and the Digital Thieves

What sends shivers down many photographers' spines is the ease with which Internet images can be illegally obtained. Most browsers, like Netscape Navigator, allow you to click on any object—like one of your best-selling photographs—and print it or copy it to the Clipboard. Once

on the Clipboard, your image can be pasted into a blank document in any kind of image editing program. From that point, many photographers feel they will have no control over their copyrighted images. To many, it is worse than the business affects of the color copier or digital copy stations; it is the color copier from hell. Before you run screaming to your lawyer, let's back up a bit.

All of the hysteria surrounding copyright issues is based on the naive assumption that stealing images isn't going on in the non-digital arena. We all know that this is not true. Even ignoring the impact of the color copier and digital copy stations, people have been stealing our images for years. Does this true story sound familiar? A client called with a quality problem. It seemed that the print of a portrait I made of their CEO was not acceptable because a publication they sent it to told them it was not reproduction quality. This sounded hard to believe, so I made an immediate appointment to meet with the client to look at the "problem" prints. Before I went, I pulled the client's file and a file print of the same image. When I went to her office, I asked to see the bad print and she showed me the poorest quality copy print I had ever seen. It was flat, unspotted, and covered with scratches. At that point I whipped out the file print and told her that this was the quality of the prints that I had delivered and without naming names suggested that someone in her organization had made illegal copies of my originals. I left with a big print order and a client better educated in what copyright means on a most practical level.

Here are a few other examples of non-digital theft. FPG, a New York stock agency, received an out-of-court settlement for $20,000 from a newspaper that illegally copied one of their photographer's slides that had been sent for review. When a New Jersey Federal District Court awarded photographer Edward Sarkis Balian $156,000 in a copyright infringement case, he wrote, "I think a message should be sent to these defendants and frankly to those people who are similarly inclined. I think the way to get the attention of a thief is to hit him in the pocketbook." Ed Balian's fine art print had been copied with a camera mounted on a copystand with nary a pixel to be found anywhere.

Digital Protection
Don't let all this reality depress you. There are a few things that you can do to protect your images on the Internet, and I'm going to share them with you.

Copyright Symbols

One of the most obvious ways to protect the rights of your digital images is with a visible copyright symbol. One of the easiest ways is to use a plug-in for your image editing programs. The one that I use is a Macintosh shareware Photoshop plug-in (ten-dollar fee) called Watermark. It was created by John Dykstra, and adds a faintly-visible copyright symbol (©) to the image being edited. When used on an image that will be distributed in digital form, it allows clients to evaluate that image and use it FPO (For Position Only) and for comp purposes, while preventing unauthorized usage. To use this plug-in, you must have a TrueType version of the Times font installed. To use Watermark, select it from Filter's "Other" hierarchical menu. A dialog box will appear, allowing you to specify how much the copyright symbol will affect the image. A value of one is almost invisible; a value of ninety-nine results in a complete reversal of the image underneath the watermark. The Repeat field controls how many times the copyright symbol is placed horizontally across the image. The default setting of one produces a single symbol scaled to cover the current selection. Clicking the OK button in the filter's dialog box will create the watermark. If the filter processing takes more than a couple of seconds, a status window will appear to show you Watermark's progress.

Watermark is available from the Adobe Photoshop library on CompuServe and from other online and shareware resources. This software is shareware, so if you use it for commercial purposes or if you keep a copy of it after the initial two week evaluation period, please pay for it. Besides keeping your conscience clear, your payment will ensure that Mr. Dykstra and other shareware developers will continue to

Figure 10-1. John Dykstra's Watermark plug-in was used with a setting of one (the default) to place a single, subtle copyright symbol across this image, that was digitized by Seattle FilmWorks Pictures On Disk process. (Original photo, ©1996 Joe Farace)

provide you with useful and inexpensive software. The shareware fee for Watermark is ten US dollars. Please send a check or money order to: John Dykstra Photography, 4788 Anderson Lane, Saint Paul, MN 55126-5853.

Digital Watermarking

Let's look at another approach to watermarking images—this time with an invisible, digital mark.

The digital watermarking feature in Adobe's Photoshop 4.0 is based on a software plug-in called Imagemarc Lite from Digimarc Corporation. Digimarc's technology allows image creators to imbed an invisible digital watermark into an image. The watermark carries an "image signature," that contains copyright and owner contact information in the form of a creator serial number. This number can include full contact information available via the Internet. The watermark is part of the image and remains so even when printed—and can be read later by scanning the image into a computer. Imagemarc Lite is designed to integrate with image tools and Web browsers so that, as an image is opened by programs such as Adobe Photoshop or Netscape Navigator, the user is informed that a watermark is present. Clicking on an icon allows the user to view the image signature to discover the photographer's contact information. This watermark persists through copying, editing, downloading, and even through photocopying and color print reproduction.

Image Size and Resolution

One of the most powerful protection tools you have at your disposal is the ability to create small, low-resolution images. Here's a three-step process for reducing file size and resolution while only minimally affecting on-screen appearance. I use Adobe Photoshop, but other programs have similar ways to adjust image size and resolution, check your user's guide. After you've opened your image, use the Image Size command in the Image menu. This opens a dialog box that shows the image's height, width, and resolution. Next, change the number in the resolution field to 72 dpi. Doing this also dramatically reduces the file size. When changing the resolution to 72 dpi for a 16.2MB TIFF image, its size was reduced to 968K. To carry this process one more step, save the file in a compressed format like GIF (or JPEG). When my test image was saved as a medium resolution JPEG file, its size was further reduced

Figure 10-2:. Adding an invisible copyright watermark to your photographs is as simple as using the Digimarc plug-in found in Photoshop's Plug-in menu. When you select it this is what you see. Clicking the "customize" button allows you to provide full copyright and contact information.

to 162K. One last step you can take is to use that same Image Size dialog box to reduce the physical size of the photograph. Since, unlike a print, it will be viewed quite close, make the digital image wallet-sized. The resulting file will look fine on-screen, but if downloaded and printed, it will have less-than-usable quality. Will this reduction in quality be bad enough to scare a digital thief? The sad answer is no.

You can extend this resolution-based protection by using a utility like Digital Frontier's LLC's HVS Color plug-in. This useful software tool is designed for Adobe Photoshop and compatible programs, and allows you to convert 24-bit images to 8 bits with no visible loss in quality. The results allow you to have realistic photographic images saved as a GIF files, providing all the advantages of 24-bit image, but at less than a third the file size. Because HVS Color achieves its effects without dithering, your GIF files will compress 5–40 percent better, meaning less download time for your Web pages. HVS Color provides a superior method of reducing images with 17 million colors to 256 or less colors with no visible image degradation. Because dithering is not used, greater than normal compression ratios (10–40 percent or more) can be achieved with lossless compression formats, such as GIF. A built-in thresholding mechanism allows selective flattening of dark and light colors, which also has a positive effect on compression. In addition, HVS Color's high quality allows images to be produced using far fewer colors, further improving compression and allowing browsers, such as Netscape Navigator, to perform more optimal color allocation. For the protection minded, it means that, if your image can be displayed with 50 colors, instead of 17 million, it makes it more difficult to use for other than on-screen viewing. Yet, on-screen viewing will be improved. HVS Color allows the user to achieve 24-bit image quality using an 8-bit system, without dithering or any visible banding. The product is available as a

plug-in for Mac and Windows version of Adobe Photoshop and compatible image editing programs, as well as for the custom code modules found in Equilibrium Technologies' DeBabelizer file conversion utility for both 68K Macintosh and Power Mac.

The bottom line is that your images are as safe on the Internet as they are anywhere else. Once the images leave your hands—no matter what form they may be in—they are fair game for thieves, *goniffs*, and other rip-off artists. What you can do regarding digital images is to work smart and take all the reasonable precautions that you can, but never lose sight that nothing will prevent a determined thief from stealing your copyrighted images.

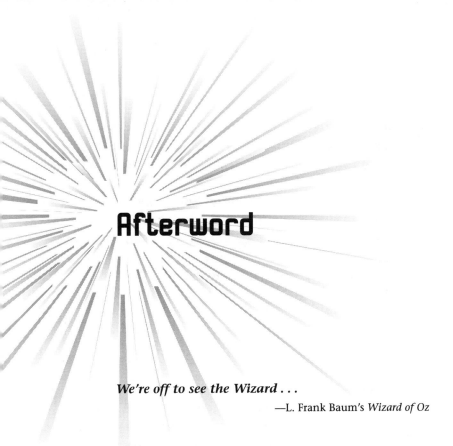

Afterword

We're off to see the Wizard . . .

—L. Frank Baum's *Wizard of Oz*

The Internet is at much the same stage that television was in the late 1940s. The technology was largely perfected, but more advancements would be necessary to make it the ubiquitous phenomenon that it is today. The same is true for content. In the 1940s, the airwaves were full of everything from "Captain Video" to "Super Circus" to "The Texaco Star Theater" with Milton Berle. Like television, the Internet and World Wide Web have the potential for being a major force in consumer advertising and consumption, while the interactivity provides opportunities for photographers and other small business people. Unlike television, which required—and still requires—huge expenditures to begin broadcasting, setting up a home page can be done by the average photographer with a few thousand dollars worth of hardware and software. That is the purpose of this book—to get you to that point. But what about the future? For a glimpse into what might hold true for the Internet, I urge you to check out a Website called The Palace at **http://www.the palace.com.**

Welcome to The Palace

The Palace uses an entertainment-based technology which creates a multimedia, graphically *shared* environment. You can see, chat, and interact with anyone else who is on the same Palace server, and they can see you, too. Unlike other, more passive Internet activities, The Palace allows you to exist in a pseudo-virtual world, where you can see and be seen the way you want to be seen. While in a Palace environment, you have complete control over your appearance (known as your "face" or "avatar"). This might be an actual picture of your face or Bugs Bunny's head. Your avatar can be anything. You can change it easily and quickly. You can change it several times in one Palace session and everyone else in there sees the change instantly (this lets you do many funny and interesting things on the fly). You can move through different rooms on that server and interact with games or other elements of the environment. The way it works is most similar to the World Wide Web: there are clients—the Palace software—and servers. Both elements act just like Web browser clients and Web servers. When a Palace client jumps to a Palace server, the software presents a virtual environment in which other avatars, who are also on that server, are visible. You can talk to them and interact with them as well as the Palace environment on that server. Just like the Web, you can jump from server to server seamlessly, moving from one Palace environment to another by moving your avatar through a "hyperdoor," which acts much like an hyperlink. ("Hyperdoors" in a Palace site let visitors step through to go to a room on another Palace server elsewhere on the Internet.) Like Web Pages, Palace sites are fully configurable and modifiable. There are many servers, and the Palace server runs on Windows, Macintosh, UNIX, and NT machines. Each Palace site can have its own individual look and flavor. A scripting language (called IPTSCRAE) allows you to build your own functionality into your Palace site, much like Java allows expansion of Web pages. By using this built-in expandability, the Palace creators have created a chess and checkers game, which two or more people can play over the Net. You can see this for yourself in the Time Warner Palace.

Some other multimedia or virtual reality elements which have recently come on the scene as additions to Web browsers are very powerful and share a resemblance to some of the outward appearances of the Palace. These technologies, however, are enhancements to Web

browsers—they do not support several key architectural requirements that a virtual shared space must have. For example: VRML allows you to move in a 3D environment, but there are no other people in there with you! Java integration is essentially the same: complex multimedia can play back locally on your system, but there is no interaction with others on that same server.

The Palace is not 3D. The primary reason is that the Palace is first and foremost meant to be the best online social space possible; it is not meant to be an imitation of reality. 3D works present problems in a shared virtual social space: you can't always see people that are in a room with you; you have to "walk" between spaces that are far away from one another, instead of just "going there." In short, projecting 3D into the inherently 2D universe of the computer monitor leads to some distortions and bad metaphors which are not best served by a "faux 3D" environment. A 3D environment would impair the "browseability"' of moving easily from Palace server to Palace server across the distributed environment of the Internet. Each time you come to a new server, there is new information to be downloaded to your computer. If the Palace were 3D, the amount of that information would be staggering, taking several orders of magnitude longer to download.

Surf on over to the Palace and download the software. Software is free but there is a modest twenty five dollar fee to register the software ensuring access to upgrades, etc.

Real-Time Video

While some computer users seem content to use the Internet for e-mail, some others are using it as a telephone—which seems like a waste to me. A better use is the creation of real-time video conferencing. What is exciting about this product is that it is no longer limited to the conference room of Fortune 500 CEOs; you can have real-time, interactive video on your desktop using an inexpensive camera such as Connectix's QuickCam and software called CU-SeeMe. A free version is available from the developer, Cornell University, at **ftp://gated. cornell.edu/pub/video/**, while an enhanced version (including a working demo) can be obtained from White Pine Software at **http:// goliath.wpine.com/cu-seeme.html.**

Enhanced CU-SeeMe is White Pine's desktop video conferencing software for real-time, person-to-person, or group conferencing. You can

use CU-SeeMe over the Internet allowing photographers, and anybody else, to communicate globally without expensive hardware. This software-only solution runs on both Windows and Macintosh computers, offering full-color video, audio, chat window, and white board communications. You can participate in "live over the Internet" conferences, broadcasts, or chats. CU-SeeMe can be launched directly from Web pages with your favorite Web browser. All of this and more over your 28.8k modem, ISDN link, or better. (For audio-only telephone use, CU-SeeMe works effectively over a 14.4k modem.)

Enhanced CU-SeeMe uses a unique protocol to manage, receive, and rebroadcast video and audio data. This protocol was developed specifically for TCP/IP networks such as the Internet and is also capable of running over ISDN networks that have TCP/IP support. Using CU-SeeMe technology person-to-person, group conferencing, and large audience broadcasting over TCP/IP networks are possible—with little or no added cost for making connections. CU-SeeMe achieves low-bandwidth connections through software-only algorithms that reduce data transmission and save you money. The software does not require expensive hardware compression/decompression (codec) boards and can be used with most video boards that support Video for Windows. Similarly, CU-SeeMe supports Apple's QuickTime to display video for Macintosh computers.

CU-SeeMe is multiplatform and supports Windows, Windows 95, Macintosh, and Power Macintosh environments. Participants can view up to eight participant windows and an unlimited number for audio and talk windows. It has a Whiteboard feature for collaboration during conferences—just the thing when discussing layouts with an art director in another city. CU-SeeMe supports 24-bit true color and 4-bit grayscale.

Connectix QuickCam

One of the keys to making teleconferencing and real-time video is having the right video hardware. Connectix introduced a golf-ball sized color video camera that fits on top of your monitor. The camera can produce 24-bit, 640 × 480 pixel video. The camera has a fast f/1.6, 5.7 mm focal length (48 degree angle of view) and manually adjustable focus lens that can record close-ups of objects as small as the serial numbers on a dollar bill or as large as a conference room. Connectix' proprietary VIDEC (Video Digitally Enhanced Compression) technology compresses video data at a 4:1 ratio with only slight loss in video quality

allowing users to get faster frame rates and larger frame sizes. At a color depth of thousand of colors (16-bit), a Power Macintosh user can expect 24 fps (frames per second) at a size of 160 × 20 and 10 fps at 320 × 240. An Auto-Hue feature adjusts the QuickCam to get natural colors when used under incandescent, fluorescent, natural, or mixed lighting conditions, and an Auto Brightness feature adjusts the camera to fit the quantity of light present. With a street price under $200, it can be attached to your computer and be operational in less than five minutes.

Figure 11-1. For under $200, Connectix' Color QuickCam is an inexpensive video camera, allowing users to exploit the video con- ferencing and real-time video aspects of the Internet.

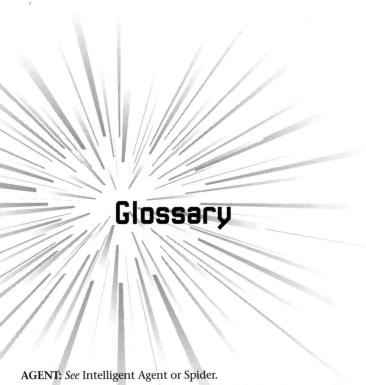

Glossary

AGENT: *See* Intelligent Agent or Spider.

ANCHOR: A spot on your Website that is linked to places on the same Web page or on other Web pages.

API: Application Program Interface. A format used by a software program to communicate with another program that provides services for it. APIs carry out lower-level services performed by the computer's operating system. In Microsoft Windows, an API helps applications manage windows, menus, icons, and other graphic user interface elements.

ARCHIE: Archie is an acronym loosely based on the word "ARCHIvE." Until the World Wide Web came along, if you wanted to search the Internet you only had a few choices: Archie, Veronica, and WAIS. Archie is an Internet utility that is used to search for file names. Over thirty computer systems on the Internet act as Archie servers and maintain catalogs of files available for downloading from FTP sites. On a random basis, Archie servers scan FTP sites and record information about the files that they find. Several companies, such as Hayes, offer software that provide a menu-driven interface that lets you browse through Archie servers on the Internet. Archie can be reached at **archie.mcgill.ca** and **archie.sura.net.**

ARPANET: A computer network created in 1969 by the Advanced Research Projects Agency of the US Department of Defense to enable scientists to communicate with one another. This was the real beginning of the Internet and consisted of four computers. By 1972, fifty universities and research sites had access to it.

AVATAR: In Hindu mythology, the form taken by a deity when descending to earth. The *American College Dictionary* prefers a more down-to-earth use as a concrete manifestation or embodiment. Both definitions seem to fit the computer-related meaning of the term "avatar," which was popularized in the science-

fiction novel *Hacker and the Ants* as the representation of a user in a 2D or 3D virtual reality world.

BINHEX: Binary Hexadecimal is an algorithm for representing non-text Macintosh files (such as software, graphics, spreadsheets, and formatted word processing documents) as plain text so they can be transferred over the Internet. The file-name extension **.hqx** designates a BinHex file.

BISDN: Broadband ISDN is built on fiber optic technology that increases ISDN's potential top data transmission speed to 155,000,000 bps.

BITMAP: Graphic files come in three classes: bitmap, metafile, and vector. A bitmap (formerly known as raster) is any graphic image that is composed of a collection of tiny individual dots or pixels—one for every point or dot on a computer screen. The simplest bitmapped files are monochrome images composed of only black-and-white pixels. Monochrome bitmaps have a single color against a background while images displaying more shades of color or gray need more than one bit to define the colors. Images, like photographs, with many different levels of color or gray are called *deep bitmap,* while black-and-white graphics are called *bilevel bitmap.* A bitmap's depth is permanently fixed at creation. The screen shots that accompany this dictionary have a resolution of 72 dpi (dots per inch). No matter what you do, you can't change this. You can make them bigger, but not better.

BOOLEAN SEARCH: A search for specific data that gives you the ability to specify conditions and allows you to use one or more of the Boolean expressions, AND, OR, and NOT. (Don't let the term "Boolean" scare you. It comes from Boolean logic, developed by English mathematician George Boole in the mid nineteenth century, in which an answer is either true of false.) An example of a Boolean search would be "find a photo lab that processes black-and-white film AND Kodachrome." Database programs typically allow you to make Boolean searches for data and so should a good Internet search engine.

BPS: Bits per second, sometimes called baud.

BRI: The Basic Rate Interface for an ISDN connection includes three separate channels—two B channels and one D channel—as standard. This means you can be talking on your telephone and surfing the Internet at the same time.

CD UDF: Compact Disc Universal Disc Format. A new disc format that defines a common scheme called "packet writing" established to assure inter-changeability of CD-R discs allowing CD-R drives to be integrated into computer systems so that they behave like any other removable media drive. CD UDF also creates a bridge between CD-ROM discs and the format selected for Digital Video (Versatile) Disc media. The CD UDF format was developed and proposed by the Optical Storage Technology Association (OSTA) by an alliance of companies including Adaptec, Hewlett-Packard, Phillips, and Sony. More information can be found at OSTA's Website: **http://www.osta.org.**

CD-ROM RFS: CD-ROM Recordable File System. A new method of recording CD-ROM discs on the desktop, engineered by Sony, that should make saving a file (or stack of files) onto a CD-ROM as easy as saving to magnetic media. The CD-R discs that are part of the system already have some software written on them allowing the disc to be read by Macintosh and Windows computers. (As I write

this, the system is brand-new and its overall impact is yet to be felt, but, if it works as proposed, it could have a major effect on removable media storage, especially for photographers. Unlike traditional magnetic or magneto-optical media, the CD-ROMs produced would be completely cross-platform.)

CERN: European Center for Nuclear Research was the original designer of the World Wide Web.

CGI: Computer Graphics Interface is a device-independent graphics language that is used for display, printers, and plotters. It is an extension of another language. *See* GKS.

CHANNEL: As used in digital imaging, channels are similar to the plates or separations found in the commercial color printing process. In an RGB image, you will find separate channels for Red, Blue, and Green, along with a composite RGB channel. Adobe Photoshop, and similar programs, includes a channels palette that allows you to look at—and manipulate, if you wish—each specific color layer. Channels are different from "layers." *See* Layer.

CLIENT: (1) Within the context of the Internet, this is software that requests information. A WWW browser, such as Microsoft Internet Explorer, is often referred to as client software. (2) In more traditional (hardware) usage, a client is a computer—sometimes called a workstation—attached to a local area network.

COCOA: A graphical programming language.

CODEC: COmpression/DECompression. Usually codec refers to a hardware product that produces compression and decompression for video—especially videoconferencing.

COMPUSERVE: A computer network, started and originally owned by tax accountants H&R Block, that can be accessed by subscribers to the service by using a modem. Using an on-line service lets you get up-to-date information as well as minor software upgrades (especially drivers for printers, scanners, and monitors) from the companies that produce these products.

CompuServe sells starter kits that include software called CompuServe Information Manager (CIM) which is available for Windows and for Macintosh computers. CompuServe has a minimum monthly billing (less than ten dollars) that includes a number of hours of access time. Time that exceeds that amount is billed additionally. Think of it like cable TV. The basic monthly rates include basic service, but if you want any premium services, such as the Photography Forum on CIS, it will cost a little extra. The Kodak Photo CD Forum is included in the basic service. You can run up a big monthly bill, but since CompuServe has lower rates after normal working hours there are ways to keep your actual bills quite modest in size. Access in most metropolitan areas is through a local phone number, so you won't have any toll charges to deal with.

One of the fun places CIM can take you is the Photography Forum. CompuServe calls sections of the network where people with common interests congregate, forums. A forum's message section allows you to post messages on what amounts to a community bulletin board eliciting feedback and comments from photographers all over the world. If you want to keep it private, use e-mail. The libraries are places where members of the forum post images and

shareware and/or freeware. You can also go to the on-line libraries listed to download information from the different conferences mentioned in the Newsflash. From time to time, conferences are held with experts available to answer your questions. These are live conferences and can include hundreds of electronically connected participants from all over the world. Some may ask questions and offer opinions, while others (called "lurkers") sit quietly and absorb what's being said. The first time you participate in a world-wide conference you will know what Buckminster Fuller meant by "global village."

Another forum—for pros only—is called the Photo Pro Forum and it has sixteen sections, including some reserved for members of the Professional Photographers of America (PPA) and the American Society of Media Photographers (ASMP), covering everything from darkroom techniques to cameras to stock photography and business matters.

There's more to CompuServe than both the Kodak Photo CD and the above mentioned photography forums. Fuji Photo Film and Polaroid have forums and there are tons of forums on Microsoft Windows and Macintosh-related subjects. Large software manufacturers, like Claris and Adobe, have their own forums where you can download updaters, that can fix any of your program's bugs with or just ask questions of experts about a given program. Smaller manufacturers, like Berkeley Systems, can be found in one of the Vendors forums that gather ten or so companies together. It would be hard not to find answers to your business or photography questions.

COOKIE: Originally a term associated with a network software component of UNIX, these are software entities that store information about a specific user—you—so that the next time this information is required, it is seamlessly provided. For example, if you access parts of the Web that require a separate password for entry, the cookie files saves it and when requested, provides the information to a "smart" server or Website thus allowing instant access. Cookie files store information— originally provided by you—in a (generally) unreadable text file for future access. Netscape Navigator uses a **COOKIE.TXT** file for this purpose.

CYBERDOG: This package of interrelated components is not a browser, per se, but nevertheless tries to make net surfing—not just Web browsing—more intuitive than a typical browser. Created by Apple Computer, Cyberdog is a set of Internet-related components that have a consistent interface. If you double-click on an Internet address, Cyberdog opens the object, whether it's a Website, a picture, or a file.

DCT: Discrete Cosine Transform. A bit rate reduction algorithm that is used in JPEG image compression to convert pixels into sets of frequencies.

DDS: Digital Dataphone Service is an AT&T private line digital service that provides transmission rates from 2400 to 56,000 bps. Not to be confused with a DAT (Digital Audio Tape) format used for creating data back-ups called Digital Data Service. Doesn't having two computer-related terms with the same initials make you wish there was an acronym czar?

DESPECKLE: The despeckle filter found in Adobe Photoshop (and other image-editing programs) detects the edges of an image—where significant color

changes occur—and blurs a selection except the edges. This has the effects of removing noise while preserving detail.

DLL: Dynamic Link Library. Microsoft Windows (3.1, 95, and NT) use dynamic link libraries as a standard method for linking and sharing various functions of the operating system. When a program is launched through Windows 95's Start menu, the program calls for and causes one or more DLLs to be loaded to assist the program with what it does. It could be sound support, graphics file translation, or in short, any repetitive operation that might be shared by several applications.

DMA: A circuit on a computer's motherboard that provides direct access to a peripheral, like a removable media drive, bypassing the microprocessor chip to speed data throughput.

DSP CHIP: Digital signal processor chip.

E-ZINE: Electronic Magazine. (Sometimes referred to as "Webzine.") Current estimates place the number of purely electronic magazines (as opposed to electronic versions of traditional print media) on the World Wide Web at three hundred. One of the highest profile e-zines is *Slate,* edited by writer, pundit, and TV personality Michael Kinsley, and produced by Microsoft, but there are many others on the Web.

FAQ: Frequently Asked Questions. A term, often found on Internet home pages, that will lead you to an area containing the most frequently asked questions that visitors to the Website may have. For the photographer, this is an excellent way to answer the number one question: how much will it cost? A FAQ section in your own home page is the perfect place to post your rate sheet as well as terms and conditions that address other potentially contentious questions such as ownership rights and charges for additional usage. Getting these sticky issues out of the way—even before sending, faxing, or e-mailing an assignment confirmation/estimate form—will make for smoother negotiations on an assignment or stock image purchase later on and in future dealings with a picture buyer.

FILTER: A plug-in is a small software application that can be added to your graphics or image-enhancement program to produce a special effect within user-definable parameters. When used with image-enhancement programs, like Adobe Photoshop, special effects similar to what can be achieved with modular camera filters—like Minolta's Cokin system—are also possible. Instead of screwing these filters on to the front of your lens, all you need to do is copy them into your image editing program's "Plug-Ins" folder or directory and they will appear within its Filter menu. One of the first digital filter packages available was Aldus (now Adobe) Gallery Effects, and it remains one of my favorites. Other popular filter packages include MetaTool's Kai's Power Tools 3.0.

FITS: Functional Interpolating Transformational System technology used by the Live Picture image manipulation program. Under FITS, instead of storing an image pixel by pixel, it is stored as a mathematical formula allowing files greater than 100+MB to be manipulated as quickly as 1MB images.

FLASHPIX: A new, open standard for digital imaging developed by a consortium of companies including Eastman Kodak, Hewlett-Packard, Live Picture, Inc.,

and Microsoft. The format will use a hierarchical storage concept allowing images to take less RAM and hard disk space than previous image-based graphic files. This will allow users to work with many on-screen images at the same time without overloading the computer's memory or adversely affecting performance. Edits will be easier, especially non-destructive edits, such as rotation, scaling, and color and brightness adjustments. This means that users will be able to experiment with changes and quickly undo them, without destroying original image data.

FREEPPP: A control panel device needed to set up the PPP connection using the CompuServe local access number. FreePPP is commonly used for PPP dialup and is not a CompuServe product. CompuServe's own PPP Utility will set up the FreePPP and MacTCP configuration and preferences for Internet access through CompuServe.

FTP: File Transfer Protocol is that part of the TCP/IP protocol that lets you send and receive files on the Internet.

FUZZY SEARCH: The least common type of search (in search engines) uses so-called "fuzzy" logic to look for data that is similar to what you are trying to find. (Fuzzy logic was originally conceived in 1964 by Lotfi Zadeh, a science professor at the University of California at Berkeley, while trying to program computers for handwriting recognition.) This is the best approach when an exact spelling may not be known or when looking for related information. If you're looking for information on the images of Jerry Uelsmann and don't know how to spell his name, you type in "Ulesman" and a fuzzy search could lead you to the correct location.

GIF: (pronounced like the peanut butter) The Graphics Interchange Format developed by CompuServe is a completely platform-independent, compressed bit-mapped file. The same file created on a Macintosh is readable by a Windows graphics program. Because some image and graphics programs consider GIF files to be indexed color, not all software read and write GIF files. But many do.

When CompuServe developed the format, it used the Lempel-Ziv-Welch (LZW) compression algorithms as part of the design believing this technology to be in the public domain. As part of an acquisition, UNISYS (formerly Univac computers) gained legal rights to LZW, and a legal battle has ensued. The way it stands now, reading and possessing GIF files (or any other graphics file containing LZW-compressed images) is not illegal, but writing software which creates GIF (or other LZW based files) may be. In late 1994, CompuServe and Unisys announced that royalties would be required on the GIF file format.

In response, developers worked to replace the GIF file format with an improved royalty-free format. A coalition of experienced independent graphics developers from the Internet and CompuServe formed a working group and proceeded to design the new format. The result is the PNG format.

GKS: Graphical Kernel System is yet another device-independent language for 2D, 3D, and raster graphics images. It allows graphics applications to be developed on one system and easily moved to another with minimal or no change. The CGI used on the World Wide Web is an extension of this language. *See* CGI.

GOPHER: A software tool that enables you to browse Internet resources. It was

developed by programmers at the University of Minnesota—home of the Golden Gophers—and features a menu that allows you to "go for" items on Internet, bypassing the typical complicated addresses and commands. You can navigate the Internet using Gopher by selecting the desired item from a series of lists and continuing through a series of lists until you locate the information you are seeking. While Gopher is a software program, Gopher sites are often called simply "Gophers."

HREF: HyperText reference. The address (*see* URL) of the destination of a HyperText link.

HTML: HyperText Markup Language, a format used on World Wide Web home pages on the Internet that uses multimedia techniques to make the Web easy to browse.

HTTP: HyperText Transport Protocol. The communications protocol used on the Internet—specifically the World Wide Web—to share information. The first part of any Website address is: **http://**.

IAB: The Internet Activities Board is ostensibly the Internet's governing body.

IETF: Internet Engineering Task Force, a subcommittee of the IRTF that who works on specifications for new standards for the Internet.

IMAP4: Internet Message Access Protocol, version 4.

INTELLIGENT AGENT: (sometimes just called "agent") This is software (or hardware too for that matter) that has been taught something through the use of heuristic programming techniques. An agent can therefore be taught your preferences and then accomplish tasks according to them. It can, for example, know that you always log on the Internet in the morning and go to a certain Website and look for new information about new photography products or film. Therefore it can be programmed to do that automatically as soon as you launch your Web browser. The possibilities are much greater than that, however, and the use of Intelligent Agents will be more prevalent in both Internet and system software.

INTRANET: A private computer network that uses the same look and feel as the World Wide Web and combines HyperText links with text-based information, animation, graphics and video clips.

IPTSCRAE: (pronounced *ipt-scray*, like the pig-Latin word for "script") A programming language that can be used to create special event-handlers which can be attached to doors, hotspots, and props. IptScrae can be used to make on-line virtual reality environments, such as The Palace, an interesting place.

IRC: Internet Relay Chat. A system that allows users to interact in real-time with other people connected to the same channel. Some pundits have likened IRC to Citizen's Band Radio and for years the Citizens Band Simulator on CompuServe that has been a popular area for its subscribers.

IRTF: The Internet Research Task Force is a subcommittee of the IAB that investigates new technologies, which it then refers to the Internet Engineering Task Force.

ISDN: Integrated Services Digital Network is the international standard for transmission of voice, data, and video at 64,000 bps over completely digital circuits and lines. Because this is a purely digital system, modems are replaced

by simpler terminal equipment connecting computers to the telephone network. Two problems are standing in the way of widespread acceptance of ISDN: the high cost of terminal equipment and the high costs for telephone companies to upgrade their central office hardware and software to ISDN.

ISP: Internet Service Providers. Companies that offer direct access to the Internet through local or toll-free telephone connections, often at a flat ("all you can eat") rate.

ITU-R: International Telecommunication Union-Radiocommunication Sector.

JAVA: Not an acronym, Sun Microsystems' Java is an object-oriented programming language that uses the most useful features of other languages, yet remains easy to use. It was created to construct software for embedded systems in the electronics market, and originally began as a subset C++ and other languages. It is different from traditional C-based languages because it is portable. Java 1.0 enables developers to write small applications, "applets," that can be embedded in a Website using a standard HTML tag and can transfer these applets from a server to a user's Web browser where they can be viewed on-screen.

JPEG: An acronym for a compressed graphics format created by the Joint Photographic Experts Group, within the International Standards Organization. Unlike other compression schemes, JPEG is what the techies call a "lossy" method. By comparison, LZW compression used by other processes, such as CompuServe GIF is lossless—meaning no data is discarded during the compression process. JPEG, on the other hand, achieves compression by breaking an image into discrete blocks of pixels, which are then divided in half until a compression ratio of between 10:1 to 100:1 is achieved. The greater the compression ratio that is accomplished, the greater loss of sharpness you can expect. JPEG was designed to discard information the eye cannot normally see, but the compression process can be slow.

LAP: Link Access Procedures are a family of ITU error correction protocols.

LAYER: This is the digital equivalent of the clear Mylar, or "onionskin" paper, that artists place over a graphic element or photograph so additional images may be drawn or placed over the original design. In image-enhancement programs, like Adobe Photoshop, layers can be used for creating separate—and cumulative—effects for an individual picture. Layers can be manipulated independently and the sum of the individual effects on each layer make up what you see as the final image. Since the contents of a layer can be an object, layers are treated as different than channels.

LDAP: Lightweight Directory Access Protocol.

LINUX: A shareware version of the UNIX operating system that has been designed to operate on PCs. The current version will run on 386 and faster machines and is available through download on the Internet. Another source is a series of Linux based CD-ROMs from Pacific Hi-Tech. (800) 765-8369.

MacTCP: Macintosh Transmission Control Protocol is a Control Panel that is bundled by Apple Computer as part of the System 7.5 (or greater) software package. MacTCP is Apple's implementation of the TCP/IP that is the official protocol of the Internet. If you have not upgraded to System 7.5 yet, this is just another reason that you should.

MASK: Many image-enhancement programs have the ability to create masks—Live Picture has a class they call "stencils"—that may be placed over an original image to protect parts of it and allow other sections to be edited or enhanced. Cutouts or openings in the mask make the unmasked portions of the image accessible for manipulation while protecting the rest of it. Graphic artists who previously used Rubylith material to create masks will be glad to find that digital masks are part of their digital repertoire too.

MCF: Meta Content Format.

MIME: Multipurpose Internet Mail Extension. This protocol was developed by the Internet Engineering Task Force for transmitting mixed-media (graphics, audio, video, etc.) files across TCP/IP networks like the Internet.

NCSA: The National Center for Supercomputer Applications at the University of Illinois at Urbana-Champaign. Founded in 1985, NCSA provides supercomputer resources to universities and organizations and has a major World Wide Web site. Their main claim to fame was the creation of the Mosaic Web browser software that has mutated into several versions that are used by sources as diverse as NetCom, Microsoft, and CompuServe. The on-line world, being as acronym-riddled as the rest of computing, has another NCSA. This one, the National Computer Security Association, was founded in 1989 to create awareness about and provide a clearinghouse for computer security issues. When you say NCSA to most Webheads, they think of Mosaic and the first acronym.

NEWSGROUPS: All of the news that's found on the Internet is called NETNEWS and a newsgroup is a running collection of messages on a particular topic.

NSFN: National Science Foundations Network is a major link in the Internet that connects supercomputer locations and 2500 scientific and educational institutions around the world.

OLE: (pronounced *oh-lay*) Object Linking and Embedding. A document protocol that Microsoft created for Windows 3.1 and Windows 95 that permits a document to be embedded within or linked to another one. When an embedded object (it can be text, graphic, sound, or movie clip) is clicked, the application that created it is loaded—if it's on your hard disk—so you can edit it. Any changes made to the embedded object only affect the document that contains it. If an object is linked instead of being embedded, the link is to an original file that is located outside of the original document. If you make any changes to the linked object, all the documents that contain that link are automatically updated the next time you open them. This is especially important in studio management spreadsheets where data, such as a photographer's film cost list, expense sheet, or hourly rates, are linked to another spreadsheet. OLE keeps track of all of these links and updates the linked master files as changes are made to the components.

OSTA: Optical Storage Technology Association.

PCMCIA: Personal Computer Memory Card International Association. The cards referred to in the organization's title are small credit-card sized modules that were originally designed to plug into standardized sockets of laptop and notebook-sized computers.

To date, there have been three PCMCIA standards: Type I, Type II, and Type III. The major differences between the types is the thinness of the cards. Type III are 10.5 mm thick, Type II is 5 mm thick, and Type I is 3.5 mm thick. The modules come in many applications that vary depending on the type and thickness. For example, there are PCMCIA cards for additional memory, hard disks, modems—you name it. PCMCIA has become such a mouthful to say that at COMDEX 95, manufacturers of these wonderful devices have agreed on a new buzzword to replace it. If you see the term PC Card, what they really mean is PCMCIA.

PDF: Adobe's Portable Document Format is a cross-platform file format that can be created by Adobe's Acrobat (and other kinds of compatible software including the new PageMaker 6.5), that preserves the fidelity of all kinds of documents including text, photographs, and graphics—across a wide variety of computer platforms, printers, and electronic distribution methods. It is yet another attempt at creating a "paperless" document system and while it has been slow to catch on, it *has* been catching on.

Adobe Acrobat is a family of universal electronic publishing software tools that allow users to create electronic documents that maintain the "look and feel" of the original—including all fonts and images—and can be distributed on electronic media including the Internet, World Wide Web, CD-ROM, and on-line services. The free Acrobat Reader software lets users view, navigate and print PDF files, and supports Windows 95, Widows 3.1, Windows NT, and Macintosh as well as DOS and workstation environments. Acrobat Reader software can be downloaded from Adobe's World Wide Web server at **http:// www.adobe.com/software.html** and is also available from popular on-line services such as CompuServe and America Online. Adobe Exchange software is available for a wide variety of platforms for under $200 at popular computer retailers or mail order firms.

PIPPIN: Apple Computer's Nintendo-like black box that can be used for surfing the Internet or playing games.

PNG: (pronounced *ping*) Portable Network Graphics is the successor to the GIF format widely used on the Internet and on-line services, like CompuServe. In response to the announcement from CompuServe and UNISYS that royalties would be required on the formerly freely used GIF file format, a coalition of experienced independent graphics developers from the Internet and CompuServe formed a working group to design a new format that was called PNG.

Here are a few features of the file format: PNG's compression method has been researched and judged free from any patent problems. PNG allows support for true color and alpha channel storage and its structure leaves room for future developments. PNG's feature set allows conversion of all GIF files and, on average, PNG files are smaller than GIF files. PNG offers a new, more visually appealing, method for progressive display than the scan line interlacing used by GIF. PNG is designed to support full file integrity checking as well as simple, quick detection of common transmission errors. And all implementations of PNG are royalty-free.

PPP: Point to Point Protocol used by Macintosh computers for Internet access.

PROTOCOL: A communications buzzword that means that the computers on both ends of a connection are operating under the same rules so they can communicate without any problems.

QTML: QuickTime Media Layer.

RF: Royalty free. A term commonly used on the Internet and by firms that sell stock photography CD-ROMs to indicate that once a user has purchased an image, no further fees are due for any additional usage. The topic of whether royalty-free digital images represent a business opportunity or the destruction of civilization as we know it is hotly debated. Opponents are sure that digital stock would bring down prices of "regular" stock, proliferate mediocre photography, and, in general, hurt the industry. These arguments sound familiar and are, in fact, the same rationale assignment photographers used years ago to describe the emerging stock photography business. I believe digital stock photography will increase opportunities for conventional stock images, as well as assignment photography. Here is why.

The major market for digital stock is not Fortune 500 companies or major advertising agencies. The buyers of digital stock are the millions of small businesses and nonprofit organization currently publishing newsletters, flyers, and other small circulation material. All these Quark XPress and PageMaker users would like to use photographs in their publications, but are not used to the process of hiring a photographer or buying stock photographs. For most of them, their last contact with a professional photographer was at their own or a friend's wedding. Consequently, some of them will unwittingly scan (and steal) images from magazines, but few will or can afford to pay standard stock agency rates. Stock Photography CD-ROMs, therefore, reach an audience stock photographers normally don't have access to. At a recent MacWorld Expo, I spoke with a woman who publishes a newsletter for her family-owned travel agency. In a recent newsletter, she was publicizing a trip to the Middle East and wanted to place a black-and-white image of some of the Holy Land sites the tour would visit. She contacted several sources asking for free pictures, but they all referred her to stock agencies. When she called them and inquired about the cost of using the images she wanted, she found the prices too high. On the other hand, she found the cost of images from a stock photography CD-ROM to be affordable. This was a sale, nobody would have made unless the images had been available digitally.

Some photographers believe that if one of their images appears on a royalty-free digital CD-ROM, some hot shot art director from a big time agency will use it in a major ad campaign. All they can think about is how much money they're going to be losing. Sorry, Charlie. No ad agency will use a royalty-free digital image for a national campaign for the same reason they won't use a tune from a music library CD. They're concerned that the same piece of music will show up in a local car dealer's TV spot. The same thing is true for image discs. The majority of people who are using royalty-free digital images are small business who can't afford conventional stock photography. In the past they wouldn't even use a professional. They might have shot the job themselves

or borrowed images from a friendly amateur photographer. Digital stock, for the first time, lets the average small business owner utilize the services of a professional photographer. Once they see the value of using a professional, it could even increase the amount of stock and assignment photography work for all of us.

Royalty-free digital images are a reality. If their concept offends you, don't participate in the process. That's your right as an independent photographer, but whether you like it or not, technology is going to change the way we work. How well we deal with these forces of change will decide our future success.

SEARCH ENGINE: Since the actual number of Websites on the World Wide Web is big and getting bigger everyday, finding the Exacta Collectors home page might be impossible without a way to search for the word "Exacta." That's the function of search engines; you type in a word or words and a list of Websites whose descriptions contain those keywords appear.

SERVER: A shared computer on a local area network (or the Internet) that interfaces with a client in the form of Internet software and/or hardware. A server acts as a storehouse for data and may also control e-mail and other services.

S/MIME: Secure Multipurpose Internet Mail Extensions. *See* MIME.

SMTP: Simple Mail Transfer Protocol allows Internet users to send e-mail (electronic mail) by allowing computers to emulate a terminal connected to a mainframe computer. E-mail allows you to send a message electronically to another user who may be located anywhere in the world.

SOHO: Small Office/Home Office. An oh-so-clever marketing term created by the explosion of at-home workers produced by corporate downsizing and telecommuting. Since many photographers already had established at-home studios, we were among the first professional class to be SOHO users, long before the term was invented and popularized. SOHO computer users typically have less complex demands on their computer systems, in terms of volume of data processed, but actually make more demands on their system as far as power, functionality, and productivity. These requirements extend to using computers for telecommunications, including Internet access, as well as digital imaging and general business usage.

The same acronym, SOHO, was applied to the trendy artist district in New York City that is located South of Houston Street—hence SOHO. The popularity of this location and acronym has spawned imitations in other cities, such as SOMA—South of Market Street—in San Francisco and LODO—Lower Downtown—in Denver.

SPIDER: A propeller-head term for Intelligent Agent. Spiders have long been though to be the most efficient form of an Intelligent *hardware* Agent and have been used in science-fiction literature, such a Greg Bear's chilling *The Forge of God* and the Tom Selleck film of Michael Creighton's *Runaway*. The Excite search engine has a software "spider" that searchers the World Wide Web for new Websites that it then posts in its database of millions of home pages.

TCP/IP: Transmission Control Protocol/Internet Protocol is the official protocol for the Internet. TCP/IP's big job is making sure that the number of bytes of data that starts at one place is the same number that gets to the other end. It

was originally developed for UNIX computer systems but is standard on all computers.

TELNET: Originally developed for ARPANET, Telnet is part of the TCP/IP communications protocol. It is a tool to allow you to log onto remote computers, access public files and databases, and even run applications on the remote host. When using Telnet, your computer behaves as if it were a "dumb" terminal connected to another, larger machine by a dedicated communications line. Although most computers on the Internet require users to have an established account and password, many allow you access to search utilities, such as Archie or WAIS. You don't have to buy any new software to access the Telnet function. Browser software, such as Wollongong Group's Emissary and Quarterdeck's Mosaic seamlessly integrates e-mail, FTP, and Telnet into Web browser activities.

TIN: While you can use your browser for accessing USENET newsgroups, there are dedicated programs, such as TIN (Threaded Internet Newsreader) that allow you to read newsgroup messages on the Internet.

UNIX: A multiuser, multitasking (doing more than one thing at the same time), multiplatform operating system originally developed by Bell Laboratories for mainframe and mini-computers back in the bad old days of computing. UNIX is constantly being overhyped as "the next big thing." Its main popularity, now, seems to be in universities and some large businesses and while there are many implementations of UNIX for both the PCs and Macintosh, none have caught on in any great numbers. One of the main reasons for this is that the operating system requires large amounts of memory and is a hard disk hog.

URL: Uniform Resource Locator. The address of a page on the World Wide Web. It includes the appropriate protocol, the system, path, and file name. e.g. **http:/ /www.li.net/~hsb60901.jpg.** Where: **www** is the system, **li.net** is the path, and **~hsb60901.jpg** is the file name.

USENET: USEr NETwork, began in 1979 as a bulletin board that was shared between two universities in North Carolina. It has grown—in 1994, the daily volume exceeded 50MB of data—into a public access network maintained by volunteers on the Internet, that provides user news and e-mail services.

UUENCODE: UUencode software allows you to convert a binary computer file into ASCII form, for sending across the Internet (or any other e-mail service), then convert it back to binary when it reaches its destination. In UUencoded form, a file may be visible and readable by your word processor, as ASCII text, but it will looks like gibberish on the screen. Some e-mail services, such as CompuServe, allow you to attach a binary (graphic, audio, or video clip) file to a message without ever affecting the message. The person receiving your, now combined, message can read your e-mail and then convert the file into its original, intended form.

VERONICA: Very Easy Rodent Oriented Netwide Index of Computerized Archives. Veronica locates gopher sites by chosen topics and prompts users to choose key words for searching, generating hundreds of references on the subject. A user can chose a reference and instantly view the information. There are a limited number of Veronica sites and a plethora of users. Veronica is a tool to help you

find the Gopher servers containing information you need and you can browse a Veronica menu just like you would a Gopher menu.

V.FC: V.First Class. A data standard created for 28,800 modems by Rockwell International before V.34 standards were finalized.

VIDEC: Connectix's proprietary Video Digitally Enhanced Compression technology that compresses video data at a 4:1 ratio with only slight loss in video quality allowing users to get faster frame rates and add larger frame sizes.

VRML: Virtual Reality Markup Language.

VRML+: A proposed extension to Virtual Reality Markup Language that will allow it to support real-time interaction with other people. It is not yet publicly available.

WAIS: Wide Area Information Server is a system to search Internet databases. You can do a keyword search using WAIS to retrieve all of the matching documents and then read them.

WEB BROWSER: A Web browser is a program that allows computer users to locate and access documents on the World Wide Web.

WEB CLIENT: A wirehead term for Browser. *See* Browser.

WEBZINE: *See* E-zine.

WINSOCK: A software standard that provides a common interface between TCP/IP and Internet software for computers using the Windows operating environment.

WORLD WIDE WEB: One of the most popular aspects of the Internet, the World Wide Web has a set of defined conventions for publishing and accessing information using HyperText and multimedia. Apparently, the WWW contains everything you ever wanted to know about anything.

YAHOO!: Despite its somewhat silly name, Yahoo! is the Honda Accord of World Wide Web search engines; it is the search engine that all of its competitors compare to themselves.

Internet Resources

AboutPeople from Now Software **http://www.nowsoft.com/plugins/ about_people.html**

AboutTime from Now Software **http://www.nowsoft.com/plugins/about_time. html**

Accufind **http://nln.com**

Adobe Systems, Inc., 1585 Charleston Road, PO Box 7900, Mountain View, CA 94039-7900; 415/961-4400 **http://www.adobe.com.**

Agfa digital imaging (scanners, digital cameras, etc.) **http://www. agfa.com**

Agfa film and conventional imaging products **http://www.agfaphoto. com**

Aladdin Systems, 165 Westridge Drive, Watsonville, CA 95076; 408/761-6200 fax 408/761-6206 **http://www.aladdinsys.com**

Alta Vista **http://www.altavista.digital.com**

Apple Computer, 1 Infinite Loop, Cupertino, CA 95014; 408/996-1010 **http:// www.apple.com**

Auto F/X, Black Point, HCR-73, Box 689, Alton Bay, NH 03810; 800/839-2008

Archie **archie.mcgill.ca or archie.sura.net**

Astound Web Player from Gold Disk **http://www.golddisk.com/awp/index.html**

Banana Software Inc., 29 Engle Road, Paramus, NJ 07652; 201/265-9855 e-mail: **alex@civ.com**

Gordon Baer Photography **http://w3.one.net/~gbphoto**

Beginner's Guide to HTML **http://www.ncsa.uiuc.edu/General/Internet/WWW/ HTMLPrimer.html**

Bender Photographic Inc. **http://www.cascade.net/~jbender/index. html**

Bogen Photo **http://www.bogenphoto.com**

Bronica **http://www.tamron.com**

Paul C. Buff, White Lightning **http://www.edge.net/buff**

Byte magazine's Website **http://www.byte.com**

Canon Computer Systems **http://www.ccsi.canon.com**

Canon USA **http://www.usa.canon.com**

Chimera **http://ww.chimeralighting.com**

CiNet's ShareWare.COM Website **http://www.shareware.com**

CompuServe Inc., 5000 Arlington Centre Blvd., P.O. Box 20212, Columbus, OH 43220; 800/848-8199, fax 614/457-0348 **http://www.compuserve.com**

Connectix **ftp://www.connectix.com**

CU-SeeMe (Cornell University) **ftp://gated.cornell.edu/pub/video/**

CU-SeeMe (White Pine Software) **http://goliath.wpine.com/cu-seeme.html**

Cyberdog (from Apple Computer) **http://cyberdog.apple.com**

Darkroom On-Line **http://www.sound.net/~lanoue**

DejaNews **http://www.dejanews.com**

Destination Beer **http://www.n-vision.com/beertravelers**

Diamond Multimedia Systems, Communications Division (formerly Supra), Vancouver, WA; 360/604-1400, fax 360/604-1401 **http://www.supra.com**

Dicomed **http://www.dicomed.com**

Digital Frontiers, 1019 Asbury Avenue, Evanston, IL 60202; 516/757-0400, fax 516/ 757-2217 **http://www.phaseone.com**

EarthLink Network, Inc., 3100 New York Drive, Suite 201, Pasadena, CA 91107; 818/296-2467, fax 818/296-2649

Eastman Kodak Company **http://www.kodak.com**

The Electric Library **http://www.elibrary.com**

Epson America Inc., 20770 Madrona Ave., Torrance, CA 90503; 310/782-0770 **http://www.epson.com**

Equilibrium Technologies, 475 Gate Five Road, Suite 225, Sausalito, CA 94965; 415/ 332-4343, fax 415/332-4433

Excite **http://www.excite.com**

Joe Felzman Photography and JFP Stock Photography **http://www. teleport.com/ ~felzman/**

FUJI Filmmaterialien (Germany) **http://www.fotoline.ch/firmen/fuji/fujifilm. htm.siete**

FUJI Imaging and Information (digital imaging) **http://www.fujifilm. co.jp**

Fuji Photo Film USA **http://www.fujifilm.co.jp/usa/aps/smartcity**

Fujitsu **http://www.fujitsu.com**

GIF Converter **http://www.kamit.com/gifconverter.html**

HotWired **http://www.hotwired.com/frontdoor**

How to set up a simple hit counter **http://www.netcore.ca/infopages/webpage/ counter.html**

Hyperzine, an on-line photographic magazine **http://www.hyperzine. com**

Ichat **http://www.ichat.com/ichat2/download.html**

Infoseek Guide **http://info.infoseek.com**

Inset Systems, 71 Commerce Drive, Brookfield, CT 06804-3405; 800/374-6738, fax 203/775-5634

Joe and Mindy's Webzine Links **http://www.nhn.uoknor.edu/~howard/ zines.html**

Jones Internet Channel, 9697 E. Mineral Avenue, Englewood, CO 80155-3309; 303/ 792-3111 **http://www.digitalempire.com**

Juno Online Services, LP, 120 West 45th Street, 39th Floor, New York, NY 10036; 212/478-0800, fax 212/478-0700

Konica Corporation **http://www.konica.com**

Leica **http://www.leica.com**

LYCOS **http://www.lycos.com**

Macromedia, 600 Townsend, San Francisco, CA 94103; 415/252-2268, fax 415/626- 1502 **http://www.macromedia.com**

ShockWave from Macromedia **http://www.macromedia.com/shockwave**

Macintosh CGI scripts **http://www.uwtc.washington.edu Computing/ WWW/ Mac/CGI.html**

Magellan **http://www.mckinley.com**

Marketwise Data Inc., 2860 S. Circle Dr., Suite 2104, Colorado Springs, CO 80906; 719/579-0993 **http://www.market1.com**

Micrografx, Inc., 1303 East Arapaho Rd, Richardson, TX 75081; 214/234-1769, fax 214/994-6227 **http://www.micrografx.com**

Microsoft Corporation, One Microsoft Way, Redmond, WA 98052-6399; 800/426-9400 **http://www.microsoft.com**

Animation Player from Microsoft **http://www.microsoft.com/mspowerpoint/ internet/player/installing1.html**

Minolta **http://ny.frontiercomm.net/~minolta**

NetCom, 3031 Tisch Way, San Jose, CA 95128 **http://www.netcom. com**

Netscape Communications Corp., 501 E. Middlefield Rd., Mountain View, CA 94043; 800/NETSITE, fax 415/528-4120 **http://home. netscape.com**

Netwriter Viewer By Paragraph International **http://www.paragraph. com/ netwriter/pictures**

Nikon Electronic Imaging, 1300 Walt Whitman Road, Melville, NY 11747-3064; 516/547-4200 **http://www.nikonusa.com**

Novatek (enlarger timers) **http://www.foothill.net/~novatek/**

Olympus Camera **http://www.plus.at/olympus**

Online PhotoWeb **http://www.Web-search.com/photo.html**

Optical Storage Technology Association **http://www.osta.org**

The Palace **http://www.the palace.com**

Paper Direct **http://www.nyca.com/paper.html**

Partners In Health (Kaiser Permanete) **http://www.kaiserper-manenteca.org**

Peanut's Collectors home page **http://www.dcn.davis.ca.us:80/~bang/peanuts**

Pegasus from Pegasus Software **http://www.jpg.com/product.html**

Pentax Corporation **http://www.pentax.com/645.htm**

Photo Traveler On Line **http://home.earthlink.net/~phototravel**

PhotoBubble **http://www.omniview.com/viewers/viewers.html**

Photo>Electronic Imaging magazine **http://www.peimag.com**

Photoflex **http://www.photoflex.com**

Photography and Digital Imaging Resource **http://www.best.com/~cgd/home/ pholinks.htm**

PointCast **http://www.pointcast.com**

Polaroid **http://www.polaroid.com**

Quarterdeck, Corp., 13160 Mindanao Way, 3rd Floor, Marina del Rey, CA 90292-9705; 800/354-3222, fax 310/309-4219 **http://www. qdeck.com**

QuickTime from Apple Computer **http://quicktime.apple.com/sw/sw.html**

ResNova Software, Inc., 5011 Argosy Dr., Suite 13, Huntington Beach, CA 92649; 714-379-9000, fax 714-379-9014 **http://www.resnova. com**

Ricoh **http://www.ricohpg.com**

Sausage Software **http://www.sausage.com.au**

Scitex **http://www.scitex.com**

The Sci-Fi Webzine **http://www.sci-fi-mag.com**

Seattle FilmWorks, 1260 16th Avenue West, Seattle, WA 98119-3401; 800/445-3348 **http://www.filmworks.com**

Second Glance Software, 7248 Sunset Avenue, NE, Bremerton, WA 98311; 360/692-3694, fax 360/692-9241

SF Times **http://www.spirit.com.au/acm/sftimes.html**

Sinar-Bron **http://www.wowdigital.com/sinarbron/sinarbron.html**

Slate, an interactive magazine of politics and culture **http://www.slate.com**

Snarl **http://www.america.net/~jns/snarl.html**

Software Avenue, P.O. Box 1324, Gilbert, AZ 85234; 602/813-0876

Sony **http://www.sony.com**

Stacy's Home Journal **http://www.users.interport.net/~sr/etc.html**

Stim **http://www.stim.com**

Studio Press, 4330 Harlan Street, Wheat Ridge, CO 80033; 303/420-3505

Mark Surloff **http://home.earthlink.net/~baxsur/**

Symantec Corporation, 2500 Broadway, Suite 200, Santa Monica, CA 90404-3063; 310/453-4600, fax 310/829-1826 **http://www. symantec.com**

SyQuest, 47071 Bayside Parkway, Fremont, CA 94538; 510/226-4000

Talker by MVP Solutions **http://www.mvpsolutions.com**

Tamron/Bronica **http://www.tamron.com**

Trudef By Advanced Multimedia Concepts **http://www.amci.com/trudef/tdpi.html**

Twin Palms **http://www.sfol.com/sfol/books/palms/twinpalm.htm**

Word Viewer from Inso Corporation **http://www.inso.com/plug.htm**

Whurlplug, created by John Louch **ftp://ftp.info.apple.com/Apple. Support. Area/QuickDraw3D/Test_Drive/Viewers/Whurlplug1d6.hqx**

Jonathan C. Winters Toy Camera home page **http://www. pointcom. com**

US Robotics, 8100 N. McCormick Blvd., Skokie, IL 60076-2999; 708/983-5001, fax 708/933-5800 **http://www.usr.com**

Web Crawler **http://Webcrawler.com**

Web Ninja, William H. Tudor **http://www.albany.net/~wtudor**

Werner D. Streidt´s home page **http://www.teleport.com/~ccox/plug-ins. html**

Wolf Camera, 1706 Chantilly Drive, Atlanta, GA 30324; 404/633-9000, fax 404/ 325-2248 **http://www.wolfcamera.com**

Yahoo! **http://www.yahoo.com**

Zoom Telephonics, Inc., 207 South Street, Boston, MA 02111; 617/423-1072, fax 617/423-3923 **http://www.zoomtel.com**

Index

Books from Allworth Press

The Internet Publicity Guide by V. A. Shiva
(softcover, 6 × 9, 208 pages, $18.95)

Arts and the Internet: A Guide to the Revolution by V. A. Shiva
(softcover, 6 × 9, 208 pages, $18.95)

The Digital Imaging Dictionary by Joe Farace
(softcover, 6 × 9, 256 pages, $19.95)

Pricing Photography, Revised Edition by Michal Heron
and David MacTavish (softcover, 11 × 8½, 144 pages, $24.95)

ASMP Professional Business Practices in Photography, Fifth Edition
by ASMP (softcover, 6¾ × 10, 416 pages, $24.95)

The Photographer's Guide to Marketing and Self-Promotion,
Second Edition by Maria Piscopo (softcover, 6¾ × 10, 176 pages, $18.95)

How to Shoot Stock Photos That Sell, Revised Edition by Michal Heron
(softcover, 8 × 10, 208 pages, $19.95)

Stock Photography Business Forms by Michal Heron
(softcover, 8½ × 11, 128 pages, $18.95)

The Business of Studio Photography by Edward R. Lilley
(softcover, 6¾ × 10, 256 pages, $19.95)

Mastering Black-and-White Photography by Bernhard J Suess
(softcover, 6¾ × 10, 240 pages, $18.95)

The Law (in Plain English) for Photographers by Leonard DuBoff
(softcover, 6 × 9, 208 pages, $18.95)

Business and Legal Forms for Photographers by Tad Crawford
(softcover, 8½ × 11, 192 pages, $18.95)

Legal Guide for the Visual Artist, Third Edition by Tad Crawford
(softcover, 8½ × 11, 256 pages, $19.95)

The Copyright Guide by Lee Wilson (softcover, 6 × 9, 192 pages, $18.95)

Overexposure: Health Hazards in Photography, Second Edition
by Susan D. Shaw and Monona Rossol (softcover, 6¾ × 10, 320 pages, $18.95)

Please write to request our free catalog. If you wish to order a book, send your
check or money order to Allworth Press, 10 East 23rd Street, Suite 400, New
York, NY 10010. Include $5 for shipping and handling for the first book or-
dered and $1 for each additional book. Ten dollars plus $1 for each additional
book if ordering from Canada. New York State residents must add sales tax.

If you wish to see our catalog on the World Wide Web, you can find us at
Millennium Production's Art and Technology Web site:
http://www.arts-online.com/allworth/home.html
or at **http://www.interport.net/~allworth**